# ÉMILE MÂLE

# RELIGIOUS ART

## FROM THE TWELFTH
## TO THE EIGHTEENTH CENTURY

FORTY-EIGHT PLATES

PRINCETON UNIVERSITY PRESS

Published by Princeton University Press, 41 William Street,
Princeton, New Jersey 08540
In the United Kingdom: Princeton University Press
Oxford

First Princeton Paperback printing, 1982
Original French title: *L'Art religieux du XIIe au XVIIIe Siècle*

LCC 82-47903
ISBN 0-691-04000-1
ISBN 0-691-00347-5 pbk.

Princeton University Press books are printed on
acid-free paper, and meet the guidelines for permanence and
durability of the Committee on Production Guidelines for Book
Longevity of the Council on Library Resources

Printed in the United States of America

Reprinted by arrangement with Pantheon Books, Inc., a
division of Random House, Inc., New York

3   5   7   9   10   8   6   4   2

# PUBLISHER'S NOTE

Émile Mâle's works on religious art are now accepted as classics. Monuments of scholarly achievement, they are written in a literary style that conveys with eloquence the power of Mâle's authority and the fineness of his thought.

The complete critical history, originally published between 1898 and 1932, comprises four large volumes: *L'Art religieux du XIIe siècle en France, L'Art religieux du XIIIe siècle en France, L'Art religieux de la fin du moyen âge en France*, and *L'Art religieux après le Concile de Trente*. From these, Mr. Mâle selected the passages he thought most significant, and supplied new connecting texts, evoking, in this brief book, an intimate, living picture of the French Middle Ages, and the grandeur of the artistic Renaissance that accompanied the Counter Reformation.

Princeton University Press is issuing an English edition, with updated footnotes and new illustrations, of all four of the volumes on religious art. These volumes will constitute Bollingen Series XC.

# LIST OF ILLUSTRATIONS

# TABLE OF CONTENTS

11

# RELIGIOUS ART OF THE WANING MIDDLE AGES

# RELIGIOUS ART AFTER THE COUNCIL OF TRENT

# RELIGIOUS ART
# OF THE TWELFTH CENTURY

# ORIGINS

<div style="padding-left: 3em;">

*DIFFUSION OF SCULPTURE. THE ROLE OF CLUNY*

Sculpture was reborn in France in the eleventh century. It was soon adopted as the most powerful auxiliary of thought by the abbots of Cluny, Saint Hugh and Peter the Venerable, who encouraged sculpture in Aquitaine, in Burgundy, in Provence, even in Spain. What a debt of gratitude we owe to these great men! They believed in the power and virtue of art. At the very time when Saint Bernard was despoiling his churches of all their ornaments, Peter the Venerable was ordering the chiseling of capitals and the sculpture of tympana. The eloquence of the ardent apostle of austerity did not convince Peter that beauty was dangerous; he saw in it, rather, as Saint Odon had taught, a prefiguring of heaven.

The men of Cluny were right. To be poor as Saint Bernard was poor requires a marvelous richness of inner life; the humble believer stands in need of help. Who can say how many souls have been moved, sustained, comforted over the centuries by these bas-reliefs and these

</div>

capitals, in which there is so much faith and so much hope? As I for one have been heartened, deciphering, in the light of cloisters or the half-light of Romanesque churches, ancient stories written in stone.

Twelfth-century art is primarily a monastic art. We do not, of course, mean to say that all the artists of that time were monks; but nearly always the regular clergy dictated the choice of subjects. In their libraries, well stocked with illuminated manuscripts, the monks preserved the treasures of ancient Christian art. They were the guardians of tradition. When they wished to adorn their churches they quite naturally went to the miniatures for models. And the conditions of miniature art explain both the exaggerated, tortuous details of nascent French sculpture and the profoundly traditional character of French iconography.

*THE INFLUENCE OF ILLUMINATED MANUSCRIPTS* The most celebrated of all the manuscripts originating in the Midi is the *Apocalypse* of Saint-Sever preserved in the Bibliothèque Nationale. In 784, hidden in a valley of the Asturian Mountains, where the Arab invasion had come to a halt, Beatus, Abbot of Liebana, wrote a commentary on the Revelation of Saint John, and incidentally implied that the end of the world was at hand. His writings were taken up by the Spanish Church and recopied from century to century, admirable miniatures contributing as much to their success as did the text itself. From the tenth century till the beginning of the thirteenth the designs were reproduced over and over again, not slavishly copied, however, but with a wealth of variations of detail. The *Apocalypse* never ceased to stimulate the imagination of the artists.

18

In the magnificent tympanum of the Abbey of Moissac we find Christ in glory among the four beasts; He is accompanied by the eighty-four elders of the Apocalypse, seated on their thrones, bearing cups and viols (Pl. 1). This is the vision of the Son of Man according to Saint John, which can be seen in its earliest form in the Roman basilicas, and later in the Carolingian manuscripts. But neither the Roman mosaics nor the Carolingian miniatures are quite like the tympanum of Moissac. Both at Rome and in the Carolingian manuscripts the elders of the Apocalypse are seen standing, and they offer their crowns to a lamb or to a simple bust of Christ. Clearly, there is no direct line of fileation between these works and the tympanum of Moissac.

Does this variation at Moissac have an artistic ancestry, then, or was it the original invention of twelfth-century sculptors? We can hardly believe the latter once we are familiar with the *Commentary on the Book of Revelation* by Beatus of Liebana. On one of the most splendid pages of that manuscript Christ is shown in glory, the four beasts with Him, the twenty-four elders forming a great circle around Him. The elders are seated on their thrones; they wear crowns, each holds a cup in one hand and a viol in the other, and their eyes are turned toward the dazzling vision, while angels fly about them in heaven (Pl. 2).

This must have been the source of inspiration for the tympanum of Moissac. Doubtless the Abbey owned a copy of the *Commentary,* and from this the artist got his conception of the elders, with their crowns, their cups, their viols similar to Spanish guitars, their finely worked wooden thrones. The noble figures of the elders passed practically unchanged from miniature to monumental art, though the sculptor, unable to arrange the figures in a circle, set them in tiers, one above the other, as high

19

as he could, on either side of the Christ. I have further found in the tympanum of Moissac the exact type of angels designed by the miniaturist—the same low forehead and thick hair. The broad folds of the mantles and tunics, laid side by side like a succession of strips, are very much in the tradition of the southern miniatures; a fine eleventh-century manuscript at Limoges shows Christ on the cross, the Virgin and Saint John draped as the figures of Moissac will soon be, in the same broad pleats of material, the same billowing folds. We might almost think that the miniaturists had suddenly turned sculptors.

**ORIENTAL ORIGINS OF CHRISTIAN ART** In order to understand the art of the twelfth century more fully we must penetrate beyond the influence of Cluny and the manuscripts, to Oriental Christian art of the fourth, fifth, and sixth centuries. This Christian art had two different aspects: the art of the Greek cities, Alexandria, Antioch, Ephesus; and that of Jerusalem and the Syrian regions.

The art of the Greek Orient is still deeply imbued with the ancient Hellenic spirit. The Greeks saw in the Gospels not their dolorous but their luminous aspect. Depicting the Passion on their sarcophagi, they show neither humiliations nor sufferings. The crown of thorns which a soldier holds over the head of Jesus is a triumphal crown; before His judges and His tormentors, Christ retains the firm attitude of the ancient hero, the stoic sage.

Though the Greeks turned Christian, their imagination remained pagan; they continued to people the world with nymphs and gods. Near Jesus baptized by Saint John they picture the god of the Jordan, crowned with water lilies. From the Red Sea, which the Jews have just crossed,

they make the spirit of the deep, βυθός, rise up, seize Pharaoh by the hair, and drag him below. They give to David for companion the Muse of Melody, who seems to dictate his psalms; while a mountain god, stretched out lazily, listens to the poet's lyre, and Echo shows her young face by the fountain (Pl. 3). Isaiah stands between a somberly veiled goddess, Night, and a child carrying a torch, Daybreak; this beautiful image was meant to signify that Isaiah received his inspiration at the precise moment when day begins to pierce through the shadows. The figure of Night, spreading a blue veil sown with stars over her aureoled head, is as magnificent as a verse out of Homer.

So the Greeks remained true to themselves. And the Homeric cast of imagination, persisting after several centuries of Christianity, lends an undeniable charm to their later art; but it must be admitted that the biblical subjects emerge somehow diminished. This Arcadia inhabited by nymphs is very different from the heroic biblical world—the vast solitary stretches over which passes the spirit of the Lord. Hellenistic Christian art did not have the secret of grandeur. Glancing through the Alexandrian *Genesis* which is preserved at Vienna, we find a last memory of the amiably graceful pictures at Herculaneum, but no trace of biblical sublimity. The Greeks felt more readily the spirit of the New Testament. They conveyed well its gentleness; its majesty seems to have eluded them.

Nothing demonstrates this better than the Greek conception of Christ. The Christ of Greek art was not a man of thirty but a beardless youth, practically an adolescent. The Greeks of Asia Minor gave Him long hair, the Greeks of Alexandria made Him short-haired, but both endowed Him with the same youthful charm. Their conception is undoubtedly appealing; Jesus is an irresistible young

21

master, a poet, all beauty and eloquence and sweetness. But this figure lacked godlike majesty. To show that He was more than a human being the Greeks had to encircle His head with the nimbus they had sometimes given to their own divinities—the same nimbus that Greek artists placed about the head of Buddha when they sculptured the first statues of him in India.

The mosaics of Jerusalem and the manuscripts of Syria, on the other hand, arising out of the very localities in which the events of the Gospel had unfolded, have a peculiar authenticity. Here Christ appears not as a youthful Greek, but as a Syrian in the full vigor of young manhood, long-haired, with a black beard. And as Hellenistic art had invested the Virgin with the tunic, the coiffure, sometimes even the earrings of the great ladies of Alexandria, so the art of Jerusalem enveloped her in the long veil of Syrian women, the *maphorion* which hid the hair and lent a modest grace to the figure. The Virgin of the mosaics was made to resemble the young girls who mounted the steep streets of Zion.

We must bear in mind that the art of Palestine was commemorative, and designed to perpetuate, on the original scene, the events of the Gospels for innumerable generations of pilgrims. Conceived for them, this art incorporated the memorable places, even the legends, that charmed these pilgrims. Thus the artists set the Nativity scene in the True Grotto at Bethlehem. The Annunciation to the Shepherds included the tower pointed out to pious travelers as the spot where the angel had appeared. Near Christ, baptized by Saint John, a cross was represented in the middle of the Jordan—the same cross that in the actual river marked for the pilgrims the place of Christ's Baptism. In the scene of the Holy Women at the tomb the sepulcher appears in the strange form of a small

temple, supported by columns; this was the *tugurium*, the monument within the Rotunda of Constantine which marked for visitors the site of Christ's tomb.

But the most impressive quality of Palestinian art is its heroic character, never attained by Hellenistic art. The mosaicists of the Holy Land represented the scenes from the life of Christ with a hitherto unparalleled solemnity and grandeur. To them the Gospel was no longer a touching story; it had already become a series of dogmas defined by the Councils. The extant copies of the ampullae of Monza, mediocre as they are, give us some hint of the powerful symmetry of the originals, works of art already possessing a hieratic quality. In the Ascension scene, Christ mounts up to heaven in an aureole borne by angels. The Syrian interpretations of Gospel events begin to show the workings of mystical thought. An angel standing on the bank of the Jordan witnesses the Baptism of Christ and symbolically unites heaven and earth. The most mysteriously imposing of all figures, however, is that of the Virgin. Facing us from her throne, she holds the Child in the exact center between her breasts; on her right are the Magi and on her left the shepherds; no queen was ever more majestic. We see emerging here the type of sovereign Virgin of which we shall find other examples in the mosaics of Sant' Apollinare Nuovo at Ravenna, in the frescoes of Santa Maria Antiqua at Rome, and in the portals of French churches of the twelfth century.

Medieval artists made use, sometimes of the Syrian, sometimes of the Hellenistic conventions, according to the origin of the manuscripts from which they drew their inspiration.

The ANNUNCIATION was conceived by the Greeks with

a noble simplicity. When the angel appears before her, the Virgin remains seated, as though incapable of rising, all the weight of her mission already upon her. A fresco in the Catacombs of Priscilla shows this Hellenistic concept in its original form. A little later we shall see the Virgin either holding or letting fall a spindle wound with purple thread—the apocryphal gospels tell us that Mary was working on the veil of the Temple at the moment of the angel's appearance. A sarcophagus of Ravenna, in almost classical style, a fabric of the Lateran, and the ivories of Alexandria show her in this attitude.

The Syrian concept is quite different. It appears on one of the ampullae of Monza, which probably reproduces the mosaic of the Church of Nazareth. Mary rises to meet the angel, and seems to assent to the divine bidding. In the Greek interpretation she appears passive; but here she asserts her willingness to participate in the salvation of mankind. The idea is more profound.

From the sixth century on, we see this version of the Annunciation throughout the Orient. The Syrian manuscripts and the frescoes of Cappadocia show us the Virgin standing in the presence of the angel.

Perpetuated in the manuscripts, the Syrian and Hellenistic conceptions appear simultaneously in French monumental art of the twelfth century. The Virgin appears seated in a capital of Saint-Martin d'Ainay at Lyons, in a capital at Lubersac (Corrèze), in a capital of the façade of Saint-Trophime at Arles, and in a capital of the cloister there. On the other hand, we find the Virgin standing in the twelfth-century window at Chartres, in a capital of the twelfth-century church at Gargilesse (Indre), in the portal of La Charité-sur-Loire, and in the fine group at the museum of Toulouse.

24

The artists simply imitated whatever models chance brought to their attention, and imitation of the model was sometimes very close. In the capital at Arles, for example, the Virgin holds in her hand the Hellenistic ball of thread and the spindle which we see in the early monuments of Hellenistic art. It would be easy to demonstrate, by going into greater detail, that the treatment of the subject in French twelfth-century art—the attitude of the angel, raising his right hand like an ancient orator and holding in his left the heraldic staff, and the gesture of the Virgin, opening her hand upon her breast—is faithful to the most ancient models.

The VISITATION was represented by Hellenistic art from the fifth century onward. We find it on the same sarcophagus of Ravenna, the Annunciation scene of which we have already mentioned. The two women advance to meet each other, grave, like the figures on the tombs, with the Greek nobility of attitude and the Greek reserve. Syrian art, on the contrary, is passionate and dramatic. One of the ampullae of Monza which, as we have noted, was doubtless the reproduction of a Nazarene mosaic, shows the two women throwing themselves in each other's arms in a tender embrace. The Cappadocian frescoes prove that this conception was current in Syria.

As early as the sixth century we find these two traditions represented side by side in Christian art. In the Basilica of Parenzo in Istria, where Syrian influences are on the whole so profound, the mosaics keep the Hellenistic form of the Visitation; the two women face each other standing, raising their hands in a simple gesture. In the manuscript of Saint Gregory Nazianzen, in the Bibliothèque Nationale, however, where Hellenistic in-

fluences are sometimes so striking, the Visitation is thoroughly Syrian, Saint Elizabeth clasping the Virgin in her arms, her face brought close to Mary's.

In the twelfth century, French artists made impartial use of both traditions, passed on to them by the miniaturists. The sculptors of the porch of Moissac and the portals at Vézelay, for instance, and the glassworker at Chartres, favored the grave Hellenistic attitude. In the capital of the triforium of Saint-Benoît-sur-Loire, however, in the portal of Saint-Gabriel near Tarascon, in the capital of the cloister at Arles, in the capital at Die (Drôme), and in the bas-reliefs of La Trinité at Fécamp, the two women embrace each other, and we recognize the Syrian inspiration.

## THE INFLUENCE OF LITURGICAL DRAMA

Traditional iconography was enriched by the liturgical plays which were presented in the churches from the tenth century onward. We give in the following an example of the influence of dramatic representation upon art.

In the twelfth century, during Easter Week, usually at vespers on Tuesday, the meeting of Christ and the pilgrims of Emmaus was enacted in a number of churches. Two travelers were seen advancing, caps on their heads, staves in their hands, chanting in low voices, "Jesus our redemption, our love, our desire." Then Christ appeared in the dress of a pilgrim, also carrying a staff, with a shepherd's scrip slung over His shoulder. The travelers did not recognize Him; and the conversation turned upon recent events in Jerusalem, on the condemnation and death of Christ. The Stranger did not seem at all surprised.

"Did not the prophets foretell," He asked, "that Christ must suffer before entering into His glory?" While they were speaking together they came to a table that had been laid, and sat down. When Christ had broken the bread He spoke these words, "This bread I leave with you, my peace I give unto you." And He disappeared. Then only the travelers understood who the Stranger must have been, and they looked for Him, but in vain. Heavy with their loss, they walked on, saying, "Did not our hearts burn within us while He was speaking?"

Thus the events recounted in the liturgy began to take on the form of a mystery play.

How early are we to suppose that the play of the pilgrims of Emmaus was enacted in the West? We can say with some confidence that, from the beginning of the twelfth century on, it was presented in many churches, for at that time it was exerting its influence upon art. A bas-relief of the cloister of Silos, in Spain, which resembles the French monuments of Aquitaine very closely, shows the pilgrims passing along the pilgrimage road of Santiago de Compostela. We recognize here the trappings of the liturgical drama. The work at Silos can be dated about 1130, the approximate date of a celebrated English psalter in the Abbey of Saint Albans, in which a miniature, dedicated to the pilgrims of Emmaus, also shows Christ with a cap on His head, carrying a shepherd's scrip and a double staff.

In neither the Saint Albans manuscript nor the bas-relief of Silos do the two disciples have identifying attributes, as they will have later on. In one of the side portals of the Abbey of Vézelay, however, the disciples are already carrying the shepherd's scrip, a detail to which the rubric of the play enacted in the Cathedral of Rouen refers specifically. And the Rouen rubric accounts for the

fact that we find the scrip at Chartres, in one of the panels of the window devoted to the Passion and Resurrection, and again in a capital of the cloister of La Daurade in the museum of Toulouse.

The influence of the Emmaus mystery play upon plastic art is indisputable. The corded cap and scalloped scrip of the Saviour, the scrips and staves of the disciples can have no other derivation. They do not appear in Oriental art prior to our twelfth-century dramatic representation, and Byzantine manuscripts of the eleventh century also show nothing of the kind.

We are now in a much better position to understand the significance of the group of statues, long considered mysterious, which ornament one of the pillars of the cloister of Saint-Trophime at Arles. The figure in the center, bareheaded and barefooted, carries staff and scrip. Two other figures, wearing pointed caps, likewise carry staves and have bags slung over their shoulders. Once familiar with the rubrics of the liturgical drama, we immediately recognize Christ and the pilgrims of Emmaus. Here as at Chartres the Christ is without a cap, but the disciples have retained theirs.

## THE INFLUENCE OF SAINT-DENIS AND OF SUGER*

Various causes contributed to the transformation and enrichment of iconography in the twelfth century. The liturgical theater was one of these agents. The genius of Suger was another.

---

* The abbey church of Saint-Denis, near Paris, burial place of the royal families of France. Abbot Suger rebuilt the church in the twelfth century.

We are too apt to believe that the great art of the Middle Ages was a collective work. The idea does contain a certain element of truth, inasmuch as that art reflected the thought of the Church. But the thought itself found its initial expression through a few superior men. It is not the multitude that creates, but individuals. Let us leave to the romantically minded the mystical notion of a people building cathedrals by instinct—an instinct less fallible than science or reason. This pretended wand of instinct never made anything come up out of the ground. If we knew history better, we would find a single great intelligence as the source of every important innovation. When iconography is transformed, when art adopts new themes, it is because a thinker has collaborated with the artists. Suger was one of those men who set art in new ways. Thanks to him Saint-Denis was, from 1145 on, the hearth from which a rejuvenated art illumined France and Europe.

Only recently have we begun to understand all that French art owes to Saint-Denis. The first discovery was that Suger's famous ambulatory, with its extraordinary, centrally ribbed chapels, had given rise to a whole school of imitations. More or less faithful copies of Suger's design were recognized at Saint-Germain-des-Prés, Senlis, Noyon, Saint-Leu-d'Esserent, Saint-Pourçain, Ebreuil, Vézelay, and Saint-Etienne at Caen. Later it was observed that the great monumental sculpture of northern France had also followed the lead of Saint-Denis. The statues and bas-reliefs of the portals at Chartres, Etampes, Provins, Le Mans, Angers—to mention only some of the better-known churches—all follow the pattern which Suger's sculptors had provided. Finally, the stained-glass windows of Saint-Denis served as model in France and Eng-

land, so that the flourishing twelfth-century school of glass painting was most fittingly designated as "the school of Saint-Denis."

All of which gives the Abbey of Saint-Denis sufficient title to nobility. But Saint-Denis has still other claims to distinction. I am convinced that the iconography of the Middle Ages is as much indebted to the Abbey as are architecture, sculpture, and painting on glass. In the realm of symbolism, Suger was a creator, a discoverer of new models, new combinations, which the artists of his own and the following age adopted. Thirteenth-century iconography owes many of its motives to Saint-Denis.

It was Suger, for example, who appears to have been the creator of one of the noblest of all compositions: the Tree of Jesse. In any case it was under his direction that the artists of Saint-Denis gave the design a form so perfect that it was to impose itself upon succeeding centuries. The great abbot took care to tell us himself that there existed at Saint-Denis a window dedicated to the Tree of Jesse. The window is still to be seen today, very much restored, to be sure; but some ancient sections remain, and the restoration as a whole may be considered faithful to the original. As a matter of fact, the window at Saint-Denis was relatively easy to restore, since a copy, made about 1145, exists in a perfect state of preservation: the Tree of Jesse Window at Chartres. Except for minor details the works are identical, and we can go to Chartres to study Suger's creation in its present greatest glory.

The conception is of such grandeur that later ages in imitating it have only succeeded in diminishing it. Out of Jesse springs a great tree. Seated one above another, and composing together the central trunk of the symbolical tree, the kings rise in tiers. They carry no scepters, they hold no banderoles; nor do they play upon the harp,

as we shall find them doing in later representations. These kings do nothing at all, are content simply to exist, their true role being to perpetuate a predestined race. Because they have lived a Virgin sits enthroned above them, and, above the Virgin, a God, over Whom hover the seven doves of the Holy Spirit. On either side of the Tree, like the generations of the spirit answering to the generations of the flesh, the prophets rise one above the other. The hand of God, or the dove which issues from the cloud over the heads of the prophets, confirms their inspiration, confers upon them their mission. From age to age they proclaim the coming of the rod of Jesse, and they repeat the same word of hope.

Such is the design of this supreme work of art. A detail adds to the conception that beauty which only mystery can give. Jesse is shown reclining, asleep, upon his bed. It is night, and a lighted lamp hangs above his head; so it is in a dream that he foresees the future. And what biblical grandeur there is in this slumber, this dreaming, this prophetic night! What magnificent visual form has been given to the verses of Isaiah: "A shoot shall spring forth from the stem of Jesse, and a flower shall blossom at the summit of that shoot, and on it shall repose the spirit of the Lord."

## ART AND THE SAINTS

*A SAINT OF AQUITAINE, SAINT FOY*  Among the important factors which contributed to the enrichment of iconography we must count the saints and their legends. We shall be dealing with French saints, and with each saint as belonging to a province, beginning with a saint of Aquitaine, Saint Foy.

The center of ancient Aquitaine, with its abrupt val-

leys and swift rivers, has all the primitive beauties. But it is a country of granite, where the rock resists the chisel; so the saints were celebrated by metalworkers rather than by sculptors. As early as the end of the tenth century several churches of Aquitaine possessed images of their patron saints in gold, silver, or copper—images which also served as reliquaries.

This is how a scholaster of Angers, Bernard, who visited the Plateau Central in the early years of the eleventh century, describes them. "Up till now," he writes, "I had supposed that saints should receive no other tributes than those accorded them by drawing and painting. But such is evidently not the feeling of the people of Auvergne, Rouergue, Toulouse, and neighboring countries. With these people it is a well-established custom that each church should possess a statue of its patron. Depending on the resources of the church, the statue is of gold, silver, or some less precious metal; and enclosed within it is the head or some other notable relic of the saint."

Thus Bernard, a man of the North traveling in the Midi, discovered another France. He has recorded for us the names of some of those statues. At the Synod of Rodez, several had been brought to the meadow at the city gates; each was sheltered under a canopy, and all together they formed an assembly more imposing than that of the bishops. There was the "golden majesty" of Saint Marius, patron of the Abbey of Vabres in Rouergue, the "golden majesty" of Saint Armand, second Bishop of Rodez, the "golden majesty" of Saint Foy of Conques, and finally, near the gold shrine of Saint Sernin, the "golden majesty" of the Virgin. In his journey south, Bernard had already encountered the "majesty" of Saint Géraud, the young knight turned monk, who had given his name to the

great Abbey of Aurillac. He seems not to have seen the "majesty" of Saint Martial in the Abbey of Limoges.

Some of these strange statues exist even today. The "majesty" of Saint Foy is still at Conques, as in the time of the scholaster Bernard. We find it hard to recognize in the gilded idol the twelve-year-old girl of Agen martyred by Diocletian's governor. Seated on her throne, glittering with gold and precious stones, the saint wears a closed crown of very ancient form and long earrings that fall to her shoulders. In either hand she delicately holds up two slender tubes for flowers. Fine antique cameos are encrusted here and there in the metal of her dress (Pl. 4).

Not being able to make the saint beautiful, the artist made her so rich as to inspire religious dread. And there shone about Saint Foy an aura of miracles even more dazzling than the blaze of gold. If some scourge devastated the countryside, if a quarrel broke out between two cities, if a baron disputed possession of one of the Abbey's domains, the statue of the saint was forthwith drawn out of the sanctuary. It was borne by a gentle horse, specially chosen for the purpose, very slow of pace. Young clerks clashed cymbals about the statue and sounded ivory horns. The statue advanced majestically, like the Magna Mater of old, when the Aquitanian mountains were pagan. As it passed, harmony was everywhere re-established, peace restored. Miracles were so numerous that the monks scarcely had time to write them down. The saint took special joy in delivering prisoners. At the portal of Conques she is seen prostrated before the hand of God. Unquestionably she is praying for captives, because fetters are suspended as votive offerings behind her. The statue of Saint Foy was carried well beyond the limits of Rouergue, was displayed in Auvergne and in the Albigensian country. Every evening a canopy was prepared for it, and

over the canopy a cradle of greenery was raised. It is fortunate for us that the "majesty" of Saint Foy has been preserved intact across so many centuries, a block of gold lighting up for us the high Middle Ages, enabling us to understand a little better the mysterious and awe-inspiring power of the saint.

*THE SAINTS OF AUVERGNE* Few saints are more poetic than those of Auvergne. No doubt they owe part of their appeal to their first historian, Gregory of Tours, an unconscious artist, who does not show us his heroes and heroines but rather lets us glimpse them through a half-light full of mystery. There are Injuriosus and Scolastica, "the lovers of Auvergne," whose tombs are united by a rose tree; the hermits of the cavern and the forest, Saint Emilien, Saint Marien, Saint Lupicin, Saint Calupan, who revive under an icy sky the prodigies of the Egyptian anchorites. There is the virgin Saint Georges whose funeral train was escorted by a flight of doves. The wildness of nature surrounding the holy men and women of Auvergne also lends them some of its charm: the desert of Chaise-Dieu colors the story of Saint Robert; the high summit of Mercoeur, not far from Brioude, appears in the legend of Saint Odilon, and the immense forest of the Combrailles country, the *Ponticiacensis sylva,* overshadows the old abbots of Ménat. . . .

A capital in the Church of Saint-Nectaire presents four episodes from the story of that saint, known as the Apostle of Auvergne. The artist takes us first to Rome, where Saint Peter is conferring holy orders upon his godson Nectaire. Immediately, the saint's struggle with the demon begins. One day, while he is waiting to cross the Tiber in order to pray in a sanctuary on the other bank, Nectaire recognizes the oarsman in the approaching boat as

Satan himself. Nectaire, however, steps boldly aboard, for an angel sent by God hovers in the sky, to such good purpose that Satan is obliged to set Nectaire down safe and sound on the farther bank. A twilit legend, this, which transports us not to the Rome of Saint Peter but to the magical Rome of the Middle Ages.

Meanwhile Saint Peter dispatches Nectaire and his companion Baudime into Cisalpine Gaul. Scarcely has Nectaire arrived at Sutri when he falls ill and dies. Baudime returns to Rome to bring the news to Saint Peter, who hastens to the spot. He touches the body with his cross, whereupon Nectaire rises up from his sarcophagus.

Saint Nectaire, who has passed through death, becomes all-powerful over death. He returns to Auvergne. One day, while he is proclaiming the Gospel, the funeral procession of a Gallo-Roman named Bradulus passes near by. Nectaire is besought to bring the dead man back to life. He takes Bradulus' arm and commands him to rise. Behind the saint depicted on the capital stands his church, just as we can see it today on its rocky eminence.

A great deal of ingenuity was required to bring so long a story within the limits of a single capital. Condensed as the work is, it remains perfectly clear. Saint Nectaire was shown to the pilgrims who visited his church in the role of a wonder-worker rather than as an apostle.

## THE PILGRIMAGES. THE ITALIAN ROADS

As one form of the cult vowed to the saints the pilgrimages had a great part in the enrichment of iconography and art. For one thing, the sanctuaries visited by the pilgrims possessed famous images which artists could imitate and multiply. For another, the pilgrimage roads be-

came the broad ways of the peoples, by which the new creations of literature and art were disseminated. As we shall see, art history traces these creations along the roads and finds them at the halting-places. . . .

It was a solemn moment for the pilgrim when, after many days of walking, he could see from the height of Monte Mario the city he had so long desired. Indeed, Monte Mario, promontory over a promised land, was called *Mons Gaudii, Mont de la Joie,* the *Montjoie* of the old French battle cry. From that point the pilgrim could see all of Rome, the Eternal City, "Rome the Golden," could view it in its immensity, with its square church towers, heroic ruins, tawny colors. Then all the pilgrims would intone together: "Hail, O Rome, mistress of the world, red with the blood of martyrs, white with the lilies of virgins, blessed be thou, O Rome, unto the end of the ages."

The city was magnificently sad. Vast monuments, temples still covered with their marble sheathings, reared up amid desert spaces. Legends clung to the ruined buildings like ivy to old walls. In the twelfth century the sense of historic reality had almost perished; the pilgrims wandered through a city of enchantment. They were shown the Castle of the Mirror, a palace where Virgil was said to have placed a magic mirror, in which the most distant enemies of the Empire had stood revealed. In Augustus' time, visitors were told, there had been as many statues on the Capitol as there were provinces in the Empire; each statue had a little bell hung about its neck; whenever a province revolted, the bell tinkled. In the Forum the pilgrims passed, not without a kind of terror, close to the place where, underground, slumbered the dragon exorcised by the holy Pope Sylvester. The statues still standing here and there were infinitely mysterious. One of

them pointed with a finger toward that secret place where Pope Gerbert had uncovered a cellar full of treasures. A statue of Faunus had spoken to the Emperor Julian, advising his apostasy.

The pilgrims' first visit was probably to Saint Peter's. There they venerated, besides the apostle's tomb, the face of our Saviour imprinted on the veil of Veronica. The imposing associations of Saint John of the Lateran must have stirred the imagination, however, quite as profoundly as did the basilica and the relic. For the Lateran was the oldest church in the world, the mother of all churches, *omnium ecclesiarum mater et caput*. There, in a palace which was like a city, lived the vicar of Christ, he who could pardon every sin. Constantine had presented this palace and church to the Pope, and nowhere was the memory of the first Christian Emperor more alive. The pilgrims went into the baptistery, saw the pool where Constantine was thought to have been baptized. He had been infected with leprosy, but on emerging from the water he was found to have been miraculously cleansed; some of the white scales were still visible, adhering to the marble of the basin. Before the Lateran, in the double solitude of the meeting-point between the ruined city and the Roman countryside, Constantine was still to be seen. For there stood the bronze equestrian statue which for centuries was regarded as Constantine. It is still in evidence today, though not in the same place, Paul II having moved it to the Capitol in 1538, on the advice of Michelangelo. It represents, as we now know, not Constantine but Marcus Aurelius. By a singular irony, the men of the Middle Ages, believing that they were doing honor to the first Christian Emperor, in reality paid homage to the persecutor of Christianity.

Whatever they may have called it, the pilgrims were

obviously much impressed by this statue; for we find curious and naïve copies of it in French churches. They merit our attention as the first works of art directly inspired by the pilgrimage.

As we travel about in the western provinces of France we frequently see on the façades of the charming churches of those regions the image of a horseman. These first equestrian statues of modern Europe have been the subject of endless conjecture. Some have believed them to represent Pippin the Short or Henry II of England; others have thought them to be Saint George or Saint Martin. However, a text long since made public leaves no doubt as to the identity of the horseman. About the middle of the twelfth century, a baron named Guillaume David, benefactor of the Abbaye aux Dames at Saintes, asked, in a testament which has been preserved, to be buried in front of the right door of the church, "beneath Constantine of Rome," *sub Constantino de Roma, qui locus est ad dexteram portam ecclesiae.* There was, then, in the façade of the church of the Abbaye aux Dames at Saintes, a statue of Constantine. It was, we know, an equestrian statue, of which traces were still visible fifty years ago.

Other proofs have come little by little to add their weight to this decisive one. In the baptistery of Saint-Jean in Poitiers a twelfth-century painting representing a horseman bears the inscription *Constantinus.* The equestrian statue which stood at the south door of Notre-Dame-la-Grande at Poitiers until the sixteenth century, when it was destroyed during the wars of religion, was commonly known as "Constantine." At the beginning of the nineteenth century the equestrian figures decorating the façade of Saint-Hilaire at Melle and that of Parthenay-le-Vieux were still called "Constantine" by some old peo-

ple. In Limoges an equestrian group, no longer in existence today, had given to an ancient fountain the name of "Fountain of Constantine." Beyond any reasonable doubt the enigmatic personage of the church fronts is the Emperor Constantine.

Along with the pilgrims to Italy came *jongleurs* who recited the French epics, and these poems were the inspiration for works of art along the pilgrimage roads. At Brindisi, point of embarcation for Jerusalem, episodes from the *Chanson de Roland* were worked into the pavement of the cathedral. The romantic heroes of the Round Table were also celebrated, and at Otranto King Arthur is represented in the cathedral pavement.

At Modena, one of the halting-places along the Via Francigena, Arthur and his companions received their most magnificent tribute: A whole portal of the cathedral is given over to them. Arthur of Brittany, Ydier, Gawain, Kay the Seneschal, and others, all designated by their names, ride around the archivolt (Pl. 5). The songs of the *jongleurs* must have impressed and charmed the Italians profoundly, for the artists thus to have dared to carve out these secular heroes at the church door. Even the clerics must have found the legends irresistible.

Even today we can understand their appeal. Everything was new about these poems. They opened the door to a world in which the poet ruled supreme with a magician's wand. In the twinkling of an eye he could change the handsomest knights into the most hideous dwarfs, then with equal rapidity change them back again. He gave the old stag of the forest a voice and conjured up a fairy palace beneath the waters of the lake. His tales were like the light-filled landscapes made by summer clouds. Imagination, set free, glided through the ether. But in this world full of marvels the most powerful enchant-

ment of all was the beauty of woman. For the first time in history, a sensuous tenderness stole into poetry. A gentle image invariably accompanied the knight through the forest. Love appeared as the ultimate goal of life, and Merlin, wisest of men, renounced his wisdom to shut himself up with Vivian in the magic circle.

The Church of the Middle Ages must have been singularly hospitable to all elevated forms of thought thus to welcome to the very door of the sanctuary the romances of the Round Table. No doubt she understood all that the new kind of knight represented in the way of moral delicacy, fine shadings of feeling; all that a society, until recently so crude, owed in courtesy and gentleness to these gracious dreams. It may well be that we owe as much to them as to our resounding epics. From century to century they helped to shape the genius of the Occident. Don Quixote, the poor madman who retains so much nobility in his madness, demonstrates conclusively the power of the tales of chivalry as a school for feeling.

## THE PILGRIMAGES.
## FRENCH AND SPANISH ROADS

The *Guide for the Pilgrim of Santiago,* written in the twelfth century, shows that the most celebrated sanctuaries were distributed along four routes.

The first led out of Provence, with the first halt at Arles. There the pilgrim venerated, near the Rhône, a tall marble column which the martyred Saint Genest had stained with his blood. Afterwards he visited the seven churches of Alyscamps, erected in the midst of ancient tombs; anyone who had Mass said in one of these churches would have all the just men buried in the cemetery for

his advocates on the Day of Judgment. Next after Arles came Saint-Gilles, where one of the most illustrious wonder-workers of all Christendom lay buried. The relics of Saint Giles, the eremite who had come from Athens to Gaul, were contained in a magnificent golden sarcophagus. "Here set this bright star of Greece," as the *Guide* says. The twelve signs of the zodiac shone upon the shrine. Beyond Saint-Gilles, passing by way of Montpellier, the road led past the famous Abbey of Saint-Guilhem-du-Désert, where Guillaume, Charlemagne's standard-bearer, had come to end his days as a penitent. At Toulouse, the pilgrim was certain to visit the splendid basilica raised over the tomb of the apostle and martyr Saint Sernin (Pl. 6). Then the road led through Auch and Lescar toward the Pyrences, which it crossed at Somport, descending into Spain by way of Jaca and Puente La Reina.

The second route was followed by pilgrims from Burgundy and the east of France and led through the Cévennes, a dangerous path along which the bell of the Monastery of Aubrac guided pilgrims lost by night. This route passed by Notre-Dame in Le Puy and Sainte-Foy in Conques. The power of Saint Foy turned Conques into a place of miracles; before leaving, pilgrims were sure to drink from the spring which bubbled up before the church door. At last the road descended into the plain at Saint-Pierre in Moissac, whence it turned toward Lectoure and Condom, passed through the ancient cities of Eauze and Aire, and ended at Ostabat, at the foot of the mountains.

A third route, which was likewise taken by pilgrims from the east of France, is described in less detail. It started from the abbey church Sainte-Madeleine at Vézelay (Pl. 8), where the sinner-saint ceaselessly intervened for penitents. Much farther west, in Limousin, the

road touched at Saint-Léonard. Saint Leonard, sovereign hope of prisoners, had delivered so many captives that his church was all but filled with chains, handcuffs, and fetters; they hung inside and outside the building like garlands. Saint-Front in Périgueux was another of the stages along this route. No saint of France had a more beautiful tomb than Saint Front; it was circular like the Lord's own. This route crossed the Garonne at La Réole, passed through Bazas, Mont-de-Marsan, Saint-Sever, Orthez, and joined the second pilgrimage road at Ostabat.

The fourth route started from Orleans, where, in the Sainte-Croix Cathedral, the pilgrim could see the miraculous chalice of Saint Euverte, which had been consecrated by the hand of Christ Himself, appearing one day above the altar. Following along the Loire, the traveler came to Saint-Martin in Tours, most ancient and most celebrated of pilgrimage shrines in France. Along this route, which passed through Poitou and Saintonge, the pilgrims found other venerable places of worship: Saint-Hilaire in Poitiers, where the head of Saint John the Baptist was preserved and a choir of a hundred monks sang day and night the praises of the Precursor; Saint-Eutrope in Saintes, a vast basilica filled to overflowing with the sick and diseased; Saint-Romain in Blaye, where the paladin Roland, "martyr of Christ," was buried; Saint-Seurin in Bordeaux, where the hero's ivory horn, split by the force of his breath, was preserved.

Beyond Bordeaux, the pilgrims entered the great desert of the Landes, a wild country, where the traveler who strayed an instant from the path sank in the sand up to his knees. At Belin, one of the halting-places, a great tomb contained the bodies of the holy martyrs Olivier, Gondebaud, Ogier the Dane, Arastain of Brittany, Garin of Lorraine, and many other companions of Charlemagne,

killed in Spain for the Christian faith. The pilgrim then passed through Labouheyre, Dax, Sorde, and reached the Pyrenees at Ostabat, not far from Port de Cize. There the three great roads to Santiago of Compostela joined. On the mountain stood a huge cross, raised up, it was said, by Charlemagne. The Emperor had prayed there, his face turned toward Santiago, and the pilgrims followed his example, each one planting in the earth, near the stone cross, a little wooden cross. From Cize the way led to Roncevaux, near which passed all pilgrims who did not cross the Pyrenees at Somport. In the church at Roncevaux they stood entranced before the stone that Roland had cleaved through with his sword. Crossing the famous battlefield, they came down toward Navarre and the most dangerous part of their journey. Here they met mountain people with bare legs, short, fringed coats, and sandals of hairy leather; each man carried two javelins, and a horn suspended from his waist. Sometimes they would howl like wolves or hoot like owls, and comrades would surge up beside them. They were Basques, a most inhospitable and dangerous race. . . .

The two mountain routes, the one coming by way of Somport and the other by Port de Cize, merged at Puente la Reina. From that point on, a single road led through Estella, Burgos, Frómista, Carrión, Sahagún, León, Astorga to Santiago. From Monte San Marcos the pilgrims could see for the first time the towers of the Basilica of Santiago. The first to catch sight of the church was proclaimed "king of the pilgrims," and the title passed from father to son, like a noble rank. Finally, after months of difficult and dangerous traveling, the pilgrims could kneel down at the apostle's tomb.

## THE WORLD AND NATURE

When the artists of the twelfth century wished to portray the world's wonders they chose, whenever possible, peoples and strange animals which the ancients had described for them.

*THE COLUMN OF SOUVIGNY*    The Abbey of Souvigny, in Bourbonnais, was one of the most famous of the Cluniacensian priories. An octagonal column, covered with bas-reliefs on four sides, can still be seen today in the church. The reliefs have suffered considerably in recent years, but a sketch made about 1880 shows them almost intact. On one side of the column we find the labors of the months, on another the signs of the zodiac, and on the third and fourth the most extraordinary peoples and monsters of Asia and Africa. These last two sides are of particular interest (Pl. 7). As it happens, the works of Isidore of Seville and Honorius of Autun, together with that curious accumulation of miscellaneous lore, the third-century *Polyhistor* of Gaius Solinus, permit us to explain these carvings rather completely; for it is evident that the sculptors followed these works.

We see depicted first the strangest peoples of the globe, each represented by a single figure. Three of the fantastic creatures, the satyr, the skiapod, and the hippopod, pursue each other around the column, in the order in which they appear in the work of Isidore of Seville.

The satyr conforms precisely to Isidore's description, having two horns on his forehead and the hooves of a

goat. "It was a satyr of this sort," says Isidore, "that appeared to Saint Anthony in the desert."

As for the skiapod, he has only one leg, but this single limb permits him to run along with the most marvelous agility. In the column of Souvigny the skiapod happens to be erect, but sometimes he prefers to stretch out on his back and use his foot as a parasol.

The hippopod, met with in the deserts of Scythia, has the form of a man but horse's hooves.

Above the hippopod the column shows, without inscription, a truly strange creature, a sort of dog with human feet. Probably this is the cynocephalus, "a creature more like a beast than a man," as Isidore of Seville observes.

Then there is the Ethiopian freak with four eyes. Neither Isidore nor Honorius has anything to say about him, but Solinus' *Polyhistor,* so thoroughly medieval in spirit, provides the necessary authority. "The Ethiopians who live beside the sea," says Solinus, "are reputed to have four eyes in their heads."

Besides this gallery of peculiar peoples—of which unluckily only a fraction is preserved, since the column is half destroyed—we find on another side the monsters that dwell at the ends of the earth. Here the artist is inspired by Honorius' chapters on the wonders of India, for every one of the monsters on this part of the column is in Honorius' book. For example, there is the manticora of Ctésias, the human-faced monster that runs faster than a bird can fly and hisses like a serpent; the griffon, part eagle and part lion, that keeps guard over treasures; the unicorn (and the artist, faithful to an old Oriental tradition, shows the horn pointing backwards) ; the elephant, most celebrated of all the animals of India; and, finally, a siren,

half woman and half fish. Thus the column of Souvigny was partly a calendar and partly a map of the world's wonders.

ORIENTAL
FABRICS

The tympanum of the abbey church at Vézelay (Pl. 8), which represents the scene of Pentecost, also has, in the border of its semicircle, pygmies, people with enormous ears, and people with dogs' heads whom the truth of the Gospel is supposed ultimately to reach. But these twelfth-century monsters have a different origin. They are derived from the Oriental fabrics which, according to Gregory of Tours, Fortunatus, and the earliest French historians, were a common ornament of the churches of the time.

In the Basilica of Saint-Denis, for example, King Dagobert had adorned the walls and arcades with materials woven in gold and sewn with pearls; and these splendid cloths, in which the pearls formed the outlines of flowers, closely resembled the hangings which decorated the palace of the kings of Persia, at Ctesiphon.

These marvelous fabrics have not entirely disappeared, chiefly because it was an early ecclesiastical custom to wrap relics of the saints in the richest materials available. Extremely ancient fabrics have come down to us preserved inside reliquaries. Today they are kept in the treasure-rooms of the churches.

The most precious French collection of fabrics is that of the Cathedral of Sens, which includes admirable silks dating from as early as the fifth century. Little more than shreds though they are, they illustrate the history of weaving over seven or eight centuries. All the fabrics preserved at Sens are Oriental in origin. Some came from Christian Egypt, from Alexandria, others from the famous workshops of Panopolis, where ancient art and craftsmanship

finally flickered out. Others are from Byzantium; but there are some that come from a more distant Orient, from the Persia of the Sassanidae.

In Persia we are at the cradle of the marvelous art. As the genius of antiquity sank into darkness, a new light shone from Persia. It was she who imposed her taste on the ancient world. The cloth of Byzantium was inspired by that of Persia and was often a mere imitation. But what is extraordinary is that the Sassanid dynasty of Persia, heir to the much earlier civilizations of the Tigris Valley and the Iranian plateaus, brought back to life the older cultures. In the sixth century after Christ there was a rebirth of three-thousand-year-old art forms; they had perhaps never died out altogether, but the rule of the Sassanidae, a time of resurrection for Persia, gave them a new life.

Chaldea and, after Chaldea, Assyria had created the most vigorous of all decorative arts, had given to the composite monster a terrible air of reality, and to the symmetry of animals set facing one another a religious grandeur. The art of heraldry was born in Chaldea long before our Middle Ages. Persia inherited this art, and with it the secret of color.

Greece had the genius for line, but seems not to have known the sensuous value of color. There could be no art more pure, and there could hardly be an art more austere, than that of Greek vase painting. Greece speaks to the lofty feelings of the soul; Persia charms the eye. Sassanid hangings and Byzantine cloths, which imitate them, are gold-colored or fire-colored; sometimes they are the color of ashes, but with a blue or rose tint, the exquisite shadings of which are an enchantment—reminiscent of the magical color-play in the sky after sunset. We have only to compare the dazzling Oriental cloths with the

47

Greek fabrics from Egypt, decorated with light-colored figures on dark, austere grounds, like painted vases, to appreciate how much gaiety and light the art of Persia brought to our world at its emergence.

It is sufficient to cite only one example of the many imitations of Oriental motives.

Romanesque monuments are forever confronting us with symbols heavy with the weight of centuries. An abacus of the cloister of Moissac has a row of two-headed eagles, and the same monster turns up again on a pillar at the Church of Civray (Vienne) and on a capital of Saint-Maurice in Vienne. We are transported in imagination to the cradle of civilization; for an ancient Chaldean cylinder shows us the first example of the two-headed eagle, and the monster appears again in the escutcheon of one of the most ancient cities of Chaldea, Sirpurla. The bird is huge, something like the fabulous roc of the *Arabian Nights,* and poises its claws on the back of a lion.

In ancient Oriental art the eagle is the noble bird that accompanies the king, tames the lion, assists the Chaldean Heracles in his labors. The image of the eagle had a religious significance and virtue for the people of Asia. We find it again, many centuries after the dominion of Babylon, among the Hittites, the important people mentioned in the Bible who occupied Syria and the plateaus of Asia Minor, and to whom Solomon applied for several of his wives. The Hittites took the elements of their art from the valleys of the Tigris and Euphrates, and the rude monuments which they left in Cappadocia have Chaldean characteristics. On the rocks of Pteria in Cappadocia we can see the two-headed eagle with a victim in either claw. Nor did the monstrous bird disappear from these regions, since we find it carved in modern times on the Moslem turrets of Diarbekr, the ancient Amida. The Seljuk Turks

carved the figure on the gate of Konia, their capital, and seem to have placed it on their flags from the earliest times.

How did this ancient Oriental symbol reach the West? By way of the fabrics, evidently. A bit of material preserved at Sens, though little more than a rag, has two-headed eagles worked in yellow on a deep purple ground. This is a Byzantine fabric of the ninth or tenth century, reproducing, without question, an ancient Sassanid original. A funeral shroud preserved at Périgueux is ornamented in the same way. The ancient motive appears again in a thirteenth-century Mesopotamian fabric preserved at Bagdad, this time inside an escutcheon which bears a strong resemblance to the arms of the German Emperors. Undoubtedly, the German blazon did come from the Orient, taken from Oriental fabrics and perhaps from Mohammedan ensigns. The Turks saw at Lepanto, on the ships of Don Juan d'Austria, the two-headed eagle that had once figured in their own flags—the ancient eagle of Chaldea now turned against them.

The influence of early Chaldean motives upon heraldic as well as upon decorative art is clear. We need look no further for the symbolic sense of the facing lions, the birds with intertwined necks, the two-headed eagles, which have long preoccupied historians and students of art. Saint Bernard was right in asserting that the monsters of the capitals had no special meaning—a few excepted. They were meant to please the eye, not to instruct. Saint Bernard thought the fanciful figures puerile and laughable. What would he have said had he known that these monsters were the legacy of the ancient pagan beliefs of Asia, that they brought spirits, demons, and idols before Christian eyes?

We who know history somewhat better do not consider

the monsters childish. They seem to us wonderfully significant, charged with the dreams of several races, handed down from one to the other over thousands of years. Chaldea and Assyria, Persia of the Achaemenidae and Persia of the Sassanidae, the Greek and Arabian Orient, the whole of Asia, bring their symbolic offerings to the Christian Church as once the Wise Men brought their offerings to the Child.

## THE STORIED DOORWAYS OF THE
## TWELFTH CENTURY

Certainly the splendid tympana above the portals are one of the chief beauties of the churches. The eye is drawn to them first of all. They invite meditation. They raise the Christian out of his wretched daily cares and prepare him for entrance into the sanctuary. Before crossing the threshold he can already catch a glimpse of another world. Over a doorway, decorated by a Virgin enthroned in majesty and surrounded by saints, we read, "Elevate thyself toward heavenly things, thou who enterest here"; and indeed the Romanesque sculptors endeavored to realize noble ideas within this semicircle of stone.

The artists of the Midi who created the carved tympana had first to resolve a difficult problem. How dispose figures effectively in a semicircle? It would seem necessary that a higher figure, placed in the center, should dominate the others. The tympanum, then, should frame a triumphal scene; it was predestined for the most august themes. The artists set about designing three types of portal: one exemplified at the Abbey Church of Moissac, representing the Christ of the Apocalypse; another as

found at Saint-Sernin in Toulouse, representing the Ascension; and, finally, the Beaulieu type, which shows Christ as the Judge (Pl. 11).

All twelfth-century doorways belong to one or another of these three types. Of the three, the Apocalyptic Christ of Moissac, surrounded by the four beasts, was the most widely imitated. We find similar arrangements throughout the Midi, and the Moissac doorway inspired the Christ in Glory of Chartres (Pls. 9, 10), which in turn was imitated throughout northern France.

Several of the famous doorways are ornamented with great statues, long regarded as enigmatic, aligned on either side of the entry. They are not easy to explain, and do not wholly give up their secret; but we can claim to have divined their significance at least in part.

The magnificent idea of affixing a statue to each of the columns of a doorway was conceived at Saint-Denis about 1135, perhaps inspired by the figures of the apostles at Toulouse, sculptured in bas-relief on either side of the portal of the cloister of Saint-Etienne. Suger, who had a hand in everything, may well have had something to do with this innovation; the metamorphosis of human figures into columns was as much a mystical as it was a plastic idea. In any case there can be no doubt that Suger personally chose the subjects for the twenty figures that were to ornament the three portals of Saint-Denis. Who were these personages? Certainly not Merovingian kings, as the Benedictines of the eighteenth century believed.

Dom Bernard de Montfaucon included in his *Monuments of the French Monarchy,* published between 1729 and 1733, drawings which show a revealing detail. A rather large number of the solemn, long-gowned heroes about the doorways wear tightly fitting caps of a corded material. A very similar kind of cap appears early in the

51

art of Toulouse, as an emblem of the Jews. We discover the same kind of cap again in the west portal at Chartres, where Saint Joseph wears it in the scene of the Presentation in the Temple. This is a legacy of the schools of the South to those of the North. We can hardly doubt that the figures wearing the corded caps at Saint-Denis are men of the Old Law. The figures accompanying them are kings and queens of the Bible, not of French history.

And once more we recognize the thoughtful genius of Suger. He wanted the Old Testament to give access to the New. He believed that the way to Christ should lead past those who had awaited Him over so many ages. What kings, what patriarchs did Suger choose? We cannot know, for the names once inscribed on the banderoles are now illegible. But it is a great deal to know that Suger saw in the heroes of the Old Law the pillars of the portico leading into the temple.

Suger's idea was taken up in the west portal at Chartres (Pl. 9), where we once more find figures wearing the corded skullcap, and, along with them, kings and queens. Even more than at Saint-Denis, these elongated statues, some of them exquisitely carved, resemble delicate, fluted columns. Like the statues of Saint-Denis, they are anonymous, the names once inscribed on the banderoles having worn away.

In the doorway of Saint-Bénigne at Dijon, which we know only through the drawing by Dom Plancher, there appeared again the Christ of the Apocalypse, the tall statues, and, near the biblical kings, a queen.

We are now in a position to identify this mysterious queen. Studying the drawing of the figure, we observe a detail which would seem unbelievable if it were not fully confirmed in ancient sources: The queen of the portal of Saint-Bénigne had a goose's foot. The artist of Dijon was

representing the famous Reine Pédauque, who was none other than the Queen of Sheba.

The Hebraic and Arabian imaginations had long been preoccupied with the Queen of Sheba. They invested her with a romantic legend in which the jinn played a part, transporting the queen's golden throne to the king's palace at Jerusalem, where she was astonished to find it on her arrival. Solomon received the queen in a room paved with crystal. The lovely queen, believing herself to be on the rim of a pool, lifted her gown and let her hideous feet be seen. The Oriental legend speaks of ass's feet; the Western version, as presented by a German manuscript of the twelfth century, specifies goose's feet. While we have no text in France dating from as early as the twelfth century, the Dijon statue demonstrates that the legend was perfectly well known at that time. It may well be that the queen with the goose's feet was represented first in the workshops of Toulouse, where, in Rabelais's time, there was still a picture of her. Her palace and baths could still be visited, and her legend was long associated with that of the young princess Austris, baptized by Saint Sernin.

The goose-footed queen of the portal at Dijon was, then, the Queen of Sheba. No less certainly the statue of the king opposite the queen represented Solomon, and in all likelihood David was there along with his successor. Why was the Queen of Sheba shown along with the heroes of the Old Law and the apostles of the New? Because, according to medieval teachings, she symbolized the pagan world coming to Christ and prefigured the Wise Men who sought, as she did, the true God. It is revealing that, on the lintel of Saint-Bénigne, the Journey and Adoration of the Magi were represented.

The superb Last Judgment in the portal of Beaulieu (Corrèze) (Pl. 11) inspired the Last Judgment of Suger's

church at Saint-Denis. And there exists in the Midi a Last Judgment even more intrinsically interesting than that at Beaulieu: the one at Conques in Aveyron.

Here the conception of the subject is entirely new. The Christ does not extend His arms in the form of a cross, as at Beaulieu; He shows his wounds, but His right hand is raised toward the elect, His left lowered toward the rejected. The apostles are not seated about Him, and the tympanum, thus cleared of accessory figures, is open for the representation of rewards and punishments. The resurrection of the dead occupies very little space. For the first time, the sun and moon appear above the place of judgment, along with angels displaying the spear, the nails, and the cross. In the following century angels will be shown taking away the two planets like useless lamps—"for the cross," Honorius of Autun tells us, "will shine more brightly than the sun."

For the first time, the elect form, at the right of the Christ, a long procession led by the Virgin and Saint Peter with his keys. Behind Saint Peter, a grave contemplative figure leaning on a tau-shaped staff may be Saint Anthony, father of eremites. Then comes an abbot, doubtless Saint Benedict, father of monks, leading an emperor by the hand. This timidly advancing figure is probably Charlemagne, legendary benefactor of the Abbey of Conques, who enters heaven not by virtue of his scepter and crown but because of the prayers of the monks whom he loved.

Neither at Beaulieu nor in the portals deriving from that original do we see the Last Judgment actually in progress. At Conques, however, Saint Michael holds the scales and weighs the good and evil while Satan, sneering cynically, tries with a push of his thumb to make the balance incline in his direction. This weighing of the souls introduces into the scene dramatic elements which

attracted the artistic imagination of the Midi. Such a scene had already been represented in southern art, for, in the museum at Toulouse, a capital dating from the beginning of the twelfth century shows Saint Michael weighing the souls in the presence of God. And the theme of the weighing was taken up throughout the South. We find it on a capital of the Abbey of Saint-Pons and on one side of the portal of Saint-Trophime at Arles. In the West, it appears on a capital of Saint-Eutrope in Saintes; in Auvergne, on a capital of the Church of Saint-Nectaire.

Southern sculptors had first come upon this motive in Oriental manuscripts, for it has become clear to us now that Eastern artists added this dramatic detail to the Last Judgment. An ancient fresco recently discovered in the church at Peristrema in Cappadocia has the angel holding the balance. The motive is traceable first to Christian Egypt and, ultimately, to a much more ancient Egypt. For many centuries, in the Egypt of the Pharaohs, a Judgment scene had been painted on the scroll of the Book of the Dead and on the walls of the tombs. In the presence of the enthroned Osiris and his forty-two assessors, Anubis watches over the scales of the balance. Shuddering, the dead man perceives that his heart is no longer in his breast. He sees it in one of the scales of the balance; and in the other scale is the symbol of Justice. The dead man defends himself, making the beautiful negative confession in which ancient Egypt revealed its aspirations. "I have caused no one to weep, I have made no one suffer. . . . I have not taken the milk out of the mouths of children, nor have I driven cattle from their pasture. . . . I am pure, I am pure, I am pure." If the two scales balance, if the pointer stands motionless, the dead man, justified, passes through the door of Amenti.

Egypt became Christian. But the Egyptians could not

forget the dreadful image of the scales, which they put in the hands of Saint Michael, Archangel of Justice.

At Conques, we find hell represented with entirely new details. The entrance is the maw of a monster which swallows up the condemned; and this is the Leviathan of the Book of Job. So faithfully has the thought of the Middle Ages been interpreted that we see the very door behind which, according to the commentators, the monster covers its visage. We further find the cauldron into which sinners are plunged. Satan, a good deal larger than anything around him, sits enthroned among the tormented and rests his feet on one of the damned. Avarice, purse-strings about his neck, is hanging like Judas, while Lust is symbolized by a couple chained together for all eternity.

Paradise is a portico under which sit the blessed. Abraham, whose image appears for the first time in the porch of the abbey church at Moissac, reappears here, receiving two of the elect to his bosom. Martyrs, virgins, holy women, all wear imperial crowns upon their heads. The martyrs carry palm branches and hold chalices recalling the virtue of the poured-out blood. The great Saint Foy of Conques has a place apart, kneeling beneath the hand of God.

Besides these three types of portal we find another, appearing toward the end of the twelfth century, dedicated to the Virgin.

It must have been about 1185 that the great portal at Senlis was finished, since the bas-reliefs there were imitated in 1189 on the rood screen of the abbey church at Vezzolano in Piedmont. As at Bourges, the entire tympanum is consecrated to the Virgin; but this time we have a moving, poetic work, in which one senses the hand and thought of a great artist. He does not waste time on sec-

ondary episodes. Two scenes on the lintel tell the whole tale. The Virgin succumbs in the midst of the apostles; then, three days after the burial, angels come to lift her body from the tomb (Pl. 12). The first of the two bas-reliefs is much mutilated, but the second remains exquisite. The resurrection of the Virgin's body by angels, a scene new in religious iconography, is a masterpiece. The pretty angels, in their clinging tunics, free from the weight of matter, are light as birds. They weigh no more heavily than swallows, whose long wings they wear. And they obey God's commands with an alacrity in which there is even more love than respect. One tenderly raises the Virgin's shoulders, while another lifts her head. An angel unable to come near her leans on the wing of a neighbor to gaze upon her. Another sets a crown upon her head. The clinging garments, the calligraphy of folds falling in lovely flourishes, the corkscrew curls arranged upon the forehead—all these characteristics relate the bas-relief to the old school. But in its feeling of life and movement, in its charm and poetry, this beautiful work heralds the art of the new day. For its time, the bas-relief of Senlis was a miracle in European art.

The lintel is dominated by a magnificent scene which fills up the whole tympanum. Mary is shown in heaven, crowned, seated at the right hand of her Son. This is the Coronation of the Virgin in its first version. She does not bow down to receive the crown, as she will do in later works. She has already received it, and is freed from the laws of time. The order of the tympanum at Senlis, vainly sought for in Bourges, is definitive: above death, which is regarded merely as an episode, the triumph.

# RELIGIOUS ART
# OF THE THIRTEENTH CENTURY

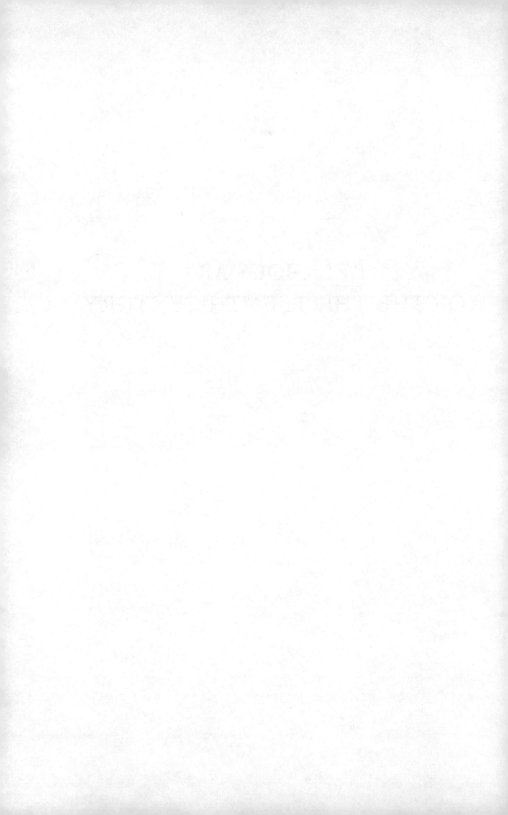

# THE SYMBOLIC QUALITY OF MEDIEVAL ART

Medieval art is eminently symbolical. Form was almost always conceived as the embodiment of the spirit. For the artists were as skilled as the theologians at spiritualizing matter.

Consider, for example, the great chandelier at Aachen, in the form of a city defended by towers. This city of light, the inscription tells us, is the heavenly Jerusalem. The joys of the soul promised to the elect appear between the battlements, next to the figures of apostles and prophets who guard the Holy City. It is the vision of Saint John that found here its image. Similarly, the artist who decorated a censer with likenesses of the three young Hebrews in the fiery furnace was giving sensible form to an idea; the fragrance mounting from a brazier is likened to the prayers of the martyrs. Another artist makes the scroll of a bishop's crook in the form of a serpent holding a dove in its mouth; this is to remind the pastor of the two virtues becoming his office: "Hide thou the simplicity of the dove under the wisdom of the serpent," say the two Latin verses engraved upon the pastoral staff. Another crosier again shows a serpent, this one menacing the Virgin with impotent jaws. In the volute, the angel announces to the Virgin that she will bring forth the Vanquisher of the serpent.

Sometimes the sculptors translated into form a doctrine taught by the liturgists. Thus, in the Sainte-Chapelle in Paris, twelve statues of the apostles are set against twelve columns, each statue carrying a cross of consecration (Pl.

61

13) . Indeed, the liturgists tell us that when a bishop consecrates a church he must bless with twelve separate signs of the cross twelve columns of the nave or the choir, to signify that the twelve apostles are the true pillars of the temple. It is this symbolism which has been given such happy visual expression in the Sainte-Chapelle.

Religious ornaments and instruments of the thirteenth century in general tend to show matter bent to express the things of the spirit. On the lectern the eagle of Saint John spreads his wings to support the Gospels. Lovely long-robed angels carry in procession the crystal cylinders in which repose the bones of saints and martyrs. Ivory Virgins come open and reveal engraved in the place of the heart the whole story of the Passion. At the chevet of the cathedral a gigantic angel overlooks the city, turns with the sun, and gives to every hour a supernatural meaning.

# THE FOUR MIRRORS
# OF VINCENT OF BEAUVAIS

In order to study the vast body of works in the cathedrals of the Middle Ages, some method of approach is necessary; and we could not do better than to adopt the divisions provided for us by Vincent of Beauvais, the great encyclopedist of the age of Saint Louis. The *Mirrors* of Vincent of Beauvais order as well as collect the knowledge of his time, and we shall follow their sequence.

The work is divided into four parts: the "Mirror of Nature," the "Mirror of Knowledge," the "Mirror of Morality," and the "Mirror of History."

In the "Mirror of Nature" are reflected all the realities of the world in the sequence of their creation by God, the

different days of creation serving as chapter headings. Elements, minerals, plants, and animals are enumerated and described one after the other. All the truths and all the errors which antiquity passed on to the Middle Ages are here preserved. Naturally, the work of the sixth day, man, is expounded at greatest length, since man is the center of the world, and the world was created expressly for him.

The "Mirror of Knowledge" opens with a recital of the drama which is the key to the riddle of the universe—the story of man's fall. No salvation is possible except through a Redeemer. But man is able by his own strength to take the first steps toward raising himself up and preparing for grace through knowledge. In learning there is a spirit of life, and to each of the seven liberal arts corresponds one of the seven gifts of the Holy Spirit. After developing this broad and humanistic doctrine, Vincent of Beauvais passes in review all the divisions of knowledge, not even neglecting the mechanical arts; for man begins the work of his redemption by the work of his hands.

The "Mirror of Morality" is closely related to the "Mirror of Knowledge." Action is "the perfection of human life"; knowledge is merely a means for arriving at virtue. We are therefore given a learned classification of the virtues and vices, a disposition in which we find the method, the divisions, and often even the turns of phrase of Saint Thomas Aquinas; for the *Speculum morale* is only an abridgment of the *Summa*.

Finally comes the "Mirror of History." Having studied humanity in the abstract, we come to living humanity, mankind in progress under the eye of God, struggling, suffering, inventing the sciences and the arts, choosing sometimes virtue and sometimes vice in the great battle of the soul which sums up the whole history of the world.

It is scarcely necessary to recall that for Vincent of Beauvais as for Saint Augustine, for Paulus Orosius, for Gregory of Tours, and for all the historians of the Middle Ages, history is the history of the Church, the history of the City of God which begins with Abel, first of the just. There is a people of God, and its history is the shaft of light which dissipates the shadows. As for the history of the pagan world, it deserves attention only because of its relation to the other history; it has only the value of concomitant circumstance. Of course Vincent of Beauvais does not disdain to tell of the revolutions of empires, he even speaks of the philosophers, learned men, and poets among the Gentiles; but such chapters are essentially episodic. The main emphasis is elsewhere. The unity of his work is achieved by the uninterrupted succession of saints of the Old and the New Law. Through them, and through them alone, the history of the world explains itself.

## THE MIRROR OF NATURE

For the thoughtful man of the Middle Ages, the world is a symbol, "an idea of God made manifest by the Word." If this is the case, then every creature must be the development of a divine thought. The world is a great book written by the hand of God, in which every being is a word charged with meaning. The ignorant man sees only mysterious figures, letters whose meaning he cannot understand. But the wise man raises himself from visible to invisible things. By studying nature he reads the thought of God Himself. Knowledge consists not in the study of things as they are but in the understanding of God's teachings as revealed in all things. For "every creature," as Honorius of Autun says, "is the shadow of truth and

life." Deep in every being are graven the figure of the sacrifice of Jesus Christ, the idea of the Church, the images of the virtues and the vices. The world of the mind and the world of the senses are one.

Adam of Saint-Victor, in the refectory of his convent, holds in his hand a nut. "What is this," he reflects, "but the image of Jesus Christ? The green and meaty envelope which covers the nut is His flesh, His humanity. The wood of the shell is the wood of the cross on which the flesh suffered. And the inside of the nut, which is food for man, is nothing less than His hidden divinity." . . .

Hugh of Saint-Victor looks at a dove, and this makes him think of the Church. "The dove," he says, "has two wings, just as, for the Christian, there are two sorts of life, the active and the contemplative. The blue feathers of the wings signify thoughts of heaven. The wavering nuances of the rest of the body, colors as changeful as an agitated sea, symbolize the ocean of human passions on which the Church makes its way. And why does the dove have eyes of such beautiful yellow gold? Because yellow, color of ripe fruits, is the color of experience and maturity. The yellow eyes of the dove symbolize the look, full of wisdom, with which the Church considers the future. Finally, the dove has red feet, for the Church advances through the world her feet deep in the blood of martyrs."

Under the guidance of the doctors, medieval artists sometimes gave a symbolic meaning even to animals and plants. Left to their own devices, however, they did not concern themselves with symbols, nor generally seek to read into the April flowers the mystery of the Fall and the Redemption. They went out into the forest of the Ile-de-France in the first spring days, when humble flowers started to pierce the earth. The fern, coiled up on itself

like a powerful spring, was still covered with a downy floss, but along the brooksides the arum was about to open. These artists of the thirteenth century looked upon the bursting buds and leaves with the tender curiosity which we know only as children and which true artists retain all their lives. The powerful lines of young plants, stretching out, aspiring toward being, impressed them by their concentrated energy. A bursting bud became the fleuron surmounting a pinnacle. Young shoots springing out of the ground became the vase of a capital. The capitals of Notre-Dame in Paris, particularly the oldest among them, are modeled upon young leaves bursting with sap, which seem by the mere force of their vitality to thrust up vaultings and abaci.

Viollet-le-Duc, in a fine article in his *Dictionary of French Architecture*, was the first to remark that Gothic art in its beginnings, about 1180, chose to reproduce the buds and curled-up leaves of early spring. The impression of youthfulness, of restrained vigor given by such ancient cathedrals as those of Sens and Laon, and by the choir of Notre-Dame in Paris, is in part explained by this fact. In the course of the thirteenth century, the buds burst, the leaves open out (Pl. 14). By the end of the thirteenth century whole branches, rose stalks and vine shoots encircle doorways; and the development continues throughout the fourteenth century. The stone flora of the Middle Ages seems to have followed the laws of nature herself. The cathedrals have their springtime, their summer, and, as the sad thistles of the fifteenth century appear, they have their autumn.

So far as the flowers and leaves of the cathedrals are concerned, it would be hard to find any particular symbolical intent. Artists chose leaves and flowers for their beauty. The art of the twelfth century preferred buds;

the art of the thirteenth, flowers. The leaves were simplified but not deformed; essential structure and general appearance were respected, so that we can identify many of them quite readily. Archeological botanists have distinguished, among others, plantain, arum, buttercup, fern, clover, celandine, liverwort, columbine, cress, parsley, strawberry, ivy, snapdragon, broom, and oak leaves— a flora familiar to French soil, and loved from childhood. The great sculptors of France found no materials too modest for their purpose; at the bottom of their art, as at the bottom of all true art, we find affection, love. The plants of the meadows and woods of Champagne or the Ile-de-France they thought sufficiently noble to decorate the house of God. So the Sainte-Chapelle is full of buttercups; and the fern of the heaths of Berry appears in the capitals of the Cathedral of Bourges; plantain, cress, and celandine wreathe Notre-Dame of Paris in garlands. The sculptors of the thirteenth century sang their May-songs too. Because of them all the springtime joys of the Middle Ages, the ecstasies of flowery Easters, the hats of flowers, the bouquets tied to doors, the fresh strewings of herbs in chapels, the magical blossoms of Saint John's Day—all the fugitive grace of spring and summers long gone survives, caught in flowering stone. Thus the Middle Ages, falsely accused of indifference to Nature, contemplated with love and wonder the least blade of grass.

## THE MIRROR OF KNOWLEDGE

Fallen humanity, according to Vincent of Beauvais, begins the work of its redemption by manual labor and the acquisition of knowledge. The cathedrals glorified knowledge and labor at once. The work to which honor

was paid was primarily the cultivation of the soil at every season of the year. Let us look at some of the bas-reliefs of the French cathedrals devoted to the labors of the months.

February does not see the resumption of work in the fields. In Italy, of course, the sun is already out in force, and the peasant is beginning to prune his vineyard, as we can see in an Italian manuscript at the Bibliothèque Nationale. But in the north of France, in the Ile-de-France, in Picardy and Champagne, in the France of the cathedrals, February is a harsh winter month. Unless something forces him out, the peasant stays indoors, warming himself at a fine wood fire. In the bas-reliefs at Paris and Amiens the little domestic scenes have a delightful intimacy about them. One would swear that the poor countryman had just come in from a long tramp in the snow and the icy wind. The moment he sits down, before he even takes off his coat, he kicks off his boots to warm himself in comfort. We can tell that the house is snug against the winter wind, that warmth and security reign within. A ham hangs from the ceiling. A chaplet of chitterlings is still hooked over the sideboard. . . .

In June comes the mowing of the meadows. At Chartres work has not yet begun. It is certainly the morning of Saint Barnabas' Day, traditionally the date on which mowing is started. The reaper marches off to the fields, his round hat on his head, his scythe over his shoulder, his whetstone at his side. At Amiens we find the reaper in the heat of action, fairly flinging his scythe into the thickest part of the hay. At Paris the hay is already dry, and the peasant, bent beneath his load, carries it off to the barn. The miniatures present minor variations of the harvest scenes. The Italian manuscript which we have mentioned has the harvest beginning in June; no doubt

the artist came from the warm Campagna di Roma. From the thirteenth century on there appears, in the books of miniatures, the motive of the sheep shearing, which becomes so frequent in the fifteenth and sixteenth centuries.

July is harvest time. At Chartres, as almost everywhere else, the peasants are cutting the grain with sickles. But in the Virgin portal of Notre-Dame in Paris the mower, with a great flourish, is sharpening a large scythe with a whetstone before setting to work (Pl. 15).

The harvest was not quite over in August, as the north portals at Chartres, Paris, and Rheims testify. But at Senlis, Semur, and Amiens the threshing is under way. And that is a hard job. Stripped to the waist, the peasant labors all alone within the broad circle of his flail.

September—and the peasant hardly has time to catch his breath before the vintage begins. In that old France which seems to have had a warmer climate than the France of the present day, the vintage came at the end of September in most regions, and the peasant treads joyously in his vat. Champagne was the only exception. At Rheims we find the grain still being threshed in September, and wine vats and wine casks do not appear for another month. At Amiens the fruit is being gathered.

In the provinces celebrated for their wines, October sees the end of the vinegrower's labors. At Semur in Burgundy, at Rheims in Champagne, the wine fermented in the vats is drained off into casks. Elsewhere, at Paris and at Chartres, sowing has begun. The peasant, wearing his winter coat, seems to walk slowly under the chill October sky, his apron full of grain, his arm outflung in the "august gesture" whose beauty was so deeply felt by thirteenth-century artists.

The realms of learning represented in the cathedrals —to proceed to another stage along the way traced toward

salvation—are of course those of the *trivium* and the *quad-rivium*. The attributes of the various liberal arts, often extraordinary, are borrowed from Martianus Capella, the African rhetorician of the fifth century. To the seven liberal arts is added Philosophy, shown at Laon conforming to the description of Boethius in his *Consolation of Philosophy*.

We remember how Boethius tells that he was in prison, deploring his sad destiny, when suddenly a woman appeared to him. "The features of her face," he says, "inspired the deepest respect. There was light in her glance, and one felt that it pierced deeper than any mortal gaze. She had the coloring of vigor and youth, though one was well aware that she was full of days and her age could not be measured as ours is. As for her height, one could form no very clear idea of it, for sometimes she reduced her stature to human proportions, sometimes her head seemed to touch the sky, and sometimes it seemed to pierce beyond the sky and disappear from the curious gaze of men. Her garments were woven with great art, of delicate and incorruptible threads; she told me later that she had woven them with her own hands. But time, which dulls all works of art, had dimmed their luster and obscured their beauty. On the lower fringe of her gown was woven the Greek letter $\pi$, and, on the upper border, the letter $\theta$. To go from one to the other there was a series of steps resembling a ladder, leading from the inferior to the superior elements. One could see that the garments had been rent violently by hands which had torn away all they could. In her right hand she carried books, and in her left hand a scepter."

This woman, whom Boethius describes with such bizarre ingenuity, is none other than Philosophy, who comes to console him in his prison. As for the mysterious

letters π and θ, commentators have agreed in recognizing a succinct method of indicating the practical and theoretical aspects of Philosophy.

The statue at Laon agrees in almost every detail with this description, the sculptor having left out only those traits incompatible with his art. He shows us Philosophy as Boethius had envisaged her, her head in the clouds, a scepter in her left hand, and books in her right. He did not even shrink from such visual representation of philosophical symbolism as the ladder, which we see, stood up against the breast of his figure. We are only surprised that the artist did not inscribe upon the borders of her garment the π and the θ.

## THE MIRROR OF MORALITY

During the Romanesque period artists had represented the combat of Vices and Virtues according to the *Psychomachia* of Prudentius. But in the thirteenth century the Vices and Virtues are designated in an entirely new style.

The Virtues sculptured in bas-relief are seated women, grave, motionless, majestic; on their escutcheons heraldic animals testify to their nobility. The Vices are no longer personified, but are represented by scenes of action on a medallion beneath each Virtue. A husband beating his wife stands for Discord. Inconstancy is a monk fleeing from his convent, flinging aside his frock. Virtue is represented in its essence, vice by its effects. On the one hand all is repose, on the other all is movement and struggle, and the contrast conveys well the idea intended by the artists: these calm figures teach us that virtue alone integrates the soul and gives it peace, and that outside of this there is only agitation. In abandoning the *Psychomachia*,

71

dear to the preceding age, the artists of the thirteenth century seem to have wanted to penetrate further, to express a profounder thought. Romanesque sculptors tell us that "the life of a Christian is one of strife"; but the Gothic sculptors add that "the life of the Christian who has lived all the virtues is peace itself; he participates already in the peace of God."

In the façade of Notre-Dame of Paris, which has the earliest typical thirteenth-century personifications, Faith has the place of honor, at the right hand of Jesus Christ. Seated on a backless bench, she holds an escutcheon on which a cross is represented. At Chartres the escutcheon shows a chalice, and at Amiens a cross within a chalice. In the north porch at Chartres, Faith is filling the chalice with the blood of the Lamb immolated upon the altar. The faith of the Middle Ages is, therefore, faith in the virtue of the sacrifice of Jesus, Who died on the cross, but it is also, as proved by the chalice, faith in the perpetuity of this sacrifice, renewed miraculously every day on the altar. So, Faith was represented by the artists according to the definition of Saint Augustine, which was taken up by Peter Lombard and accepted by all Christendom: "Faith is the virtue whereby we believe in that which we do not see." The sacrament of the Eucharist is its most perfect symbol.

Beneath the images of Faith in the façades at Paris, Amiens, and Chartres, a human figure is shown adoring a hairy, monkey-like figure, Idolatry. This was the naïve image the men of the Middle Ages gave to the pagan gods. They held the belief that the statues of the ancient gods were inhabited by dangerous demons who occasionally manifested themselves in these hideous forms; whoever adored them worshiped Satan.

Wisdom can be identified immediately, both at Paris

and at Chartres, by her shield, which shows a serpent coiled around a staff. No escutcheon could be more noble, since it derived from the words of Christ Himself: "Be ye wise," He said, "as serpents."

Folly, the obverse of Wisdom, merits closer study. At Paris, at Amiens, in the rose at Auxerre, and at Notre-Dame in Paris, Folly is an almost naked male figure, carrying a club, picking his way through a shower of stones, sometimes being hit on the head by one. Almost always this man holds to his mouth a nondescript shape. The figure seems to be taken straight from everyday life— a madman pursued by invisible urchins throwing stones. In the Middle Ages the madman is traditionally represented carrying a club (which later on will become the cap and bells), and eating a bit of cheese. Several poems in the popular tongue, notably the *Folie Tristan,* describe madmen in the exact semblance of this figure of Folly. There is no doubt that the artists, in creating this figure, were following tradition.

## THE MIRROR OF HISTORY

*THE OLD TESTAMENT* The Old Testament has always been regarded as a prefiguration of the New. God, seeing everything in the light of eternity, had established a profound harmony between the Old and New Testaments. Or, to use the language of the Middle Ages, the New Testament reveals to us in full sunlight what the Old Testament had shown in the uncertain glimmer of the moon and stars. In the Old Testament, truth is veiled; it is the death of Christ that tears away this mystical veil. Therefore it is written in the Gospels that the veil of the Temple was rent from top to

73

bottom at the moment when Jesus yielded up the ghost. The Old Testament has meaning only in relation to the New, and the Synagogue, insistent on explaining it by itself, remains blindfolded.

Thus, at the beginning of the thirteenth century, when artists were decorating the cathedrals, the doctors were affirming from the height of their chairs that the Scriptures were at once history and symbol. It was agreed that the Bible could be interpreted on four different planes: historically, allegorically, tropologically, and anagogically. Historically, the Bible communicated real facts; allegorically, the Old Testament prefigures the New; tropologically, moral truth was shown hidden beneath the letter of the Scriptures; and finally, anagogically, the Bible revealed in advance the mysteries of the future life and of eternal beatitude. For example, the name "Jerusalem" could, according to Guillaume Durand, be given any and all of the following four interpretations: Jerusalem, in the historical sense, is the city in Palestine whither pilgrims travel; allegorically, it is the Church Militant; tropologically, it is the Christian soul; and, in the anagogical sense, it is the heavenly Jerusalem, the final fatherland. Not all passages of the Bible were susceptible of quadruple interpretation; some had only threefold meaning. The history of Job's sufferings, for example, had on the first plane the value of historical fact; secondly, it was an allegory of Jesus' Passion; and thirdly, it was a figure of the trials of every Christian soul. Still other passages permitted of only two explanations, and some had to be taken at their literal value.

Stained-glass windows at Bourges, Chartres, Le Mans, and Tours illustrate clearly the concordance between Old and New Testaments, and we take as an example the

Crucifixion surrounded by figurative scenes as it appears in these windows.

In the medallions surrounding the Crucifixion scene we see the image of the spring which gushed forth under Moses' rod, the brazen serpent, the murder of Abel, finally the marvelous cluster of grapes brought back by the spies from the Promised Land. Since the time of Saint Paul the Church had regarded the rock smitten by Moses as an image of Jesus Christ. This likening, briefly touched upon by the apostle, was amply elaborated by the commentators on the Book of Exodus. According to the *Glossa Ordinaria,* which sums up all the interpretations, the spring which leaped forth under Moses' rod was the water and the blood issuing from Jesus' side. The throng that murmured against Moses waiting for the miracle symbolizes the new peoples who would not submit to the Judaic law but would come to slake their thirst at the living spring of the New Testament. This explains the proximity of a scene apparently so remote from the Crucifixion.

The brazen serpent which Moses raised up on a pole to heal the people was already mentioned in the Gospels as a figure for the Elevation on the cross. The commentators, therefore, explain this Old Testament passage more briefly than others. Isidore of Seville, quoted by the *Glossa Ordinaria,* only says that Jesus is the new serpent Who has vanquished the old, and adds that brass, the most solid and durable of all metals, was chosen by Moses to express the divinity of Jesus Christ and the eternity of His reign.

Abel was first of the just, prototype of the future Messiah, and his death struck the interpreters as a transparent figure for the death of Jesus Christ. They went on to say

75

that Cain, oldest of the children of Adam, was clearly symbolic of the ancient people of God. Abel slain by Cain was Jesus put to death by the Jews.

On the other hand, the grapes brought back from the Promised Land were a symbol much less easy to interpret, for the commentators enlarge diversely and variously on the famous passage from the Book of Numbers. The twelve spies sent down by Moses into the land of Canaan who declared on their return that the Promised Land could not be taken are the scribes and Pharisees who persuaded the Jews not to believe in Jesus Christ, Jesus being meanwhile in their midst under the figure of the marvelous grapes. This cluster of grapes that the two spies carried back between them on the staff from the land of Canaan is Jesus hanging upon the cross; for Jesus is the mystic vine whose blood has filled the chalice of the Church. The two bearers also express a mystery. He who goes ahead, his back turned on the grapes, is the blind and ignorant Jewish race turning its back upon the truth; whereas he who follows behind, eyes fixed upon the grapes, is the image of the Gentiles who advance with eyes fixed upon the cross of Christ. This mystical explanation, that of the *Glossa Ordinaria,* was followed implicitly by the artist who designed the symbolical subjects for the reliquary of the True Cross at Tongres. To the first of the bearers, the one who does not look at the grapes, the artist gave the conical cap of the Jews, indicating unmistakably that that personage symbolized the Old Law. In this example we see with what faithfulness the artists translated the thought of the Church. . . .

But the most profound of these works of twofold meaning is the one in the central bay of the north portal at Chartres. There we find ten statues of patriarchs and prophets arranged in chronological order, all symbolizing

or foretelling Jesus Christ and at the same time summing up the history of the world. Melchizedek, Abraham, and Isaac represent one age of mankind. They recall the time when, to use the language of the doctors, "men lived according to the law of circumcision." Moses, Samuel, and David represent the generations subject to the written law, who worshiped God in the Temple (Pl. 17). Isaiah and Jeremiah, Simeon and John the Baptist stand for the span of prophetic time lasting until the coming of Jesus Christ. And Saint Peter, coming last, clad in the dalmatic, crowned with the tiara, bearing the cross and the chalice, announces that Jesus has abolished the law and the prophecies, and, by creating the Church, has established for all time to come the dominion of the Gospel (Pl. 18).

Each of the great figures of Chartres bears a symbol which announces Jesus Christ, which *is* Jesus Christ. Melchizedek has the chalice, Abraham rests his hand upon the head of Isaac, Moses holds the brazen serpent, Samuel the sacrificial lamb, David the crown of thorns, Isaiah the rod of Jesse, Jeremiah the cross, Simeon the Holy Child, John the Baptist the lamb, and Saint Peter, at the end, also has the chalice. Thus the mysterious chalice which appears at the beginning of history in the hands of Melchizedek reappears in the hands of Saint Peter. The circle is closed. Each of the figures is a Christ-bearer, a christophorus, transmitting from generation to generation the mysterious sign.

*THE GOSPELS* The Gospel scenes are represented in the thirteenth century as mysteries embodying profound symbols. Christ's birth, for example, is portrayed in a way which on closer study appears strange indeed. This scene, repeated several times in the windows, has no trace of tenderness, of human feeling. Never, as in

77

Italian art of the *quattrocento,* do we find the mother kneeling before the Child, contemplating Him with clasped hands, enfolding Him in an infinite love. On the contrary, the mother, reclining on her bed, seems to turn away her head so as not to see her Son. She looks vaguely before her as though at something invisible. The Child does not lie in a cradle but, strangely enough, on a raised altar which in several windows occupies the whole central part of the composition. A lamp hangs over His head, between open curtains. We feel that we are looking not at a stable but at a church; and it was indeed a church that the artist-theologian of the thirteenth century wished to suggest. From the moment of His birth Christ has to appear according to His true nature, as a victim. The cradle where He lies, the *Glossa* tells us, is the altar of His sacrifice. One French manuscript of the thirteenth century shows us, directly above the Child Jesus stretched upon the altar, Christ crucified. The tree of the cross rises out of the altar on which the Child is laid. Here, the symbol is plainly apparent to the eye.

Human feelings are stilled in the presence of such a mystery, even the feeling of maternal love. Mary, the commentaries tell us, ponders in religious silence the words of the prophets, and those of the angel, which have just been accomplished. Saint Joseph shares her silence, and husband and wife, eyes fixed before them, seem withdrawn into their own souls. We have far to go from this majestic conception, wholly theological in its grandeur, to the picturesque crèches which appear at the beginning of the fifteenth century and mark the end of great religious art.

*THE APOCRYPHA* Popular imagination was early at work on the Gospels, trying to add to them and to fill in the gaps. The legends go back to the earliest Christian centuries. They were born of love, of a touching desire to know more of Jesus and those near Him. The people found the Gospels too brief. They could not resign themselves to the omissions, taking literally the words of Saint John: "But there are also many other things which Jesus did, which, if they were written every one, the world itself, I think, would not be able to contain the books that should be written."

This old desire to explore the hidden life of Jesus has, indeed, been constant throughout all ages. The *Meditations* of the Pseudo-Bonaventure, the revelations of Saint Brigitt, of the Spanish Franciscan, Maria of Agreda, and the astonishing tales of Sister Catherine Emmerich, all prove that the tender curiosity which gave rise to the apocryphal gospels continues up to modern times.

The small Christian communities in the Orient never wearied of hearing about Jesus. His childhood particularly, on which the canonical books touch so little, roused their imagination. Marvelous tales were told, some of them originating among the Christian people of Syria, others among the fellahs and sailors along the Nile, whence caravans spread them to the furthermost parts of Arabia. In the desert halting-places it was told how the Child Jesus had molded birds out of clay, and then, beating His hands together, had made them fly away; at the teacher's, it was said, He had read off all the letters of the alphabet at first sight; with the skill of a master craftsman, He had helped His foster-father Joseph make plows. . . .

None of the scenes from Jesus' childhood furnished richer material to the popular imagination than did the Adoration of the Magi. Their mysterious figures, shown

79

in the Gospels as through a veil, aroused the eager curiosity of the people. So legends gradually filled in all that Saint Matthew leaves out. We learn the names of all the Wise Men, the events of their journey, the circumstances of their life and even of their death. It appears that the Wise Men died true Christians, baptized by Saint Thomas during his journey to the Indies. The Cathedral of Cologne piously received their relics. Great families of the Middle Ages counted the Wise Men among their forebears. In the ruins of the Château des Baux near Arles we can still see the escutcheon decorated with the star which attests this noble origin of an illustrious house. The people honored the Wise Men in their own way, bringing their names into magical exorcisms and incantations. The names of the three Wise Men, written on a ribbon that was worn around the wrist, were powerful cures for epilepsy.

In the Middle Ages, picturesque traditional beliefs about the Wise Men abounded. The East from which they came set men dreaming. Imagination, carried away to the land of the Queen of Sheba, the land of gold and spices, knew no bounds. The Wise Men, it was said, were descended from Balaam and had inherited the secrets of the ancient soothsayer. The gold pieces which they brought to the Child Jesus had been struck by Terah, father of Abraham, and had been given to the Sabaeans by Joseph, the son of Jacob, when he came to buy perfumes for the embalming of his father's body. . . .

No legend was more scrupulously followed by the artists than that which assigned a different age to each of the Wise Men. In windows, bas-reliefs, and manuscripts the first King is always an old man, the second one a man of mature years, the third a beardless youth. We need recall only one of many examples: the celebrated Adora-

tion of the Magi on the choir screen of Notre-Dame in Paris. It follows an old tradition, already adopted by the miniaturists of the eleventh century, and going back much further than that. The most ancient mention of the legend is found in a curious passage formerly attributed to the Venerable Bede, in the *Collectanea* accompanying his works. "The first of the Magi was Melchior, an old man with long white hair and a long beard. . . . He it was who offered the gold, symbol of divine royalty. The second Wise Man, named Gaspar, young, beardless, and of ruddy complexion, . . . presented the incense, an offering manifesting Christ's divinity. The third, Balthasar, brown-skinned [*fuscus*], wearing a full beard, . . . testified by his presentation of the myrrh that the Son of Man must die."

Similarly, all the legendary scenes attributed to the life of the Virgin—her death in the midst of the apostles, her funeral rites interrupted by the Jews, her resurrection in the presence of her Son, and her coronation in heaven— are to be found in all French cathedrals.

At Notre-Dame in Paris the Coronation of the Virgin appears in a new guise (Pl. 19) . This time it is a coronation in the true sense of the term, performed, however, not by Christ, but by an angel who descends from heaven to set the crown on her head. The tympanum showing this scene is admirable in every respect. The art of the Middle Ages has nothing more chaste, nor more sublime.

Seated beside her Son with folded hands, the Virgin turns her pure face toward Him, while the angel sets the crown upon her head. Jesus, radiant with divine beauty, blesses her and presents her with a scepter which blossoms like a flower—the symbol of His power which He wills henceforth to share with her. The Virgin's gesture, meanwhile, is expressive of both gratitude and modesty. At one

time this group was gilded, and Mary appeared like the Queen of the psalmist, dressed in a golden mantle. Now the setting sun and the summer evenings restore to her once more her ancient splendor. Roundabout, in the curve of the arch, are gathered the angels, kings, prophets, and saints, who form the court of the Queen of Heaven.

Fra Angelico's exquisite picture in the Louvre, showing Mary crowned by her Son in a choir of shining virgins, saints, and martyrs, all clothed in celestial colors, has all our admiration. But let us do justice to older masters, who, two centuries earlier, had treated the same subject with even greater majesty. The artists of the cathedrals had ranged the whole of Paradise in concentric circles about the Virgin, had, like Dante, opened heaven to the eyes of men, had shown Mary surrounded by "more than a thousand angels with outspread wings, each angel shining with particular splendor, glorifying her."

*THE SAINTS AND THE GOLDEN LEGEND* The Middle Ages drew much moral nurture from the *Golden Legend,* and we can readily understand the charm it had for them.

The wealth of biographies in the *Legend* provided the Christian with an extremely varied panorama of human existence. To know the life of the saints was to know humanity in all times and places, all ages and conditions. The novels, the "human comedies," of recent times are less diverse, less rich in experience than the immense collection of the *Acta Sanctorum,* of which the *Golden Legend* is the digest. No trade, no liberal profession, was without its saint or saints. There were saints who had been kings, like Saint Louis, popes like Saint Gregory, knights-errant like Saint George, shoemakers like Saint

Crispin, beggars like Saint Alexis. There was even a law-yer who had been canonized, and the people expressed their astonishment in the hymn sung in honor of Saint Yves:

*Advocatus et non latro,*
*Res miranda populo.*

(A lawyer who is not a scoundrel—something to amaze the people.) Shepherds, ox-drovers, plowboys, servant girls, all had been judged worthy to sit at the right hand of God. The lives of such humble Christians demon-strated that there was an awesome depth in every station of life. For the reader of the Middle Ages, these lives were the richest treasury of wisdom, and in this book every man could find a model for himself.

The *Golden Legend* gave men not only a knowledge of life, but also one of the world, of other climates, other epochs. History and geography were seen through its per-spective glass. True, the world perceived through the *Golden Legend* appeared a little vague and misshapen, as on an old map; nonetheless, it was an image of reality. According to the day of the week, the reader was trans-ported to the deserts of the Thebaid, with its ancient tombs inhabited by holy men and jackals; or to the Rome of Saint Gregory, deserted, in ruins, ravaged by the plague; or to the riverbanks of Germania; or he might set sail with the narrator for the "Island of the Saints." By the end of the Christian year the imagination had run through all countries and epochs, and the humble Chris-tian who knew in this world only his own street and church steeple had shared in the life of all Christendom.

Even greater than the value of the realistic element, however, was the charm of the marvelous, as revealed, for instance, in the legend of Saint Eustace:

83

Placidas, general of Trajan's armies, saw one day the image of Jesus Christ between the horns of a great stag he was pursuing. The miracle converted him. He was baptized along with his wife and took the name of Eustace. Then, to test him as He had tested His servant Job, God ruined him. Penniless, Eustace and his family embarked for Egypt; and because he had no money to pay for their passage, the ship's captain retained Eustace's wife. Stricken to the heart, but still having his children with him, Eustace plunged into the unknown country where he had landed and came to the bank of a river. The river was swift and dangerous, and as Eustace could carry only one child across at a time, he was obliged to leave the other on the near bank. But while he was returning for the second child, a wolf on one side and a lion on the other carried off both of his children at once. Broken with grief, Eustace made his way to a village near by and took service as a laborer. He remained for several years in the village, mourning his sons, whom he believed to be dead. Meanwhile they were growing up a little distance away, with some peasants who had rescued them from the wild beasts.

The story ends like the romances and comedies of antiquity. Indeed, the dramatic device to which Menander and Terence had such frequent recourse, recognition, *anagnorisis,* is very cleverly put to use by the hagiographer. Soldiers of Trajan pass through the village where Eustace is staying and recognize their general. Restored by the Emperor to command of the legions, Eustace recognizes his two sons, who have joined the army; and the two young men are also recognized by their mother, who overhears them recalling their childhood at an inn. After such a multitude of trials, Eustace and his wife and children are reunited. But their happiness is brief. Trajan's successor, Hadrian, learning of Eustace's religion, has him

84

and his wife and children shut up in a bronze bull and revives for them the torture invented by Phalaris. And this is the legend of Saint Eustace as told by the windows at Auxerre, Le Mans, Tours, Sens, and, most magnificently of all, at Chartres (Pl. 20).

*THE ASPECT OF THE SAINTS*  The artists, and particularly the sculptors, whose work it was to give form to figures of such greatness, found themselves at grips with one of the most challenging problems of art. It was their task to make each saint's visage radiant with his own particular virtue. Every saint in the *Golden Legend* had his special quality: Saint Paul is the man of action, Saint John the contemplator. Saint Jerome is the scholar whose eyes have gone dim over books, and Saint Ambrose the prototype of the bishop, the keeper of the flock. There is no sentiment, nor shade of sentiment, which some saint may not embody. Saint George is courage meeting death halfway, and Saint Stephen patient resignation before death. Saint Agnes, Saint Catherine, Saint Cecilia, all represent virginity. But Saint Agnes is the ingenuous, ignorant, and defenseless virgin who has the lamb for her emblem. Saint Catherine is the wise virgin, possessing knowledge of good and evil, able to dispute learnedly with the learned, while Saint Cecilia is the virgin-spouse who embraces chastity voluntarily in the nuptial chamber.

The lives of the saints offered all this subtle variety to art, with the result that the art of the Middle Ages—almost entirely a representation of the saints—is of all artistic epochs the most idealistic; it was expected to reveal the soul. Strength, charity, justice, moderation, these had to appear on the faces, and not as cold abstractions; the saints were living realities. To speak in the language

85

of the doctors, the saints had within them more true life than all other men. Only the saints really lived.

*SECULAR HISTORY*     Though we see the baptism of Clovis at Rheims, and the story of Charlemagne in a window at Chartres, secular history occupies a comparatively small place in the cathedral art of France. The history of the crusades did, however, inspire the glassworkers with one highly interesting work, which survived at Saint-Denis until the time of the Revolution. Today we can know it only through Dom Montfaucon's *Monuments of the French Monarchy.*

It was natural that the monks of Saint-Denis, guardians of ancient historical relics, chroniclers of the history of France, should have had the idea of dedicating a window to notable victories of the holy war. Would this not, moreover, be a pious work to the memory of true martyrs? So the stained glass of Saint-Denis, of which we know only a few panels, was conceived by an artist full of the epic power of the great twelfth century. The incidents are secondary so far as history is concerned, but imposing, truly heroic, in themselves: the duel of a Saracen and Robert, Count of Flanders, for instance (*Duellum Parthi et Roberti flandrensis comitis*), or the single combat between an infidel and the Duke of Normandy (*R[obertus] du[x] Normannorum Parthum prosternit*). However, the three great victories of the First Crusade, the taking of Nicaea and of Antioch, and the capture of Jerusalem by Godfrey of Bouillon, were not forgotten and evidently occupied the center of the composition. The Christian knights are distinguished from the heathen by the cross on their helmets. Altogether it is a great misfortune that a monument of capital importance for French history

should exist only in Montfaucon's book, and there only in mediocre plates designed and engraved by artists completely alien to the genius of the old masters.

The life of Saint Louis is the last in the series of historical tableaux which the men of the Middle Ages admitted to their cathedrals. But this king was also a saint, and it was primarily as a saint that he found admittance in the churches. The window at the Sainte-Chapelle, however, showing several episodes of the king's life and notably the translation of the crown of thorns, was put in place before his canonization in 1297, and Louis appears without a nimbus.

*THE LAST JUDGMENT*
The "Mirror of History" of Vincent of Beauvais concludes with the culminating scene of the world's history, the Last Judgment (Pls. 21, 22).

Suddenly, at the appointed hour, in the middle of the night and at the very instant at which Christ once rose from the dead, the Judge will appear in the clouds. "And then," says the Evangelist, "shall appear the sign of the Son of Man, in heaven; and then shall all the tribes of the earth mourn, and they shall see the Son of Man coming in the clouds of heaven, with power and great glory." The brief passage from Saint Matthew, meditated on by all Christendom and enriched by many commentaries, found its perfect artistic realization in the thirteenth century.

At the summit of the tympanum where judgment is to be delivered appears Christ, seated on His throne. He has neither crown nor belt of gold, as the figure of the Apocalypse has. He desires to show Himself to men just as He was when among them. He has put on His humanity again. He raises both hands to show His wounds, and the

tunic, open over His breast, shows the scar in His side. We feel that He has not yet opened His mouth to speak to mankind, and the waiting is portentous.

What is His intention in thus showing His wounds? "He displays His scars," explains one of the doctors, "as testimony to the truth of the Gospel, and to prove that He was in truth crucified for our sakes." But that is not all. "Christ's wounds," says another, "are evidence of His mercy, for they recall His voluntary sacrifice. Further, they justify His wrath, remind us that all men have not willed to profit from His sacrifice." And Saint Thomas Aquinas adds, "His wounds are proof of His strength, since they attest His triumph over death." So the gesture of Jesus designates Him at once as Redeemer, Judge, and Living God.

The Son of Man is flanked by angels, some carrying the cross and the crown of thorns, others the spear and the nails. The angelic hands, almost always veiled, touch the sacred objects with reverence. The "signs of the Son of Man" of which the Evangelist speaks are, according to the testimony of all the Fathers, the instruments of His torture, and especially His cross. . . .

Finally, to enrich the scene even more, the artists introduced to right and left of the Judge the Virgin and Saint John in attitudes of prayer. The Gospels say nothing about them, but the theologians contrived to justify the presence of these two additional figures. Honorius of Autun remarks that the Virgin and Saint John scarcely knew death, as both had been ravished from the earth by Christ Himself, and thus appear as the first fruits of the Resurrection.

I should be more inclined to believe that the artists who introduced the Virgin and Saint John into the Judg-

ment scene were impelled by a simple and human feeling of piety. Were not the mother and the beloved disciple, who remained with Christ at the foot of the cross on the day of sorrow, worthy to share in the day of His triumph? But if this is the reason, why should they be shown kneeling, hands clasped like suppliants? Here we touch upon one of the most delicate sentiments of the Christian soul. Theologians had declared that at the supreme moment no prayer could swerve the Judge; but this the humble throng of suppliants refused to believe. They continued to hope that on the day of days the Virgin and Saint John would still be powerful intercessors, capable of saving more than one soul by their prayers. The artists were inspired by a belief which they shared with the people. To law they opposed grace, and in the midst of the severe ceremonial of justice they left room for a glimmer of hope.

Men are resurrected at the perfect age of thirty-three, the age at which Christ rose from the dead. Thereupon Saint Michael appears with his scales.

Saint Michael stands clothed in a long robe with straight folds (in the thirteenth century he does not yet wear knightly armor), and the balance is suspended from his hand. Near him, a trembling soul waits for the verdict: his good deeds have been placed in one of the scales and his sins in the other. The devil is present, acting as accuser before the supreme tribunal, and the subtle advocate performs prodigies of dialectics, dares to match wits with God Himself. Believing that the noble archangel, who looks straight before him with such a candid air, will never suspect his trick, the devil presses down the scale with his thumb. The shabbiness of this grocery-store rascality leaves Saint Michael unmoved, and he does not trouble to notice. Meanwhile the scales in his hand do

89

their duty honestly and incline in the proper direction. Satan is vanquished. The archangel gently strokes the little soul. . . .

Next, the just are separated from the unjust. On the left, the damned are precipitated into the open maw of a monster—the Leviathan. To the right, the elect advance toward the gates of Paradise.

Now we are on the threshold of Paradise. The elect wear long robes, or sometimes even the garments of their earthly rank and condition, contrary to the doctrine of Honorius of Autun, who endeavors to prove that the just will be clothed in their innocence and the splendor of their beauty alone. Whether to conform to the words of the Apocalypse, ". . . those who have put on white robes, . . ." or because they wished to recall up to the very gates of Paradise the struggles of earth, medieval artists preferred to clothe the blessed in the garments of their earthly station. Kings, bishops, abbots walk among the host of holy souls into the heavenly city. At Bourges, a king advances with a flower in his hand. This entrancing figure is meant to express the union of royalty and sanctity. The artist may have been thinking of Saint Louis, recently dead. But the figure at Bourges is not a portrait; rather, it is the exemplar of the Christian king, of which Saint Louis was the perfect incarnation. In any case, the king at Bourges is slender as a knight and "beautiful as an angel," to quote Fra Salimbene, the delightful painter of the holy monarch. It is noteworthy that at Bourges, at the Church of La Couture in Le Mans, and again at Amiens, a Franciscan girt with the triple-knotted cord walks alongside the king at the head of the elect. It is at least possible that the artist of Bourges, whose work must have been done after the death of Saint Louis, wished to bring together in the same tribute the two purest souls of his age,

Saint Francis of Assisi and Saint Louis. It is at any rate clear that the recently founded order of the Franciscans, the way newly opened toward salvation, was glorified at Bourges, at Amiens, and at Le Mans.

So the elect walk forward clothed in the garments which they wore in this life; but the angels at the gate of heaven prepare to decorate them with kingly emblems. They hold crowns which they will place upon the heads of those who pass beyond the threshold. The crowning of the just has a place in almost every representation of the Last Judgment. At Notre-Dame in Paris the saints have already received their crowns and so walk like kings even before entering Paradise. At Amiens the angels, crowns in their hands, form a graceful frieze above the heads of the elect.

Finally, Paradise. Dante makes us understand the impossibility of sculpture's expressing eternal bliss. His Paradise is music and light. Souls are singing lights. Form vanishes, dissolved by light a hundred times more ardent than that of the sun. The Holy of Holies is a great rose with petals of fire, in the depth of which the Trinity may be perceived in the mysterious form of a triple circle of flames.

Only the limpid colors of Fra Angelico could have given a kind of reality to the dazzling vision; for color can inspire almost as much as music. But what can the sculptor do with his half-pagan art and his ponderous figures, which seem to bear the weight of original sin?

Yet the sculpture of the Middle Ages was too idealistic an art not to attempt to express the inexpressible. Once at least, in the portal at Chartres, it attempted to render in stone the infinite beatitude of the chosen.

In order to understand these figures we must keep in mind certain of the teachings of the theologians concern-

ing eternal life. Once the world has been judged, it will be renewed. Everything that has been disorderly and intractable in nature, heat, cold, and storms, everything that arose as a result of the first sin, will disappear. The primordial harmony will be re-established, the elements purified. Water, sanctified by Jesus when He plunged His body into the Jordan, will become more brilliant than crystal. The earth which martyrs watered with their blood will be covered with unfading flowers. And the bodies of the just will participate in this universal renewal and become glorious. The body and the soul will each be enriched with seven immortal gifts. The gifts of the body will be beauty, agility, strength, liberty, health, sensuous delight, longevity; and the gifts of the soul will be wisdom, amity, concord, honor, power, security, and joy. All the things which we so sadly lack in this life we shall possess at last. The body will participate in the nature of the soul; it will be agile, strong, and free as thought. The soul will be pure harmony, reconciled with the body and with itself. . . .

The artists of the thirteenth century saw the fourteen sublime gifts of the soul and body as a choir of fourteen radiant virgins, and they are so represented on the north porch of Chartres Cathedral. . . . These fourteen Beatitudes are crowned and aureoled queens, with a divine nobility and grace of attitude. Their hair is loose upon their shoulders and their ample robes fall in simple folds, tracing the pure lines of their bodies. In one hand each holds a scepter, and with the other touches lightly a great shield ornamented with an emblem. Each virgin has her blazon. Liberty wears two crowns to signify that sovereigns are the freest of men. Honor has a double miter on her shield, the miter being the symbol of highest honor. It was of the bishop wearing the miter that the psalmist

wrote, "Lord, Thou hast crowned him with honor and glory; Thou hast established him over all that has issued from Thy hand." Longevity has on her buckler the eagle, who in his old age is rejuvenated by the sun's fires; Knowledge, the griffon that knows of hidden treasures. Some of the attributes of the Beatitudes are less learned: Agility has three arrows, Strength a lion, Concord and Amity have doves, Health has fish, Security a strong castle, and Beauty has roses.

All these beautiful virgins represent our souls in beatitude. Their serenity, their beauty, make the Christian who contemplates them forget the imperfect world, and reveal heaven to him. Through them Paradise is made visible; and one cannot say of the artists who created these noble figures that they were unequal to the grandeur of the subject, or incapable of expressing eternal bliss.

# CONCLUSION

In one of the chapters of *Notre-Dame de Paris,* where light is mingled with so many shadows, Victor Hugo remarked that "Humankind conceived nothing in the Middle Ages which it did not write in stone." We have sought laboriously to demonstrate what the poet grasped with the intuition of genius.

Hugo spoke truly, again, when he said that the cathedral is a book; this encyclopedic character of medieval art is most evident at Chartres, where every one of the "Mirrors" found its place and fullest development. The Cathedral of Chartres is the whole thought of the Middle Ages made visible. The ten thousand human figures painted or sculptured at Chartres compose an ensemble unique in Europe.

Several other great French cathedrals may once have been as complete as Chartres, but time has been less kind to them. Nowhere, however, does there appear an effort of such scope to embrace the whole of the universe. One facet only is realized at Amiens, another at Bourges. Certainly the diversity is not without its charm; but all of the French cathedrals, except Chartres—either because men really desired them so, or because time, casting down part of the edifice, has destroyed an equilibrium—seem intended to throw into relief a particular truth or doctrine.

Amiens, for example, is a messianic or prophetic cathedral. The prophets of the façade, thrown out before the buttresses like sentinels, seem to look into the future. Everything in this solemn structure conspires to voice the approaching advent of a Saviour.

Notre-Dame of Paris is the Virgin's church. Four of the six portals are dedicated to the Mother of God. She occupies the center of the two great roses. In one, the holy men of the Old Testament, in the other, the labors of the months are given their order in relation to her. She is the center toward which all things turn. Nowhere was the Virgin more devoutly loved; the twelfth century in the Saint Anne portal, the thirteenth in the Virgin portal, the fourteenth in the bas-reliefs of the north side, glorify her unceasingly from age to age.

Laon Cathedral is a scholarly monument. The seven liberal arts and philosophy are sculptured in the façade and painted in one of the rose windows; and the truths of the Scriptures are everywhere imaged in their most mysterious form, the verities of the New Testament disguised in the symbols of the Old. We have the impression that scholars conceived Laon Cathedral and lived in its shadow. The cathedral itself has the austere visage of learning.

Rheims is the national cathedral. Other cathedrals are catholic, that is to say universal; but Rheims is French. The baptism of Clovis occupies the summit of the pignon, the kings of France appear in the windows of the nave. So rich is the façade that any further decking out for coronation days was superfluous. Canopies of stone are inalterably in place above the door, and Rheims is forever in readiness to receive monarchs.

At Bourges the virtues of the saints are exalted, the windows illustrating the *Golden Legend,* and the life and death of apostles, confessors, and martyrs forming a dazzling crown around the altar.

The portal at Lyons Cathedral relates the wonders of creation. Sens tells of the vastness of the world and the variety of God's works, and Rouen is like a rich Book of Hours in which God, the Virgin, and the saints take up the center of the pages while fantasy playfully fills out the margins.

Let us not, however, exaggerate the differences. In each cathedral we can sense the same desire to communicate an encyclopedic teaching. In each one, doubtless, a chapter of the *Mirror* seems to have been developed by preference, but only rarely were the other chapters completely neglected.

The statues and windows of the churches were means by which the clergy of the Middle Ages endeavored to instruct the faithful in the greatest possible number of truths. Churchmen understood perfectly well the power of art over minds still childish and unenlightened. For the vast masses of the unlettered, for the populace who possessed neither psalter nor missal, and who remembered only as much of Christianity as they could see with their own eyes, the idea had to be given substance, clothed in perceptible form. In the twelfth and thirteenth centuries

the doctrinal truths were incarnated in the personages of the liturgical plays. Christian thought created its organs of expression with miraculous power. Here again Hugo was right: The cathedral is a book of stone for the untutored, and a book which the printed book gradually rendered obsolete. "The Gothic sun set behind the great printing press of Mainz." . . .

Let us now enter the cathedral. We are first awed by the sublimity of the great vertical lines. One cannot enter the vast nave of Amiens without feeling purified. The church, by its beauty alone, acts as a sacrament. Again we find an image of the world. Like the plain and the forest, the cathedral has its atmosphere, its fragrance, its light and shadow, its chiaroscuro. The great rose with the setting sun behind it seems, in the hours of evening, to be the sun itself, on the point of disappearing at the edge of a marvelous forest. But this is a transfigured world, where light is more dazzling than in ordinary life, and shadow more mysterious. The uproar of life breaks against the outer walls and becomes a remote murmur. This is indeed the ark against which the winds shall not prevail. No other earthly enclosure has given to man a feeling of more profound security.

If we feel this now, how much more strongly must the men of the Middle Ages have felt it. For them the cathedral was total revelation. Words, music, living drama of the mysteries, immobile drama of the statues—all arts were fused within the cathedral. And something more than mere art: pure light, light before it is broken into multiple rays by the prism. Man, confined within his social class, within a trade, his forces dispersed and frittered away in the work and life of every day, recovered here a sense of unity, and regained equilibrium and harmony. The crowd, assembled on great feast days, felt itself an or-

ganic whole, the mystical body of Christ, Whose soul mingled with its soul. The faithful were humanity, the cathedral was the world, and the spirit of God simultaneously filled man and all creation. The words of Saint Paul became a reality: Men lived and moved in God. These things the men of the Middle Ages felt, on the great days of Christmas and Easter when, shoulder to shoulder, the entire city filled up the huge church.

Symbol of faith, the cathedral was equally a symbol of love. Everyone had a part here. The people offered what they had, their strong arms; they hauled carts and carried stones upon their heads, showing the great good will of the giant Saint Christopher. The burgess gave his money, the baron his land, the artist his genius. For more than two centuries all the vital forces of France worked together. Even the dead had a part, the cathedral being paved with tombs, and generations long gone, lying with folded hands upon their biers, continued to pray within the old church. Here past and present met in a single sentiment of love. The church was the expression of the city's innermost consciousness.

The genius of all Christendom flowers here, but also the genius of France. The ideas which assumed substance in the French cathedrals are not the property of France alone; they were the common patrimony of Catholic Europe. Yet France is recognizable in this passion for the universal. France alone was capable of turning the cathedral into an image of the world, an abstract of history, a mirror of spiritual life. The distinction of France lies in the fact that she was able to impose upon a multitude of ideas a superior law. Other cathedrals of the Christian world, all of them of a later period than those of France, do not express so much nor express it so clearly. No church in Italy, in Spain, in Germany, or in England is

comparable to Chartres. Nowhere else has so much thought achieved such form. If we consider how much in our other cathedrals was destroyed by the wars of religion, by bad taste, and by revolutions, even opulent Italy seems poor in comparison. There can be no doubt that, in the domain of art, the greatest achievement of France was the cathedral.

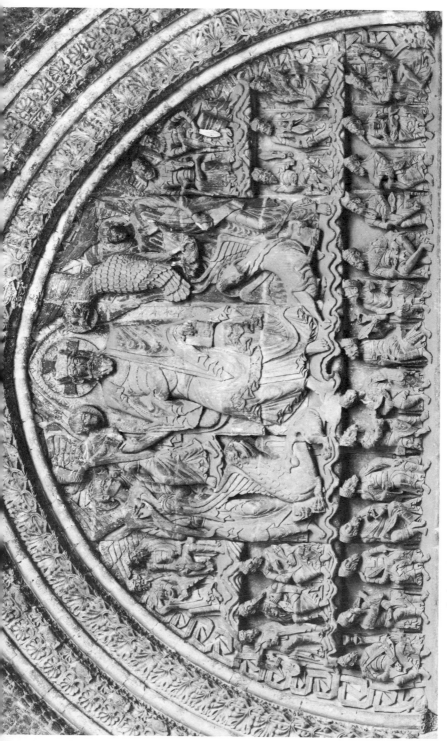

1. Apocalyptic vision of Christ. Moissac, Abbey Church of St.-Pierre. South portal, tympanum.

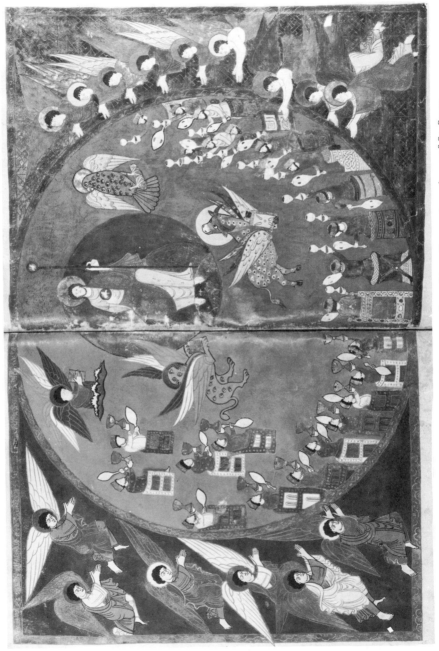

2. Christ between the four beasts and the twenty-four elders. Beatus Apocalypse of St.-Sever. Paris, Bibl. Nat., ms. lat. 8878, fols. 121v.-122r.

3. David as harpist. Paris Psalter. Paris, Bibl. Nat., ms. gr. 139, fol. IV.

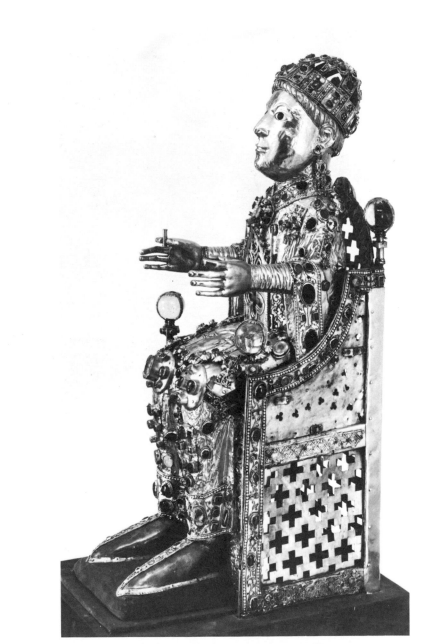

4. St. Foy. Reliquary statue. Conques, Treasury
of the Abbey Church of Ste.-Foy.

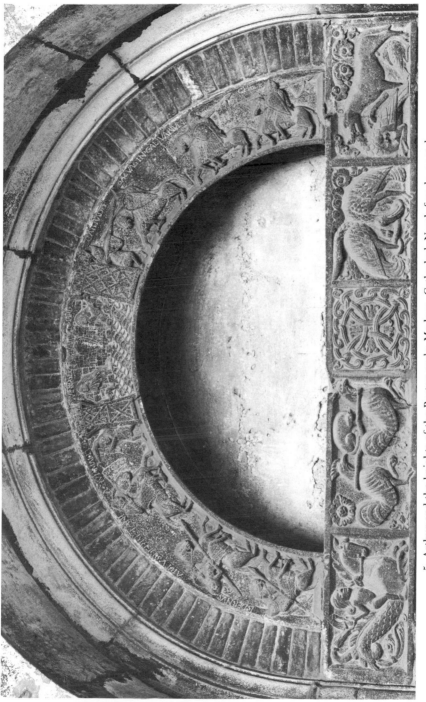

5. Arthur and the knights of the Breton cycle. Modena, Cathedral. North façade, portal.

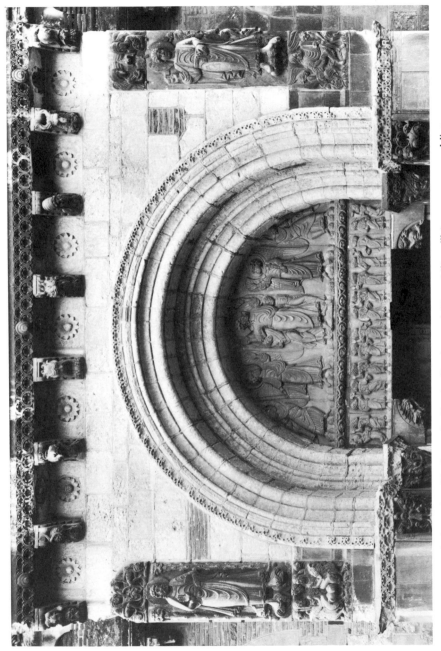

6. Ascension. Toulouse, St.-Sernin. South portal (Porte Miègeville), tympanum and linten.

7. Monsters. Column from Abbey Church
of St.-Pierre (cast). Souvigny,
Musée Lapidaire.

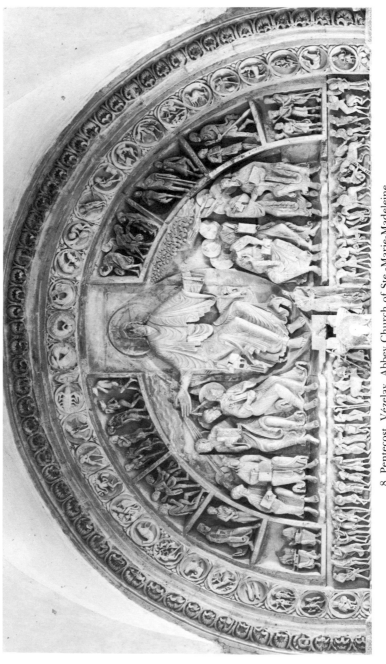

8. Pentecost. Vézelay, Abbey Church of Ste.-Marie-Madeleine. Tympanum of the central portal (narthex).

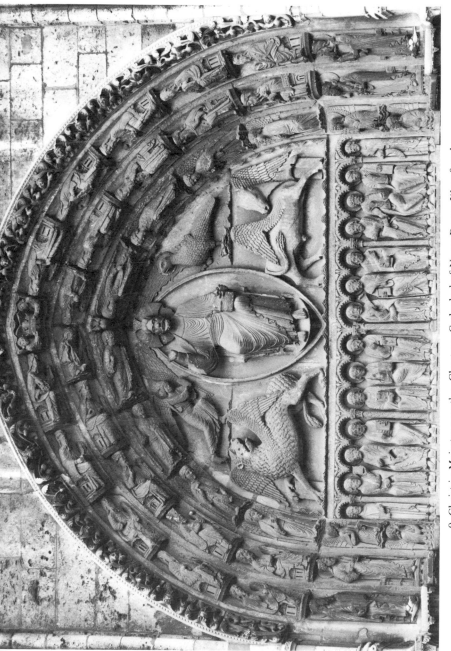

9. Christ in Majesty; apostles. Chartres, Cathedral of Notre-Dame. West façade, Royal Portal, central tympanum.

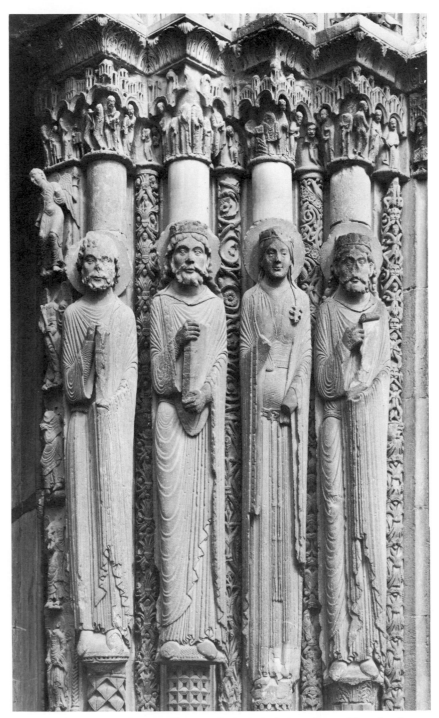

10. Old testament figures. Chartres, Cathedral of Notre-Dame. West façade,
Royal Portal, jambs of central door.

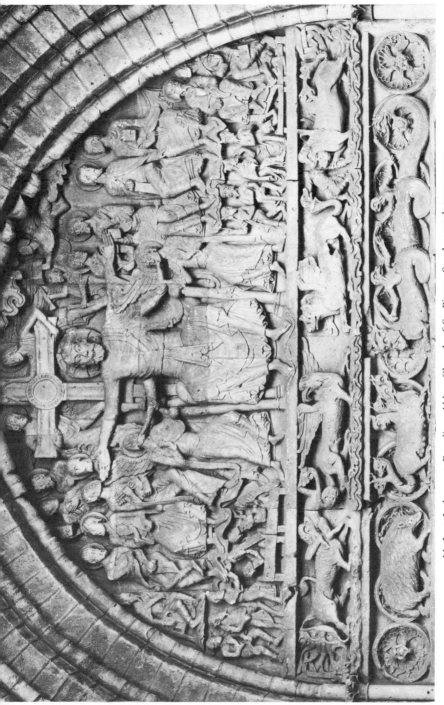

11. Last Judgment. Beaulieu, Abbey Church of St.-Pierre. South portal, tympanum.

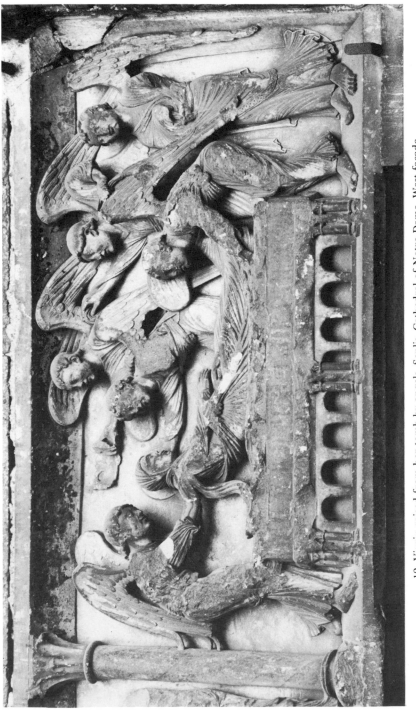

12. Virgin raised from her tomb by angels. Senlis, Cathedral of Notre-Dame. West façade, central portal, detail of lintel.

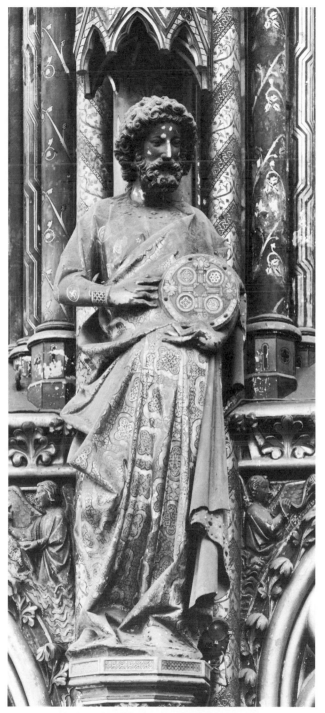

13. Apostle with the Cross of Consecration.
Paris, Sainte-Chapelle.

14. Watercress branch. Paris. Cathedral of Notre-Dame. West façade,
left portal, archivolt (detail).

15. July (mower with scythe). Paris, Cathedral of Notre-Dame.
West façade, left portal, jamb (detail).

16. Charity and Avarice. Amiens, Cathedral. West
façade, central portal, socle reliefs.

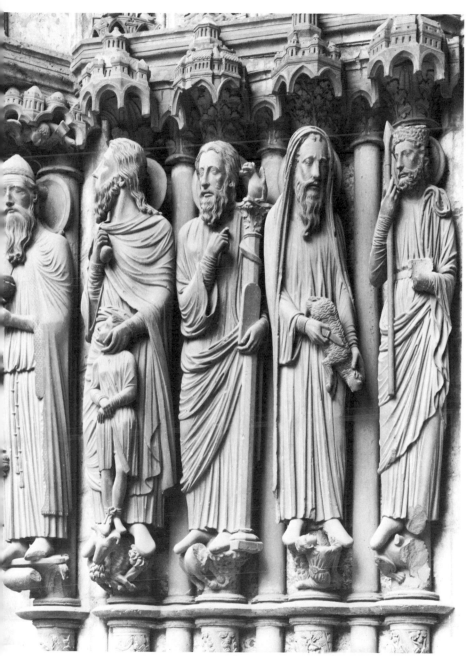

17. Melchizedek, Abraham, Moses, Samuel, David. Chartres,
Cathedral of Notre-Dame. North portal.

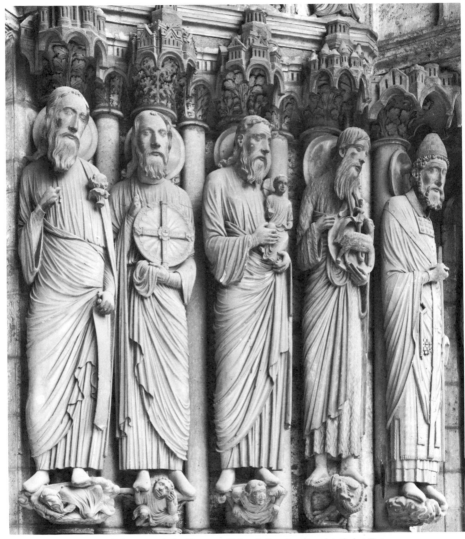

18. Isaiah, Jeremiah, Simeon, Saint John the Baptist, Saint Peter.
Chartres, Cathedral of Notre-Dame. North portal.

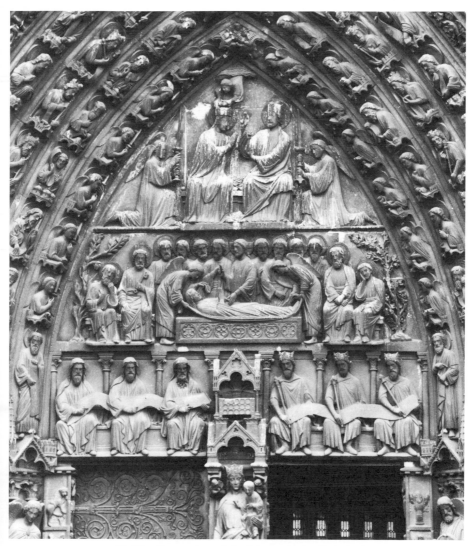

19. The Coronation of the Virgin. Paris, Cathedral
of Notre-Dame. Virgin portal.

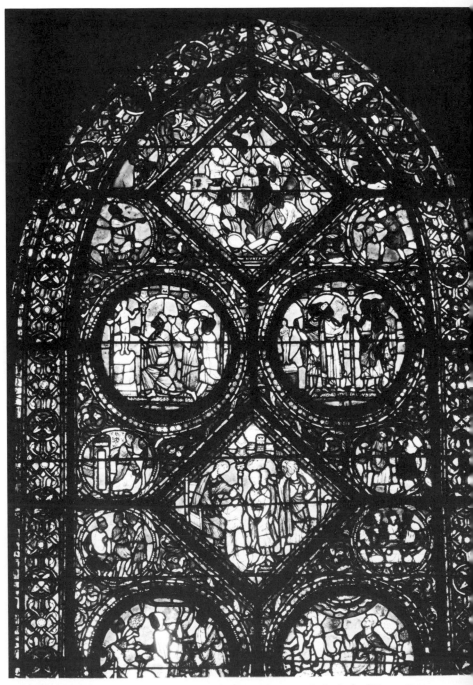

20. Legend of Saint Eustace (upper section). Chartres, Cathedral of Notre-Dame.
Nave, north aisle, stained glass.

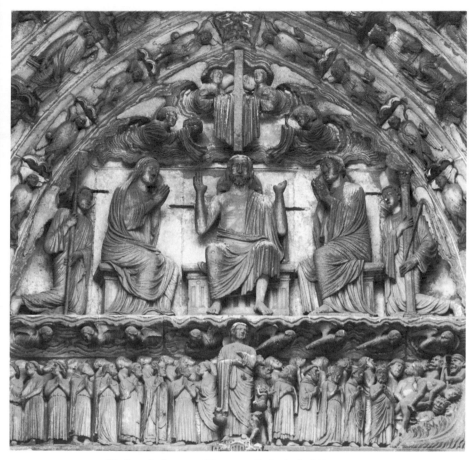

21. Last Judgment. Chartres, Cathedral of Notre-Dame.
South façade, central portal, tympanum.

22. Last Judgment, The Damned. Bourges, Cathedral of St.-Etienne. West portal.

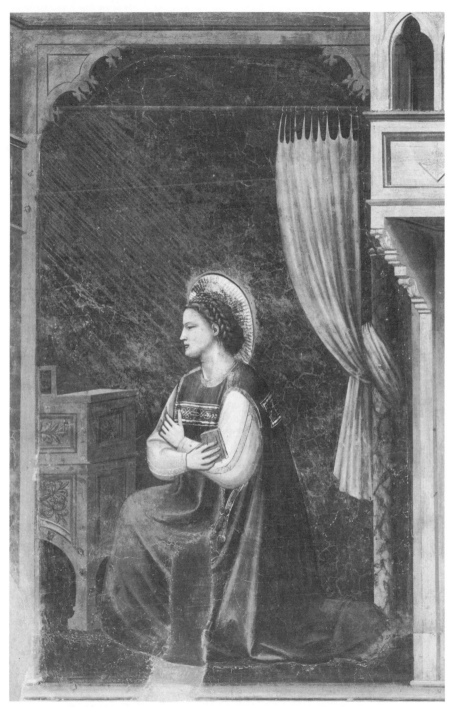

23. Giotto: Annunciation, kneeling Virgin. Padua, Arena Chapel.

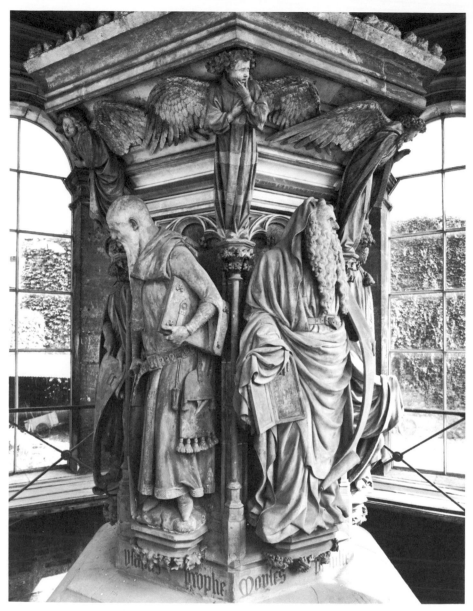

24. "Well of Moses." Dijon, Chartreuse of Champmol.

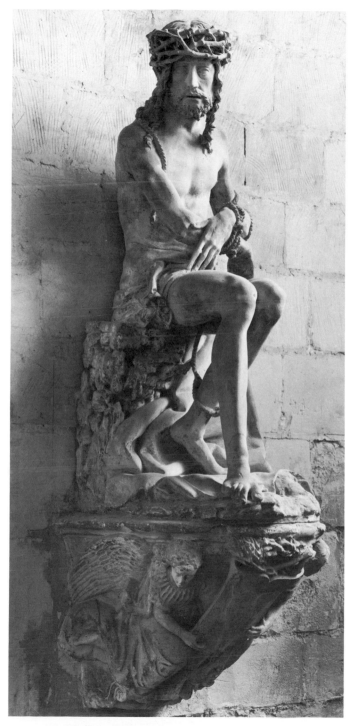

25. Christ seated awaiting death. Troyes, Saint-Nizier.

26. Pietà. Bayel (Aube), Church.

27. The Holy Sepulchre. Tonnerre (Yonne), The Hospital.

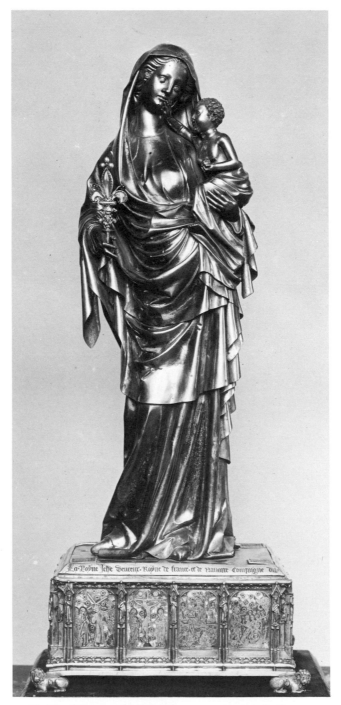

28. The Virgin and Child (silver statuette given by Jeanne
d'Eureux to the Chapel of Saint-Denis). Paris, Louvre.

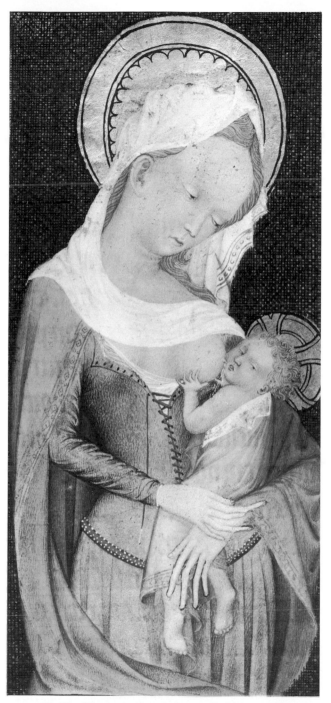

29. The Virgin nursing. *Rohan Book of Hours*. Paris,
Bibl. Nat., ms. lat 9471, fol. 33V.

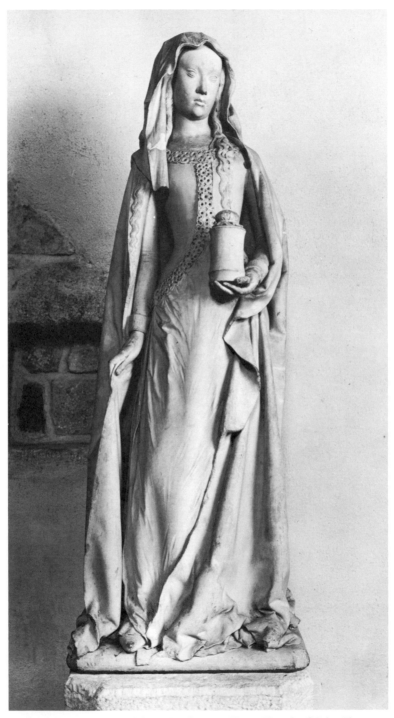

30. Statue of the Magdalen. Montluçon (Allier), Church of Saint-Pierre.

31. The dead body of the Cardinal Lagrange, detail from tomb of the Cardinal. Avignon, Musée Calvet.

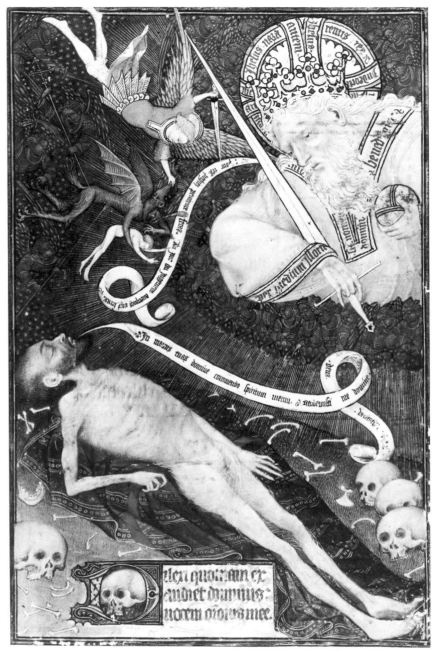

32. A dead man face to face with God. *Rohan Book of Hours*. Paris, Bibl. Nat., ms. lat. 9471, fol 159.

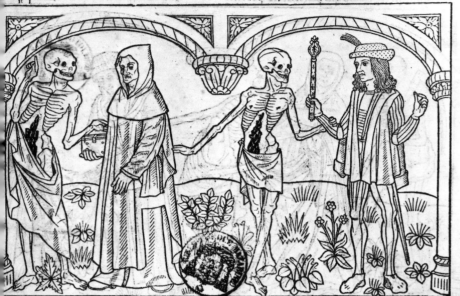

:So moii fenioi iam finis temporis inftat
mq3 patet moitis ianua Vado moii

Vado moii pulcer Vifu mors ipfa decoii
Vel forme nefcit parcere Vado moii

Bis duo fut que coidetenus fub pectoie mifi. Mois mea. iudiciu. baratri nov. fuy paradifi

### Mois
Vir facrate deuoteq3 frater
Semper Viuens in abftinentia
Arripite atius hoc iter
Nulla Vobis fit refiftentia
Hic proderit plus paciencia
Non ad Vitam fed ad pium finem
Refpiate datur fentencia
Super omnem mois Vincit hominem

### Carthufienfis
In mundo fum moituus Vt conftat
Vnde minus cupio Viuere
Quauis moiti quilibet refiftat
Suo poffe fic conuenit ire
Velit deus meam reapere
Nunc animam dulciter Vt fuas
Bonitates poffim reapere
Eft hodie talis qui nichil cras

### Mois
Cliens Virgam regalem defferens
Vt Videtur Vos eftis rebellis
Fruftra tamen eritis differens
Choreare fentencia talis
Eft choiea aunctis generalis
Mundi maioi tranfit hac femita
Mois comunis eft bonis et malis
Nec eft fortis quin fortis fit ita

### Cliens
Mois moidere aur me nunc prefumis
Qui fum cliens et regis feruitoi
Te iudico furiofam nimis
Quauis ego fim tuus debitoi
Vndiq3 fum captus ecce toitoi
Qui me cedit nec Vltra patitur
Mois q ego fum fuus creditoi
Qui non difcat Viy ita moiitur.

33. Guyot Marchant: *Danse Macabre* (1490), The Pope and the Emperor.
Paris, Bibl. Nat., Res. Yc 1035, Pellechet 4107.

Dado mou:nõ me tenet ornatus neqʒ Vestis    Dado mou magnus:mũdi moritur⁹ amator
Linea nec mollis aufcitra Dado mou.          Hunc fpernens poffum dicere:Dado mou

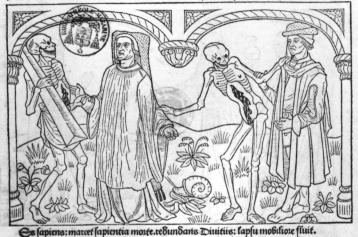

Es fapiens:marcet fapientia mouſe.redundans Diuitiis:lapfu mobiſioue fluit.

Mois                                Mois
Canonice mulfum prebendate         Hic cernite mercator qui prídem
Ecclefie diſtributiones            Per patrías mulfas quefuiſtis
Modo Vobis erunt interdite         Nunc pedeſter nunc equeſter tandem
Nec ibitis ad proceffiones         Sic nobifcum Vos choreabitis
Propter Veſtras retributiones      Veſtrum forum poſtremũ facitis
Dite Via Vobis eſt feclufa         Hiis choreis quibus mous prefidet
Moui decet per leges coïmunes      Pfus laffatus foro non eritis
Mous aduenit. hora non preuifa.    Talis cupit qui fatis poffidet.
Canonicus                          Mercator
Hoc me parum confortat audite      Sub et fupua Velufi poteram
Vt dimittam auras et prebendas     Iter feci pro pane lucrando
Sed mous fortis me Venit ferire    Nunc equeſter nunc pedeſter eram
Non amplius afcendem cathedras     Nunc gaudia perdo mouiendo
Nunc choreas et mouiſales odas     Letus eram femper acquirendo
Choueabo Veſtes abiciens          Et ecce mous dura que me cogit
Canonicos et pulchras tunicas      Choueare fic omnia perdo.
Bene moui fit quifque aupiens,     Parum ſtringit qui nimis colligit

35. Vérard: L'Art de bien vivre et de bien mourir.

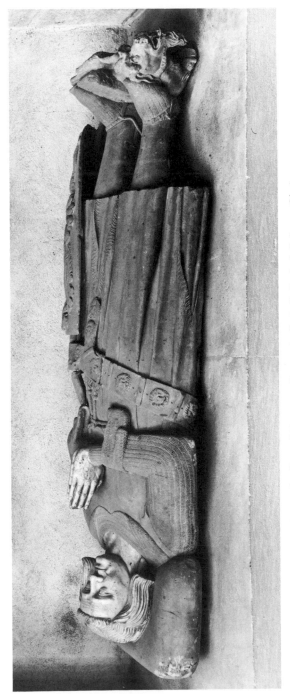

36. Tomb effigy of Haymon, Comte de Corbeil, Corbeil (Seine-et-Oise), Church of Sainte-Spire.

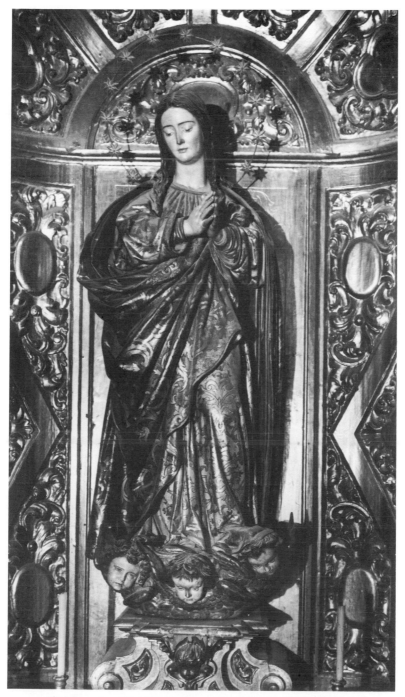

37. Montañes: The Immaculate Conception. Seville, Cathedral.

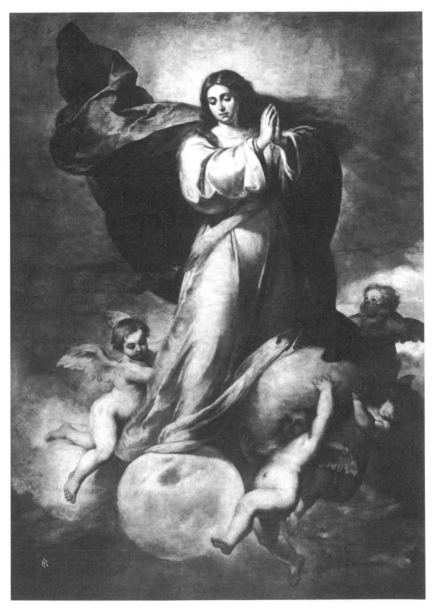

38. Murillo: The Immaculate Conception. Seville, Museum.

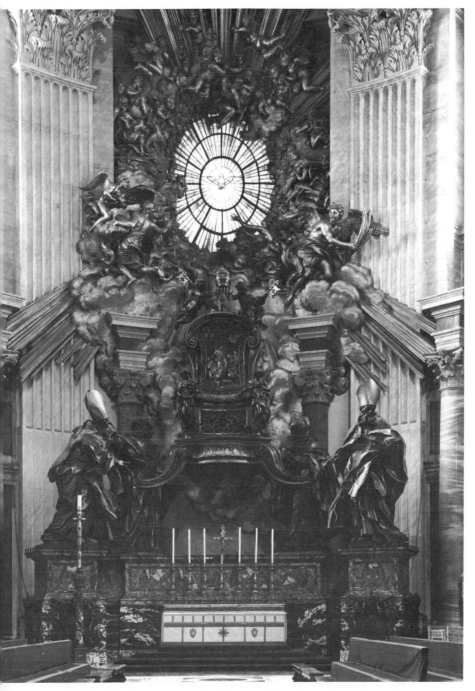

39. Bernini: Monument of the Throne of Saint Peter. Rome, Saint Peters.

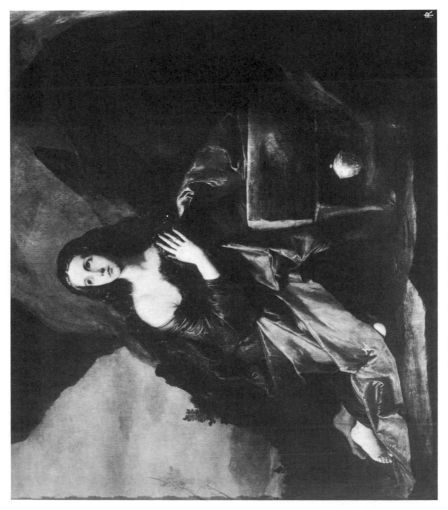

40. Ribera: Kneeling Magdalen. Madrid, Prado.

41. Stefano Maderna: Saint Cecilia. Rome, Church of Saint Cecilia in Trastevere.

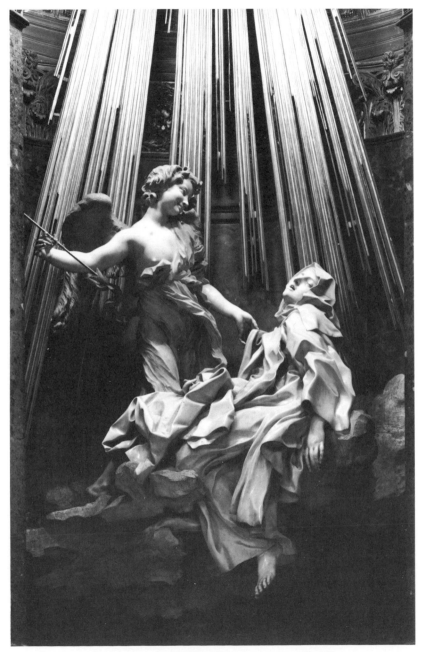

42. Bernini: Saint Theresa and the Angel. Rome,
S. Maria della Vittoria.

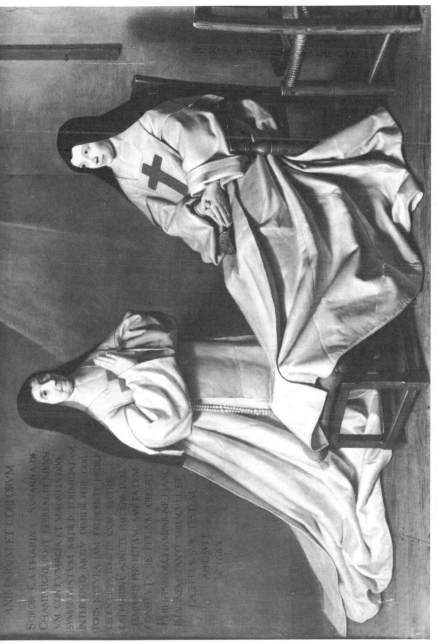

43. Philippe de Champagne: Mother Catherine Agnes Arnauld and Sister Catherine de Sainte-Suzanne. Paris, Louvre.

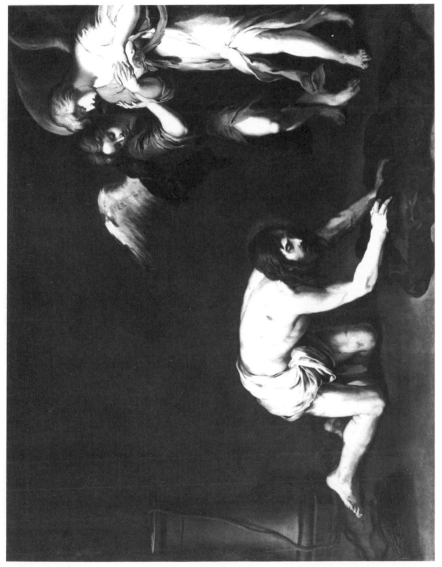

44. Murillo: Christ after the Flagellation. Boston, Museum.

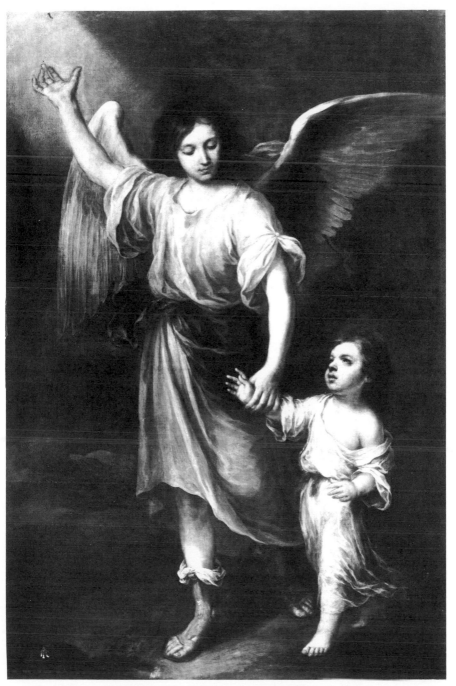

45. Murillo: The Guardian Angel. Seville, Cathedral.

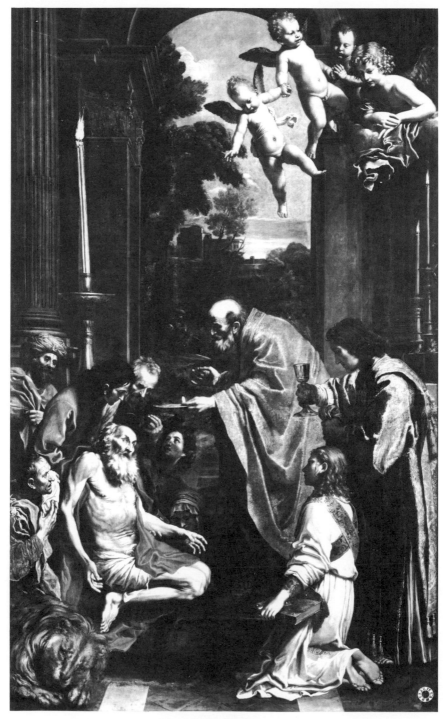

46. Domenichino: The Last Communion of Saint Jerome. Rome,
Vatican Collection.

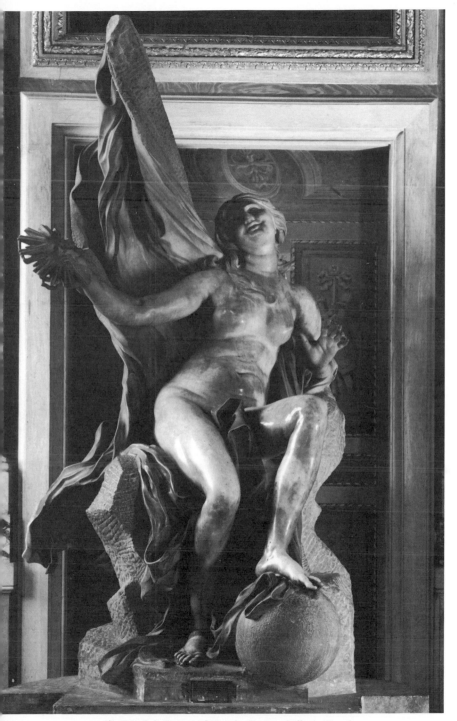

47. Bernini: Statue of Truth. Rome, Galleria Borghese.

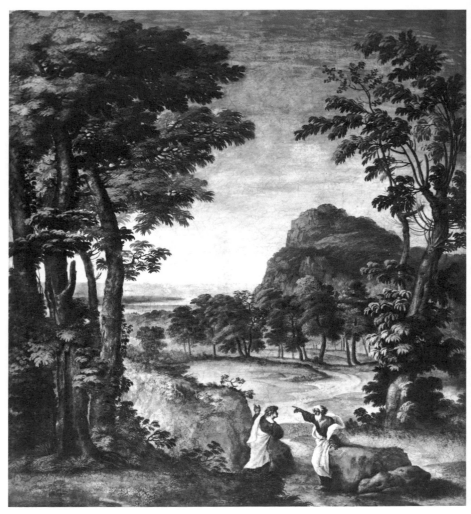

48. Gaspard Dughet: The Prophet Elias and His Servant.
Rome, S. Martino ai Monti.

# RELIGIOUS ART
# OF THE WANING MIDDLE AGES

## GENERAL CHARACTERISTICS

In the fifteenth century as in the thirteenth, Christian thought remains the unique inspiration of French art. Throughout the medieval period art seems oblivious of the vicissitudes of politics, indifferent to defeats as to victories, unconcerned with events beyond the speculations of the theologians and the dreams of the mystics. It is interesting to observe the faithfulness with which art reflects successive phases of Christian thought and feeling, like a sea which has no color but that of the sky, sometimes luminous and sometimes somber. Thus the serene art of the thirteenth century is followed by the passionate and mournful art of the fourteenth and fifteenth centuries. After the earnest theologians of the high Middle Ages, preoccupied with doctrine, come the religious poets with the gift of tears, disciples of Saint Francis of Assisi. Did the artists read their books and listen to their sermons? Possibly; but, from the fourteenth century on, Franciscan Christianity appeared to them in other forms even more likely to impress them. Italian art in the first place, full of the spirit of Saint Francis, the religious theater in the second, reflecting the same order of inspiration, set before artists the most tragic scenes of suffering, grief, and death. A new iconography was born.

*THE INFLUENCE OF ITALIAN ART* French art owes many picturesque and moving touches to Italian art. The Italian artists, however, did not invent such traits. They took them from a book which

101

was extremely celebrated at the time, the *Meditations on the Life of Jesus Christ* attributed to Saint Bonaventure, in reality the work of an unknown Franciscan of the thirteenth century.

The *Meditations* differed profoundly from anything that the Gospels had hitherto inspired in the West. Other books had been addressed to the intelligence. This appealed to the heart. Whatever lengthy scholastic disquisitions we may find in it were later additions of the fourteenth and fifteenth centuries. The author was writing for a woman, a sister of the order of Saint Clara; and he was well aware that all she wanted was an appeal to her emotions. So he devised a series of colorful scenes from the life of Christ, in which imagination constantly supplements history. Often it reads like a new apocryphal gospel. Our author knows things that nobody else ever suspected; for instance, that the infant Saint John loved the Virgin so fervently that he did not want to be taken from her arms; that on the day when Jesus and His parents left Egypt to return to Nazareth, the burghers of the place escorted the Holy Family well beyond the gates of the city, "and one of them, who was rich, called to the Child to give Him a few pence, and the Child, out of love of poverty, took the money and thanked him."

He abounds in the minute details that might interest women, speaks of household trifles and demeans himself to downright childishness. Wondering what kind of meal the angels might have served to Jesus after the forty days of fasting in the wilderness, he emerges with the following suggestions: "The angels betook themselves to the Virgin's house and received from her a little stew which she had prepared for Joseph and herself. The Virgin also provided bread, a napkin, and everything that was needed. Very probably she also sent Him some fish, if she was

able to find any. Returning to the Lord, the angels arranged all these things on the ground and solemnly blessed the repast."

Not everything, however, is in this key. In the scenes of the Passion, there are deeply moving descriptions that reveal the great artist, related by imagination to the Sienese painters, who before long were to adorn with their frescoes the churches of Tuscany. Saint Francis was a poet, the author of the *Meditations* a painter, both profound artists and Italians to the core. In reading the *Meditations,* the frescoes of the luminous cloisters of the monasteries mentioned by the author inevitably come to mind: Colle, Poggibonsi. He was so much of an artist that sometimes he drew his inspiration from other works of art. Certain details in his descriptions seem to have been borrowed from Byzantine pictures; but he was most abundantly served by his own lively imagination and delicate sensitivity. It was he who inspired Italian artists with many happy touches which contributed to the transformation of the old iconography. Here follow a few examples:

Describing the Annunciation scene, the author of the *Meditations* was the first to think of making the angel kneel before Mary. And the Virgin herself kneels to hear the words of Gabriel. "She knelt, filled with the spirit of devotion, joined her hands and said, 'Behold the handmaid of the Lord.'" That is why Giotto, in the fresco at the Arena Chapel in Padua, shows not only the angel, but also the Virgin kneeling (Pl. 23). Italian painters of the fourteenth century repeatedly followed his example.

The author of the *Meditations* was the first to think of the Virgin of the Nativity otherwise than recumbent upon her bed. He visualized her kneeling before her Son. "Meanwhile the mother, having knelt, worshiped

103

Him, saying, 'I thank Thee, Lord, Holy Father, because Thou hast given me Thy Son. I adore Thee, eternal God, and I adore Thy Son, Who is also my Son.' Joseph likewise worshiped the Child, and the angels of heaven came to kneel down before the newborn Babe." Well before the French and Flemish artists, Italian painters brought the angels out of heaven to kneel at the feet of the Child. We find this done as early as in Bernardo Daddi's "Madonna Surrounded by Angels," in the Berlin Museum.

Into the Adoration of the Magi, conceived simply and gravely up to this time, the author of the *Meditations* now introduces picturesque and tender elements. He has the Wise Men kiss the feet of the Child; the page deserves quotation: "The three Kings came accompanied by a great multitude and by a procession of honor, and they halted before the hut where the Christ was born. Our Lady heard the sound of the host and she took the Babe up in her arms. They entered into the little house, knelt, and worshiped the Child. . . . Then they offered Him gold, frankincense, and myrrh; they opened their treasures and presented them; they unfolded before Him their cloths and precious carpets. Whereupon they kissed the feet of the Child, devoutly and worshipfully. Who can say whether the wise Child, to strengthen them in His love, did not also give them His hand to kiss?" Such is the origin of the new iconography of the Adoration of the Magi adopted by Italian painters from the thirteenth century onward.

The scenes of the Passion, which the Byzantines had already charged with so much emotion, are further enriched by affecting details. Jesus carrying the cross is surrounded by a seething crowd that prevents Him from speaking to His mother. "Consider how He advances, bent beneath the cross, breathing with difficulty. . . . His

104

mother could not come near Him or even speak to Him because of the multitude surrounding Him. So, with John and her companions, she took a shorter way so that she might come ahead of the crowd and approach Him. . . . At a crossroads outside the city she met Him. When she perceived Him, weighed down under the heavy wood which she had not seen before, she became rigid with anguish and could not speak a word. Nor could her Son speak to her, pressed roundabout as He was by those who were leading Him on to Calvary." We recognize the Ascent of Calvary as treated by the Sienese painters. Simone Martini and Pietro Lorenzetti were inspired by this text, showing Jesus carrying His cross in the thick of the crowd, and Mary, accompanied by Saint John and the holy women, perceiving Him just as the long procession files out through the gates of the city.

Byzantine artists had shown the Virgin at the foot of the cross, supported by the holy women but overcoming her grief and remaining standing. The author of the *Meditations* makes her collapse into the arms of the Magdalen. . . .

Thus the new Italian iconography was compounded out of Franciscan sensibility and Oriental depth of emotion, the artists of the *trecento* contributing their own ingenuous love of life. As soon as these rich and varied themes penetrated into France, they began to exercise their attractive force and little by little to replace the more ancient motives.

*THE INFLUENCE OF THE RELIGIOUS THEATER* The religious theater of the Middle Ages, often inspired by the *Meditations on the Life of Jesus Christ*, in turn exercised a profound influence upon art. It particularly modified the costumes of the personages.

In studying the miniatures of the fourteenth century, one notices a sudden, surprising change in the treatment of the costumes of the angels toward 1380. No longer do they wear the long white robes of the thirteenth century, those beautiful, chaste tunics that belong to no country or time, but seem the very garments of eternal life. Now they are swathed in heavy, brilliantly colored capes, held together by jeweled clasps. Sometimes a thin band of gold encircles the blond hair. The angels resemble young acolytes serving an endless Mass; they prefigure the angelic musicians of van Eyck, adolescent clerics concertizing in heaven. Such are the angels in the manuscripts of the Duke of Berry, fifty years before the altarpiece of Ghent. And such were the angels in fourteenth-century plays.

I can give proof of this, if not for the fourteenth century, at least for the fifteenth: In the Book of Hours of Etienne Chevalier, Jean Fouquet had the happy idea of representing a theater. The martyrdom of Saint Apollonia is performed before us as a mystery play, much as if we were at Tours on a feast day. The scaffoldings are up for heaven, earth, and hell. Spectators, musicians, devils, tyrant, clown—everybody is in his place. While the executioners torture Saint Apollonia, the angels, seated in Paradise, look on from a distance. The angels are tiny, of course, but one of them can be seen quite distinctly; he wears the costume of a choirboy.

We may therefore be certain that the angels in fif-

teenth-century mysteries were generally so arrayed. What is true for the fifteenth century must be even truer for the fourteenth, for this ecclesiastical vestment must date back to the time when dramatic representations were more or less the concern of the clergy. Bishops and canons were eager to lend fine vestments and ornaments from their treasury, and brooches set with precious stones, in order to enhance the magnificence of the feast. This must have led to the naïve concept of dressing angels like choirboys.

Nothing must have seemed splendid enough when it came to God Himself. How was a poor actor to convey the idea of infinite power? Some majesty, at least, could be suggested by piling on His head the emblems of human sovereignty, crowns of one, two, or even three tiers. God appeared seated on the trestles of Paradise, sometimes wearing the closed crown of the emperors, sometimes bedecked with the tiara of the popes. The tiara must have been even more common than the crown, since, from the end of Charles V's reign on, we find God represented by preference in the guise of a pope. Up until that time the figure of God had retained the simplicity of the thirteenth century: seated on a backless bench, bareheaded, dressed in a plain tunic, bestowing the blessing with His right hand. One felt oneself in the presence of an ideal type, which owed nothing to reality. Toward the end of the fourteenth century came a radical change, as the painters began to take for models what they saw about them. So there arose the God-pope, or God-emperor of the fifteenth century, the imposing figure, of which van Eyck has furnished the most perfect example. Van Eyck's God, dazzling with jewels, wears the triple crown with pendants of the popes, and carries the crystal and gold scepter of the emperors.

Other particulars of costume are also to be explained

by theatrical custom. Nothing is more surprising, for those who study the windows of the late fifteenth and sixteenth centuries, than to see Jesus, during His sojourn on earth, always dressed in a purple tunic, and, after His resurrection, always clad in a cloak of flaming red. We find this all over France, and our surprise grows as we recognize the same pattern with the miniaturists. How explain this concord? One cannot assume, as in the case of the high Middle Ages, hieratic formulas imposed by the clergy. Here again one must invoke the traditions of the religious drama. A precious manuscript in the Bibliothèque Nationale preserves the text of a mystery played in the fifteenth century at Valenciennes. The text was illuminated by the painter Hubert Caillaux, who, as documents show, had painted the scenery and overseen the staging of the drama. We must allow for some play of fancy in the illumination of the manuscript, but more often than not it must reflect the actual staging. And it is a striking fact that in these miniatures Jesus is shown wearing a purple robe for the time of His human life, and a red mantle for the time thereafter.

From the end of the fourteenth century on, the Transfiguration scene shows a curious detail. Christ is clothed in white, in accordance with the Gospels, but, to convey the idea that He shines with supernatural light, the artists often paint the face of Christ a yellow-gold color. This naïve device is found quite frequently in windows of the fifteenth and sixteenth centuries. It is another relic of the religious theater. In the mystery plays, to give the effect of radiance, the face of the actor playing the part of Jesus was smudged over with yellow-gold paint. In the margin of the *Mystery of the Passion* by Arnould Gréban we read, "Here the clothes of Jesus should be white and

His face resplendent like gold," a text which is given significance when compared to the following rubric from the *Passion* of Jean Michel: "Here Jesus enters the mountain to put on the whitest of robes, and to overlay His face and His hands with gold. . . ."

The same explanation applies to several analogous traditions which otherwise would remain enigmatic. It has frequently been remarked that, beginning with the fifteenth century, the Virgin always has fine blond hair falling over a blue mantle. Miniatures and stained-glass windows offer abundant examples, and the limpid blue of the garments and the gold of the hair harmonize delightfully in the windows. These celestial colors are appropriate to the youth of the Virgin. But as years pass and trials come, the Virgin's garments change. The blue of her mantle becomes almost black, and her hair is hidden beneath a nun's coif, covered by a fold of her mantle. At the foot of the cross the Virgin appears as a widow or a religious. Her dress is a masterpiece of appropriateness; it was invented the day that it became necessary to show the Virgin upon the stage, alive and in motion before spectators.

The extraordinary garments in which fifteenth-century artists deck out the prophets are also theatrical costumes. Jeremiah and Ezekiel, who, in the fourteenth century, wore only plain tunics and Jewish skull caps, acquire high hats with upcurved brims and pendant strands of pearls. They have rich furs, jeweled belts, tasseled purses. Such bizarre attire, part of it quite unlike the fashions of the time, could only have been devised for a solemn procession or a spectacle. It reveals a desire to astonish the imagination, to call up images of things remote in space and time.

109

Thus attired, the prophets made their appearance in the manuscripts, and, before long, in Claus Sluter's "Moses Fountain" at Dijon (Pl. 24). It would seem almost certain that the "Moses Fountain" is the translation into stone of a mystery. Toward the end of the Middle Ages a strange drama was performed called the *Judgment of Jesus,* in which the Virgin pleaded the case of her Son before the judges of the Written Law, the prophets. She hoped to extract from them a favorable verdict, but the judges replied with the inexorable versets taken from their books. One after another they answered that Jesus must die for the redemption of mankind. Zachariah said, *"Appenderunt mercedem meam triginta argenteos";* David, *"Foderunt manus meas et pedes meos, numerarunt ossa";* Moses, *"Immolabit agnum multitudo filiorum Israel ad vesperam."* And so the dreadful sentences continued. Now these texts are precisely the ones that the prophets of Dijon have on their phylacteries. The grouping of six prophets, which appears only in this mystery, and the agreement of six biblical texts give our hypothesis a probability that approaches certainty. Claus Sluter's work takes on a new aspect, and in this light the melancholy or implacable faces of the prophets find an explanation—they are judges. It becomes evident at the same time that their costumes derive from the mystery.

At the beginning of the sixteenth century, the prophets display, in the windows of Auch, a regal magnificence reminiscent of the fabulous luxury of the famous *Mystery of Bourges.* In Italy the prophets appear in the same splendor—witness Perugino's frescoes in the Sala del Cambio at Perugia, and the engravings attributed to Baccio Baldini. No wonder the Pope was astonished at the sublime simplicity of the garments of Michelangelo's prophets in the Sistine Chapel; he would have preferred a lit-

tle gold. Whereupon Michelangelo said, "Holy Father, these were simple men and had small use for the riches of this world."

Much has been written about the mysteries. The art of the poets who composed them, the style, the versification, have been discussed at considerable length, though, as literature, they are of little worth. Everything but the essential has been said about the mystery plays. If they merit attention, it is not at all for their literary qualities, for in point of fact the religious dramas of the fifteenth century are poor things. But let us not judge them too severely. Their chief merit was that they inspired the greatest painters. To have suggested groupings, attitudes, costumes, and even color to Roger van der Weyden, Jean Fouquet, and Hans Memling is to have had no slight effect upon art. This amounts to saying that the *tableau vivant* was the most important element of the medieval theater. And this must have been the sentiment of the fifteenth-century public—for I should find it difficult to believe that anyone listened with much attention to the metaphysical discourses of Justice and Mercy, or to the long sermon preached by Saint John the Baptist. But to see Jesus in person, to see Him live and die and rise from the dead before their very eyes—that was what moved the crowd, even to tears.

Scholars have asked themselves innumerable questions about the stage setting of the mysteries, as if this were a problem difficult to solve. We need only to look around us. Pictures, windows, miniatures, altarpieces confront us with what people saw at the theater. In some works the imitation of theatrical scenes is even more striking, for they show simultaneous action, as did the mysteries. Memling's pictures of the Passion and of the Life of the Virgin, where we see ten different scenes set against the same

111

landscape background in which the actors of the play are shown moving ingenuously from one "mansion" to another, give us a very exact idea of what a mystery was like.

## NEW EMOTIONS: PATHOS

After long years devoted to the study of the truly holy figures that ornament the French cathedrals of the thirteenth century, the art of the fifteenth century comes almost as a shock. The instinctive question is whether the artists are still interpreting the same religion. In the thirteenth century all the luminous aspects of Christianity are reflected, goodness and gentleness and love. All the countenances seem lighted by the radiance of the Christ in the main portal. Very rarely does art concern itself with grief and death; and if it does, these are transformed into images of incomparable poetry. At Notre-Dame in Paris, Saint Stephen, expiring under the stoning of his executioners, is the image of charitable innocence. The Virgin, stretched out upon a shroud held by two angels, seems gently asleep. Even the Passion of Christ evokes no painful feelings. In the rood screen at Bourges the cross Christ carries on His shoulder to Calvary is a triumphal cross set with precious stones. The imposing Passion of Bourges has a serenity equal to that of Greek art; one is reminded of the mutilated metopes of a temple.

The essence of Christianity found its most luminous expression in thirteenth-century art, and no doctor of the Church has asserted more clearly that the secret of the Gospels, the ultimate message, was love, charity.

By the fifteenth century this celestial radiance has long since been extinguished. The majority of works left to us from the epoch are somber, art offering few images but

112

those of sorrow and death. Jesus is no longer teacher, but sufferer; or, rather, He offers His wounds and His blood as the supreme teaching. From now on we find Jesus naked, bleeding, crowned with thorns. We find the instruments of His Passion, His body laid dead upon the knees of His mother. Or, in a dark chapel, we find the figures of two men laying Him in the tomb, and women trying to hold back their tears.

It seems that the keyword to Christianity is no longer "to love," but "to suffer."

Hence the recurring subject of the age upon which we are about to enter is the Passion. The high Middle Ages rarely chose to depict any but the triumphant Christ; the thirteenth century found in the teaching Christ the subject for its greatest works; the fifteenth century saw in God the Man of Sorrows. The Passion had always been at the center of the Christian faith, but formerly the death of Christ had been a dogma that addressed itself to the intellect. Now it was a moving image that spoke to the heart.

**CHRIST SEATED UPON CALVARY** Christ upon the cross is not, however, the typical or the original subject of the period. Fifteenth-century artists created a new figure proper to their own sensibilities, a figure which is like a sorrowful summing up of the whole Passion.

Naked, exhausted, Christ is seated upon a hillock. His feet and His hands are bound with cords. The crown of thorns tears His forehead, and what blood is left in Him slowly oozes away. He seems to wait, and an unspeakable weariness fills the half-closed eyes.

This pathetic statue is to be found everywhere in France (Pl. 25) . So completely is the meaning of the past

113

lost in the present, however, that I have never seen it designated by its true name. It is called *Ecce Homo,* and sometimes an inscription lends credence to this error. For the error is manifest. Though the *Ecce Homo* as a subject is not frequent in the art of the waning Middle Ages, it does occur, but in very different form. Christ, standing, is offered up to the people, dressed in derisory purple, usually holding in His hand the reed scepter. The statue we speak of now shows Christ sitting, bereft of his cloak, with hands bound. It is manifestly another moment in the Passion that the artists have chosen, but which one?

One detail made me feel at once that the scene did not belong in the praetorium. At Salives in the Côte-d'Or, at Vénizy (Yonne), and at Saint-Pourçain (Allier), we find at the feet of the seated Christ a death's-head. In the language of religious art, the death's-head signifies Calvary; this was the first hint that the artist was depicting not the beginning but the end of the Passion. For further proof, a bas-relief at Guerbigny (Somme) shows Jesus seated upon what is unmistakably the rock of Calvary, for behind Him rises the cross, near by lies the robe which has just been torn from Him, and on the robe are the dice. It is easy to accumulate other evidence. A bas-relief at Saint-Urbain in Troyes shows the episodes of Calvary, and, just below the Crucifixion, Jesus seated, hands tied, crowned with thorns, despoiled of His robe. A window at Maizières (Aube) has a similar figure, placed between Christ carrying the cross and Christ crucified. . . .

Though its origin remains obscure, the significance of the figure is now fully apparent. Christ has already been mocked, crowned with thorns, scourged. He has carried His cross along the way to Calvary. The executioners have torn away the robe which had become like His own

flesh, stuck fast to all His wounds. Now He is sitting down, exhausted, and there remains nothing for Him but to die. In supreme derision—as though He were capable of fleeing—His hands and feet have been bound. His head falls on His shoulder, His arms are crossed on His breast, and He waits. This sitting Christ is a summing up of the Passion. He has explored all the depths of violence, ignominy, and bestiality in man.

To relate the agony of a God, to show a God exhausted, beaten, covered with bloody sweat—such an undertaking would have made the Greeks of the fifth century recoil. The heroic Greek conception of life made the notion of suffering repugnant. Suffering, which destroys the equilibrium of body and soul, was to them slavish, a disorder which art should not perpetuate. Strength, beauty, and serenity alone should be offered to the contemplation of men. Thus the work of art could become beneficent, thus art provided the city with the models of perfection toward which it should tend.

Such is the lesson that classical antiquity has taught and will teach; and it is a lesson which has given new pause to men since the Renaissance. Michelangelo, however Christian, remained under the spell of ancient heroism. His Christ carries the cross triumphantly, a beautiful athlete with no trace of suffering on His unmoved countenance. Like the Greeks, Michelangelo scorns suffering and teaches others to scorn it. Under his influence the French, about 1540, began to feel ashamed of the place they had been giving to suffering in their art. The "Christ at the Column" in Saint-Nicolas in Troyes is a hero undismayed by the outrages inflicted by slaves. The sculptor of this statue did more than imitate Michelangelo's methods—he shared in his spirit. What makes the history of

115

Renaissance art so dramatic in France and in all of Europe is that it is the history of a struggle between two life principles, two conflicting concepts.

What, in the last analysis, was the message of the Gothic masters? They affirmed the existence of suffering; and it is pointless to deny what we find woven into the warp and woof of things. Religion or art from which suffering is excluded cannot express the fullness of human nature. Even the Greeks, weary of their beautiful, unconsoling legends, began to mourn the death of Adonis with the women of Syria. Emotions long pent up forced an issue at last.

Let us beware, then, of criticizing our Christian artists. We have previously said that in giving expression to sorrow they intended to glorify grief and to proclaim that the supreme teaching of the Gospels was "to suffer." This, however, was not their ultimate thought. What they really wished to glorify was not suffering but love: they show us the suffering of a God who died for us. Suffering has meaning only when accepted with love, and when transfigured into love. Love remains the supreme lesson of Christian art in the fifteenth century, as it was in the thirteenth.

*THE PASSION OF OUR LADY* The Passion of Our Lady continued after Our Lord's Passion had come to an end. Mary is the main protagonist in the scenes to be now described. The Passion of Our Lady seen as a parallel to that of her Son is, indeed, a favorite concept of the mystics, who invariably associate the Son and His mother in their meditations. Jesus and Mary, they repeatedly affirm, are more than united in the mystery of the Passion: they become one and the same. "The sufferings of Jesus were my sufferings," says the Virgin when she appears to Saint Brigitt. "His heart was my

116

heart." At the mere thought that her Son was going to die the Virgin's womb felt torn. Men's hearts are not great enough, the mystics said, to encompass the immensity of such grief. Jean Gerson complains that he has not enough tears. And Suso asks: "Who will grant me to shed as many tears as I write letters to relate the sufferings of Our Lady?" And so, from the fourteenth century onward, to *Christi Passio* is added *Mariae Compassio,* the compassion of the Virgin, which is the echo of the Passion in her heart.

In French art of the fifteenth and sixteenth centuries, the figure of the Virgin holding the body of her Son on her knees sums up all the sufferings of Our Lady. The origin of this moving motive goes back to illustrated manuscripts, some dating as far back as 1380. The *Pitiés,* for so the group of the mother with her dead Son were called, seem to have appeared earlier in painting than in sculpture.

By the end of the fourteenth century, the treatment of the motive has become set in its main lines, and hardly varies afterwards. The Virgin, almost disappearing in a great dark mantle, is seated at the foot of the cross. Her Son's body lies upon her knees, feet rigid, right arm hanging inert and grazing the ground. With one hand the Virgin holds up the head of her Son, and with the other she clasps it against her breast.

How often we find, in the half-light of village churches, this Pietà, with its aura of inexpressible desolation. Sometimes the workmanship is admirable, more often it is rough and crude, but it never fails to move. Similar at first glance, these Pietàs reveal to the attentive observer a great variety in the expression of tenderness and sorrow. Anyone familiar with the mystics of the Middle Ages finds here the echo of all their modes of feeling.

117

In some manuscripts, the Virgin is shown holding the body of her Son upon her knees, but the body, in what at first appears as an inexplicable peculiarity, is hardly larger than that of a child, and fits entirely within the maternal lap. This is by no means artistic incompetence, for a little further on, the artist gives the body its true proportion. What he wanted to express was a thought familiar to the mystics, namely, that to the Virgin holding her Son upon her knees He must have appeared again as a child. "She believes," says Bernardin of Siena, "that the days of Bethlehem have come back. She imagines Him asleep, she rocks Him against her breast, she thinks that the shroud enveloping Him is a swaddling cloth."

Sometimes, particularly in the sculptured Pietàs, the Virgin bends over her Son's face and contemplates Him with a strange, grief-stricken avidity. Saint Brigitt writes: "She contemplates His blood-filled eyes, His beard dried stiff and hard as rope." According to Ludolph the Carthusian, "she considers the thorns which have sunk into His head, the spittle and blood which dishonor His visage. And she cannot look her fill at this spectacle." But she utters no cry, speaks not a word. To these descriptions corresponds the Pietà in Bayel (Champagne), a masterpiece of contained emotion (Pl. 26).

Elsewhere the Virgin, without looking at her Son, clasps Him with all her strength to her breast, as if putting into this embrace all of the force that was still in her. An example of this treatment is the fierce Champenoise Pietà in Mussy. The artist chose the moment when Joseph of Arimathea came to the Virgin for the body for burial. Weeping, he tells her that the hour has come and tries to take the body from her arms, but she will not allow Him to be taken from her. This is an episode often elaborated upon in the devotional literature of the fifteenth century.

Again, we find a Pietà of quite different character: In Autrèche (Touraine), the Virgin is shown praying with downcast eyes and hands folded in prayer. An admirable restraint and modesty veil her grief. Here, the beauty of the concept approaches the sublime: following a thought of Saint Bernard, the Virgin gives to the world the sacrificial example. The Pietàs of Bayel and Mussy stir emotional depths; the Pietà of Autrèche addresses itself to the highest spiritual faculties. With penetrating tenderness she teaches the fundamental tenet of Christianity: forgetfulness of self. I consider this Pietà one of the most beautiful inspirations of Christian art.

Even when the Pietàs resemble one another closely, small differences reveal individuality of thought and workmanship. Sometimes, the main attention has been given to the body; it is either rigid, or hangs over the knees "supple as a ribbon," comparable to an empty envelope whence the soul has been withdrawn. Sometimes the hair, freed of its crown of thorns, follows the movement of the head and falls in a heavy mass. A whole workshop might take up the happy inventions of a gifted artist, and if someone should one day take the pains to make a study of all the Pietàs in France, it is these little details which will make it possible to group them and, perhaps, to determine their origins.

*THE HOLY SEPULCHERS* It was in the first part of the fifteenth century, and apparently in the region of the Burgundian school, that the extraordinary, striking entombment scenes—large figures grouped around a sarcophagus—began to make their appearance. And it was in the early fifteenth century that the mystery plays first put before the eyes of the artists the enactment of entombment scenes.

119

The Holy Sepulchers of art have every appearance of being rather faithful reproductions of *tableaux vivants* (Pl. 27) . The grouping of figures, the rather bizarre costumes—hats with turned-up brims, fur robes for the old men, broad turbans for the women—all suggest theatrical attire. Ordinarily, the composition comprises seven figures. Two old men, one at either end of the sarcophagus, hold up the cadaver in its winding sheet. In the center, as is fitting for the principal figure, is the Virgin, supported by Saint John. To her right, one of the holy women stands near the head of Christ. On her left, another woman stands next to the Magdalen at the feet of Christ. . . .

Another grouping occurs almost as frequently as the first. Here, the Virgin is not placed in the center but near the head of Christ, again supported by Saint John, while the two Marys and the Magdalen stand near the feet. In both versions, the two old men hold the shroud in identical positions. . . .

Another version shows the Magdalen, either seated or kneeling, as an isolated figure facing the sarcophagus, according to the passage from Saint Matthew. This is the case at Bessey-les-Cîteaux (Côte-d'Or) , at Rosporden (Finistère) , and notably at Solesmes (Sarthe) , where the Penitent and the group accompanying her compose one of the most restrained of all images of deep grief. This last arrangement does not seem to have found great favor in France, but it was widely adopted by Flemish and German artists. . . .

Nothing could be more alien to the true spirit of the subject than agitation. In such a scene, silence imposes itself. After the horror of the Passion, the shrieks and outrages of the multitude, Jesus rests at last in the peace of half-light, surrounded by those who love Him. The great fifteenth-century artists must have felt this, and conceived

the episode not dramatically but lyrically. For now all is accomplished, nothing remains to be said or done. In silent contemplation the body is watched as it is lowered in the tomb. Withdrawn into themselves, the protagonists seem to listen each to his own heart. What unites them is only the shared grief. Even the dramatic poets of the time, elsewhere so garrulous, here fell mute. In the theater, the entombment scene was performed in silence.

## NEW EMOTIONS: HUMAN TENDERNESS

*THE VIRGIN AND CHILD*
From the end of the thirteenth century on, the artists seem no longer able to grasp the great conceptions of earlier times. Before, the Virgin enthroned held her Son with the sacerdotal gravity of the priest holding the chalice. She was the seat of the All-Powerful, "the throne of Solomon," in the language of the doctors. She seemed neither woman nor mother, because she was exalted above the sufferings and joys of life. She was the one whom God had chosen at the beginning of time to clothe His word with flesh. She was the pure thought of God. As for the Child, grave, majestic, hand raised, He was already the Master Who commands and Who teaches. So appear the Virgin and Child at the Saint Anne portal of Notre-Dame of Paris.

But at the end of the thirteenth century we come back down to earth from heaven. Everyone knows the charming gilded Virgin of the Cathedral of Amiens; but less well known are the ivory statuettes of the same period. Several are marvels of grace. The Mother and Child look at each other, and exchange a smile. It would be impossible to express a more intimate communion between two beings; it seems that they are still one, that they have not

121

yet been parted. If this pair is divine, it is only because of the depth of their tenderness. . . .

In tracing these new emotions back to their origins, one encounters again Saint Francis and his disciples. In the twelfth century, the Gospels appear above all as an idea; in the thirteenth, the Franciscans reimbue them with life. There is a gentle human warmth in the *Meditations on the Life of Jesus Christ*. All the nuances of feeling expressed by the artists of the fourteenth century are already inherent in this new apocryphal gospel: The Child Jesus sees His mother weep and tries to comfort her: "The Child at her breast put His little hand on the mouth and face of His mother and by so doing seemed to beg her to cry no more." This is exactly the gesture of the Child in the group of Jeanne d'Evreux, now at the Louvre (Pl. 28).

As for the Virgin nursing her Son, the Virgin who consoles, who embraces, and who gives her milk: "The mother leaned her face against her little Son's, nursed Him, and comforted Him in every way she could, because He cried often, like all little children, to show the misery of our humanity." Or again: "She knelt to put Him in His cradle, because she knew that He was her Saviour and her God, but with what maternal delight she kissed Him and embraced Him! . . . .How often she gazed with loving intentness on His face and on every part of His sacred body . . . with what joy she nursed Him! One can believe that in nursing Him she felt a sweetness unknown to other women" (Pl. 29).

Such a book, which Franciscan preaching soon made known throughout Europe, expanded and slackened the soul. At the beginning of the fourteenth century the atmosphere breathed by the artists was no longer the same: it had become more tepid.

## NEW ASPECTS OF THE SAINTS

The cult of the saints sheds over all the centuries of the Middle Ages its poetic enchantment. But it may well be that the saints were never better loved than during the fifteenth and sixteenth centuries, up to the eve of the day when half of the Christian world denied its old affections. The number of works of art devoted to the saints during these centuries is prodigious. In Champagne the simplest village church exhibits even today two or three statues of saints, two or three legendary windows, delicate works of the waning Middle Ages. And so it was throughout France. Where the works of art themselves have disappeared there are documents to tell of them.

Saints were everywhere in those days. Sculptured at the gates of the city, they confronted the enemy and defended the town. Every tower of Amiens had its saint: Saint Michael, Saint Peter, Saint Christopher, Saint Sebastian, Saint Barbara, Saint Margaret, and Saint Nicholas stood as sentinels. A saint's statue was as useful to a château-fort as well-placed loopholes. The frivolous Duke of Orléans had tricked out Pierrefonds with statues of heroes, and small good came of it, while, better advised, the Duke of Bourbon had equipped three towers of his castle of Chantelle with images of Saint Peter, Saint Anne, and Saint Susanna.

The burgher had no towers to defend, but his wooden house needed protection all the same. Fire, plague, sickness, and death had to be kept at bay. And so the façades of medieval houses often show more images of saints than an altarpiece. A house at Luynes has, along with an image

of the Virgin, one of Genevieve, patron saint of the city, and another of Saint James, always mindful of those who undertook the great pilgrimage to his shrine. These enchanting houses are becoming increasingly rare—even in Rouen only a few are left. The streets in such great Gothic cities as Paris, Rouen, and Troyes must have been an impressive sight. Not only did each dwelling display its gallery of saints, but the signboards swaying in the wind added considerably to the number of Saint Martins and Saint Georges and Saint Elois. The cathedral that scaled the heavens above the rooftops did not carry a richer load of blessed souls.

In the villages the saints were less numerous, but venerated with equal fervor, and the image of the patron saint of a church was regarded as a precious talisman. In the provinces of central France the statue of the patron saint was sold under the porch of the church on his feast day to the highest bidder. The "king" of the auction became for a few hours the master of the holy image and carried it off to his house, where it brought good luck. The honor of carrying the statue, the relics, and the banner of the saint during processions was warmly disputed, and in the pilgrimage churches rival parishes sometimes fought bloody battles about the shrine.

In this ancient, rustic France the saints were associated with the fragrance of orchards, much to the increase of their power over the human heart. As the blossoming time of the vines approached, it was the custom in Bourbonnais to carry the equestrian statue of Saint George through the vineyards, and to wash the feet of his horse with wine. In Anjou, on the twenty-third of April, Saint George was implored to set the fruit of the cherry tree.

The aspect of the saints changes surprisingly about the beginning of the fifteenth century. Two hundred years

earlier they had worn long tunics—simple, noble garments that lent them majesty and a quality of timelessness. Now it seems that the saints, so long remote, graciously approach humanity. They adopt the fashions of the reign of Charles VII, of Louis XI, and of Louis XII. Jean Fouquet's Saint Martin is a youthful knight just back from fighting the English, and who has helped his King to reconquer France. The marvelous Saint Adrian in the window at Conches, a young soldier with fair hair, could be a hero of the Italian Wars; it is from Milan, perhaps, that he has brought the jewel that flashes in his cap.

Saint Cosmas and Saint Damian become, in the Book of Hours of Anne of Brittany, two physicians of the Paris faculty. On their heads they wear little skullcaps, or sometimes hoods, and they have good thick coats for winter. There is no elegance about their dress. They are even too busy to shave every day. Cosmas and Damian are two hard-working doctors, somewhat scarred by life, a little gruff but well-meaning and sufficiently accessible.

Saint Crispin and Saint Crispinian, whom we find in a sculptured group at Saint-Pantaléon in Troyes, are two young shoemakers working together in their shop. One of them is peacefully cutting up leather and the other is stitching on soles when two hulking soldiers, bearded and mustachioed, dressed in slashed jerkins like Swiss mercenaries, enter and lay heavy hands on their shoulders. Here are two saints with whom the shoemakers of Troyes could feel perfectly at home. They could look with knowing approval at the stool, the hatchet, the bucket, and the little dog curled up beneath the workbench.

Never were artists more familiar in their treatment of the saints than in the time of Louis XII and François I. They would have liked to bring even the garments of the apostles up to date, we may be sure, but this they did not

125

dare do on any great scale. The sculptor of Chantelle does embroider the hem of Saint Peter's tunic, however, and Leprince, in an admirable window at the Cathedral of Beauvais, gives Saint Paul the great two-handled sword of the Battle of Marignan. Greater liberty was taken with the evangelists. In the Book of Hours of Anne of Brittany, Jean Bourdichon had Saint Mark looking exactly like an old and very comfortable notary. Seated in a rich study, dressed in a fine fur-trimmed robe, and wearing a skullcap, he is about to draw up some inventory or other.

One after another the secondary characters of the Gospel story abandon the traditional tunic. In Jean Bourdichon's Book of Hours of the Arsenal, Joseph, in the Flight to Egypt, is shown in the guise of a wandering journeyman. He wears a skullcap, has a sack on his shoulder and a big staff in his hand. Boldest of all, however, is the statue of Saint Joseph now in Notre-Dame at Verneuil—the living image of a young carpenter of the time of Louis XII. In short costume, a rose in his cap, tool bag at his waist, he carries the broad hatchet, the emblem of his trade. Except for the legendary flowering scepter of Saint Joseph which he carries and the little Child at his feet, no one would dream of associating him with the husband of Mary. It is hardly necessary to add that Saint Anne becomes a grave matron with wimple and cornet and Saint Elizabeth, the Virgin's cousin, a young burgess with her keys at her belt.

The painters, with their language richer and more varied than that of the sculptors, take quite charming liberties. Fouquet and Bourdichon would like to have us believe that every saint in the calendar lived in Touraine. Saint Anne, we should conclude from Fouquet's paintings, lived in a rose-grown garden within sight of the

church towers of Tours. It was on the Quai de Chinon that Saint Martin divided his cloak with the beggar; and, if we are to believe Bourdichon, Saint Joseph did not take the Child into Egypt but into a pretty Indre valley with ancient manor houses on the heights.

All these saints who seem to live and breathe now in France and who are completely French in their dress have become even more Gallic as regards their features. This is particularly true of female saints, not one of whom, I believe, would have been considered beautiful by the Italians. What claim to great art have these little peasants of Touraine, of Bourbonnais, with their round faces and snub noses? They make no such claim, of course, and therein lies their charm for us today. One of the prettiest is the Magdalen of Saint-Pierre at Montluçon—a mere girl, slender-waisted, almost a child (Pl. 30). Soon this charming round face will become heavier, the narrow waist thicken—but for one blissful instant the young saint is virginal loveliness incarnate. The Italian beauty at an early hour lays claim to the infinite duration of an essence, an idea. The beauty of the French saints, like that of the young French peasant girls, flowers only for an instant: their charm is that much more touching. French beauty has always been one of expression, and can therefore never convey the impression of permanence:

*Toujours sa beauté renouvelle,*

says Charles d'Orléans of the woman he loves. The same is true of the young French saints.

This little world of saints had an infinite charm for the men of the time. In their familiar guise they were no doubt less respected than they were loved; but their powers of persuasion may have been all the greater. "Saint

Yves over there, with the magistrate's cap, the robe, and the dossier in hand—why, he was a man just like me," the lawyer might say. "So it is possible in our profession to be unselfish now and then." In the same way the shoemaker was sure to pay good attention to counsel given him in the name of a saint wearing the same kind of apron that he wore himself.

The charm was broken the day that the Italians taught the grand style to the peoples farther north; then the saints bade adieu to humanity and ascended again into heaven. The heroes and philosophers of antiquity who now represented Saint Peter or Saint James had no message for anybody. Where did they come from, these men with the pure profiles, the great cloaks, the dominating air? No one knew, and probably no one cared very much. Except, of course, the scholar. The humanist strolling about Saint-Etienne in Troyes could observe with satisfaction that the recently sculptured "Meeting of Saint Anne and Saint Joachim" might have done very well as a "Last Interview of Portia and Brutus."

After 1348, when the plague began periodically to devastate France, there were new and powerful reasons for having recourse to the saints. The plague descended at the very moment when gunpowder was invented, giving mankind two new prospects of sudden death. After the terrible year of 1348, when, according to Froissart, "the third part of humanity died," the plague stayed with France. Sometimes it abated; the fifteenth lived less in fear of it than the fourteenth. But in the early days of the sixteenth it broke out with renewed violence. Most terrifying was the suddenness of its attack: well and alive one day, one was dead the next. The Black Death was even more redoubtable than instant death, for one might ask for a priest and fail to get one. The sick man knew that

within a few hours he must appear before God burdened by all his sins, and yet often nothing could be done for his salvation.

We can form no adequate conception of the dread that paralyzed the cities during the epidemic of the sixteenth century. Life came to a standstill. In the streets of Rouen nothing was to be seen but the sinister tumbrel painted black and white. So-called "servants of danger" went from one quarter to another, entered the houses marked by a white cross, brought out the corpses and threw them into a cart. After a while the citizens could no longer bear the sight of the dreadful procession—a girl died simply from the terror of hearing it come—and they decided that the plague-stricken should be carried off during the night. So the cart wheels ground up to Saint-Maur Cemetery in the glare of torches. Ten paces ahead walked a priest, breathing through a perfume ball. The procession passed by dimly lit churches where people prayed all night long. Once inside the enclosure, where there were no monuments or tombstones of any kind, the "servants"—sometimes they were monks—hurriedly threw the bodies into a ditch, covering them with so little earth that wolves often came the next night to dig them up again.

Human knowledge was helpless. Some celestial protector had to be found, and popular piety knew of several protectors: Saint Sebastian, Saint Adrian, Saint Anthony, and, most celebrated of all, Saint Roch.

*SAINT ROCH* The most recent and most powerful of protectors had lived in the fourteenth century, at the time when the great epidemics were beginning. He was a saint of the kind most beloved in France, not a contemplative but a man of action. Saint Roch was born in Montpellier, which belonged at that time to the

129

King of Majorca. As soon as he had grown to manhood he set out on a pilgrimage for Rome. On the old road through Tuscany—the same still taken by mail coaches in the nineteenth century—at Aquapendente, he encountered the plague, and instead of fleeing, as anyone else might have done, he stopped and nursed the sick. The plague having subsided, he was on the point of leaving for Rome when he learned that it had just broken out at Cesena. Saint Roch made straight for that place. Then, following the epidemic stage by stage, he went first to Rimini, then to Rome. The holy city was at that time supremely desolate. Bereft of the popes, half empty, unearthly silent, and ravaged by the plague, it was little more than an enormous tomb. Saint Roch stayed there three years. When he left for France the plague had attacked northern Italy; Saint Roch followed it. He was tending the stricken at Piacenza when he was himself attacked by the malady. Hiding himself in a wood, he awaited death calmly; and here legend merges with history. In those melancholy ages when reality was so somber and man so harsh, it was frequently the animals that took pity; and as a doe nourished Genevieve of Brabant, so a dog brought a loaf of bread every day to Saint Roch. He was able to keep alive, to get well, and eventually to return to France. But at Montpellier no one recognized the emaciated pilgrim who looked like a beggar. Suspected of being a spy, he was thrown into prison, where he stayed five years. One morning the jailor found him dead; but he noticed that the dungeon was lit up by an unearthly light.

Thus died a young man, at the age of thirty-two, without wife or child, without fortune or achievement, denied by his own people, and whose whole life had been made up of devotion to others. When men heard his story they

became pensive. It seemed right that God should have given some reward to His servant. So the story was told that an angel had brought down a tablet to the cell of Saint Roch, and on the tablet it was written that this man was a saint, and that God would save from the plague all who should invoke Him in the name of Saint Roch.

The cult of Saint Roch, already extensive in the fourteenth century, spread throughout Europe in the fifteenth. In 1414 the bishops, gathered at Constance to halt the plague which was devastating the city, organized a procession in honor of Saint Roch. From that time on we find him invoked in every country. He inspired such confidence in Italy that the Venetians stole his relics at Montpellier and built in their honor the Church of San Rocco and the famous Scuola which Tintoretto decorated.

The French persevered in their cult of Saint Roch. In the sixteenth century the great epidemics gave rise to confraternities of Saint Roch everywhere, including the smallest villages. Bourbonnais alone had one hundred and fourteen parishes honoring Saint Roch with special devotions. His power extended even to animals. On his feast day, August 16, blessings were said over the herbs, mint, pennyroyal, and rocket, which, mixed with the food of cattle, kept them safe from contagious diseases. . . .

For the artists, Saint Roch had many attractions: He combined the romantic appeal of the voyager and the hero. It was generally agreed that the noble youth was handsome. His portrait was preserved at Piacenza; it had been painted, people said, by a nobleman whom Saint Roch's example had converted and who became famous in his own right under the name of Saint Gothard. The portrait still existed in the seventeenth century. It showed a man short of stature but gentle and gracious of face. His hair falling in long curls, his slightly reddish beard gave

him the air of an apostle; his hands, which had tended so many of the suffering, were delicately shaped. Whether the portrait had any authenticity or not, it served as a model for other artists—for the sculptor of the chapel of Saint-Gilles at Troyes, among others, and for Jean Bellegambe's picture in the Cathedral of Arras. It was believed that such exalted charity would put its mark on the features and make men resemble Jesus or at least His apostles. Saint Roch was therefore made to resemble Saint James both as to features and dress; he was given hat, coat, staff, and scrip—everything that stood for journeyings and adventures, for exposure to storms and the heat of the sun. In Troyes, two keys engraved on his cloak serve as a reminder that he was on his way to the city of the Prince of the Apostles.

However, some traits specifically his own distinguish Saint Roch from Saint James. One leg is left bare and shows a deep wound, as though an arrow had just been extricated. To the popular imagination, the plague was an arrow loosed by the hand of God. An angel descends to Saint Roch, with delicate touch joins the lips of the wound and anoints it with heavenly ointment. This is the angel who, according to legend, was sent by God to heal Saint Roch. Then there is the good dog by the saint's side, sometimes with the loaf of bread in his muzzle. . . .

*THE VIRGIN* Of all holy men and women the Virgin was the most honored and the most loved. Art exalted her above all creatures, and conceived her as an eternal thought of God. And the men of the Middle Ages loved the Virgin with a disinterested love— they did not beseech her incessantly for miracles. They conceived of her as a sublime idea, in which the soul and the heart may forever discover new wonders. Her purity

132

in particular was the eternal subject of the solitary's conversation with himself. Womankind, fallen, fragile, and dangerous, stood forth perfect and spotless in the celestial essence of womanhood, worthy of infinite love. The monk who fled women found in his monastery the Virgin.

In the latter centuries of the Middle Ages the religious orders contributed most to the exaltation of the Virgin. Each monastery had its poet as it had its bell for sounding the angelus, and the many thousands of prose pieces, hymns, and little poems, which have been collected in our day, were written mostly by monks. Many of these works are repetitions of established formulas, but some reflect the ethereal conception of the universe which was that of the cloister. Inside monastery walls the world was spiritualized by the habit of contemplation; realities trembled, dissolved, and evaporated in prayers. The perfumes which mounted from flowers were likened to virtues—modesty, charity, forgetfulness of self. Since he was always meditating on the Virgin, the monk saw her everywhere. The clear spring in the cloister was her purity. The high mountain which closed off the horizon was her grandeur. She was the springtime, coming adorned with a garland of flowers that was a garland of virtues. When the monk stepped out of the monastery all the magnificent things he saw about him were only diminished aspects of the beauty he contemplated in the Virgin. She was the field of grain nourishing within us the bread of eternity, she was the rainbow colored by a ray of God's evening, she was the star from which a drop of dew falls upon our interior aridity. . . .

In the early years of the sixteenth century there appeared in France a touchingly poetic figure of the Virgin as a girl, almost a child, in the attitude that Michelangelo gave to Eve at the moment of her appearance upon earth,

hands clasped in adoration. The young Virgin seems suspended between heaven and earth, wavering like a thought still unexpressed, as yet only an idea within the mind of God. Above her God pronounces the words of the *Canticle of Canticles: Tota pulchra es, amica mea, et macula non est in te.* And to adorn still further the beauty and candor of the spouse that God has chosen, the artist visualizes the suavest metaphors of the Bible: the enclosed garden, the tower of David, the fountain, the lilies of the valley, the star, the rose, the mirror without stain. Everything most admired by man becomes a reflection of the Virgin's beauty.

Such imagery is the outgrowth of a long development extremely interesting to analyze. For several centuries the doctors of the Church had identified the Virgin with the Sulamite in the *Canticle of Canticles.* This ancient love poem, impregnated with a thousand perfumes, burning and sultry as Syria, had become, in the Christian commentaries, as virginal as the summits of the Alps. The beloved "whose hands drop myrrh on the bolt of the door, whose garments smell of frankincense," is the Virgin Mary, mother of the Saviour.

One of the most mystical books of the fifteenth century, the *Canticle of Canticles* illustrated with woodcuts, had made these metaphors and similes almost popular. The Bridegroom is the Lord Himself, conceived as a candid adolescent. The most ardent words are translated into the language of the soul, and the contrast between text and illustrations is at times so sharp that it has the impact of great poetry. "A bundle of myrrh is my beloved," says the text, "he shall abide between my breasts." And the engraving shows us the Virgin standing, clasping to her breast her crucified Son. The spirit of the illustrated *Canticle of Canticles* is exactly that of the monastic poetry

134

written in honor of the Virgin. Both, to use the language of Saint Francis of Assisi, are chaste as water.

Like the concept of the girl-Virgin, the grouping of the biblical emblems around Our Lady was also the slow growth of time. Long before, the liturgical writers had chosen the most beautiful biblical metaphors for the adornment of the offices of the Virgin. "Star of the sea," "closed garden," "rose without thorns"—all the lovely biblical phrases came to compose together the richest of ornaments, the most marvelous of diadems:

> *Botrus, uva, favus, hortus,*
> *Thalamus, triclinium.*
> *Arca, navis, aura, portus,*
> *Luna, lampas, atrium.*

> Grape and cluster, honey, garden,
> Marriage bed and banquet-room,
> Ark and ship and breeze and haven,
> Moon and lamp and coming home.

So reads the Missal of Evreux. All the missals convey the same mild music by whole columns of nouns: flowers, perfumes, precious metals, colors, honeycombs, all that is most delicious in nature. The most delicate poets of later times have not been more sensitive to the enchantment of words. Thus, the litanies of the Virgin, which, in their present form, did not appear until 1576, have a distant origin. These beautiful words were recited perhaps less for the sake of a specific prayer than for the solace the words alone brought to the heart.

It certainly took ingenuity to create these metaphors, depict them, and surround with them the Beloved of the *Canticle of Canticles.*

## THE NEW SYMBOLISM

*THE SIBYLS*   In the Middle Ages Christ was announced by the prophets, and sometimes by sibyls. With the Renaissance, the rebirth of the ideas and forms of antiquity, the pagan figures predominate, and form part of vast cyclical works like the windows of the Cathedral of Auch.

No other work of that period can compare in amplitude of concept with the windows of Auch. They are designed as follows:

The first window shows the creation, followed by the fall. Adam tills the soil; Cain slays Abel; labor and death penetrate into the world as a result of the first sin.

Then the history of the world unfolds:

First come the patriarchs, Noah, Abraham, Isaac, Jacob, Joseph, the distant forebears of the Messiah. They are followed by the prophets who announce the Messiah to God's chosen people. Next come the sibyls, who foretell the same event among the pagans. Finally come the apostles, who go to the ends of the earth preaching the doctrine of the God Whom we see dying on the cross in the last window.

The windows of Auch tell after their own fashion the history of the world, establishing an inner harmony within history. Each window unites within its divisions a patriarch, a prophet, a sibyl, and an apostle—the different ages of the world meeting and joining.

The analogy between the windows of Auch and the ceiling of the Sistine Chapel is striking. Both works demonstrate the same conception of history. It is true that the apostles are missing in the Sistine Chapel, the work of

Michelangelo being strictly prophetic, giving an impression of a great awaiting. But in the Sistine Chapel as at Auch we see the creation of the world, the creation of man and woman, the fall, the story of the patriarchs, the ancestors of Jesus Christ according to the flesh, and finally His ancestors according to the spirit, that is to say the prophets and the sibyls. The analogy is complete. We cannot suppose that Arnaud de Moles, artist of the windows at Auch, knew the frescoes of Michelangelo; moreover, the two works are exactly contemporary. They are simply evidence of the rapid diffusion of the ideas of the humanists.

Even today these sybils are strangely moving. Asia and Africa, Greece and Italy speak through their mouths. From Persia to the Hellespont, from the Hellespont to Cumae, from Cumae to Libya, they form a circle about the cradle of Christ. At Samos, the home of Anacreon, at Tibur, the home of Horace, they announce an unknown God. The Erythraean Sybil of Ionia, who spoke to the Atrides, proclaims that a virgin shall give birth. The Sybil of Cumae, guardian of the magic bough and of the gate to the dead, writes upon leaves which the wind disperses that a child will descend from heaven. The beautiful priestess of Apollo, seated upon the sacred tripod, the Sibyl of Delphi, carries in one hand the crown of thorns; this, then, is the ultimate revelation of the Pythia, the secret of "the word of the golden hope," as Sophocles writes in the first chorus of *Oedipus Rex*. A God will come, and He shall die, and He shall be greater than the immortals.

Such thoughts, which come to us today before the imposing Sibyls of the Cathedrals of Auch and Beauvais, must have been intensely present in humanistic minds of the sixteenth century. And what does it matter if their

137

pronouncements were an invention of the fifteenth century! The truths that they express do not depend on a few obscure phrases. They teach that the pagan world had presentiments of Christianity. They recall to us that Plato defined virtue as "the imitation of God," that Sophocles spoke of the laws which are superior to the laws of men, that Virgil placed in the Elysian fields along with the poets and the heroes "those who love others," and that, in all of his prophetic work,

*L'aube de Bethléem blanchit le front de Rome.*

THE "WINDOW OF CHARIOTS" AT SAINT VINCENT IN ROUEN — The art of Italy had conceived the history of Christianity as a triumph. French artists in their turn were happily inspired by this conception, as the "Window of Chariots" at Saint-Vincent in Rouen demonstrates.

Once more we have a history of the Fall and the Redemption: a woman looses all the sins upon the world, and another woman brings back into the world all virtues.

First comes the earthly Paradise, the gracious dream of an artist-poet. Within a vast wild park, where lambs graze next to lions, where flights of birds pass overhead, a splendid procession advances. On a golden chariot sit Adam and Eve, chaste and nude; before and behind them walk the Virtues in the form of maidens.

Below the Paradise, we see the consequences of original sin: Evil triumphant. This time the serpent, with a woman's bust, rides in the chariot. Wound around the trunk of a tree and floating overhead is a standard bearing the image of death: the blazon of the new king of this world. Adam and Eve, hands tied and heads bowed, walk before their conqueror. Toil and Grief accompany them,

and behind the chariot comes the procession of Vices in derisive pomp. Women are mounted lasciviously on symbolical beasts. The standard marked with the image of Justice, which Adam carried in the earthly Paradise, is now in their hands. Only, with a satanic irony, they have reversed the banner, so that Justice stands on her head.

Another triumph succeeds the demonic triumph, as the innocence of the first days returns. Once more purity and suavity are dominant. The Virgin, the Regenerate Eve, is now seated upon the golden chariot. Flying angels precede and announce her; a solemn procession of prophets and patriarchs walks before her. A banner adorned with a white dove floats in the sky, and, behind the chariot, comes a devout throng that seems to meditate upon the inscription, *Tota pulchra es, amica mea, et macula non est in te.*

Everything about the "Window of Chariots" is a delight —the purity of design, the freshness of the colors like a bouquet of wildflowers, red poppy, cornflower, buttercup, and purple clover, and the pale blue backgrounds with the outlines of cathedrals breaking through. The artist must have seen some Italian engravings, for his Virtues are related to the dancing nymphs of Mantegna, and his triumphal chariots are reminiscent of the engravings of Baccio Baldini. Nonetheless his work is perfectly original, and unique in its kind.

## ART AND HUMAN DESTINY

Having celebrated Christ, the Virgin, and the saints, the art of the waning Middle Ages turns to man himself and speaks of Christian duties. We are shown Vices and Virtues, Death, Rewards, and Punishments. The following excerpts concern the role of death in art.

*DEATH IN ART*     The thirteenth century treated death with unique restraint. Some of the figures graven upon the funeral stones or laid out upon the tombs seem the epitome of purity and grace. Hands clasped, eyes open, young and transfigured, they seemed to participate already in eternal life.

But at the end of the fourteenth century death is suddenly revealed in all its horror. A funeral statue in the episcopal chapel at Laon shows how much the mind and mood of man have changed. It is a corpse in a state of mummification rather than of decay. The poor figure, half mummy, half skeleton, hides its nudity with fleshless hands. The distress, the abandonment, the nothingness of this dead man are beyond description. Guillaume de Harcigny, an illustrious physician of the fourteenth century, was the man who wished thus to be shown on the outside of his tomb, somewhat as he was inside it. A pupil of the Arabs and of the Italian school, Harcigny was reputed the cleverest man of his time. He attended Charles VI at the beginning of his madness and calmed the violence of his first attacks. Harcigny died in 1393; his tomb was no doubt begun immediately, and the statue cannot have been finished much later than 1394.

In 1402 Cardinal Lagrange died at Avignon. He had

desired two tombs, one for his flesh at Amiens, another for his bones at Avignon. Of the tomb at Avignon only a few fragments remain, one of the most interesting being a bas-relief representing a corpse—the Cardinal himself, dried up, mummified, like Guillaume de Harcigny (Pl. 31). But this time the dead man speaks out. We can read on a banderole the harsh words that he ordered set down in Latin: "Wretch, what reason hast thou to be proud? Ashes thou art, and soon thou wilt be like me, a fetid corpse, feeding-ground for worms." Thus in the age of Charles VI, at the moment when art abandons most of its ancient traditions, cadavers are set before us in all their repulsive ugliness.

The image of death appears a little later in the manuscripts. It was during the first half of the fifteenth century that death began to inspire the miniaturists; before that time I have found only a few timid, unrealistic images which give no feeling of terror. About 1410 or 1415, however, one of the illuminators for the Duke of Berry painted a truly formidable figure of Death. It is a dried-out corpse, a black mummy draped in a white shroud, brandishing a dart, and on the point of striking an elegant, unsuspecting young man. We cannot help remembering the awful vision that appeared to the Duke of Orléans a few days before his assassination.

About the same time, an unknown miniaturist illuminated the admirable Book of Hours of the Rohans. A man of powerful and somber imagination, he was at once appalled and fascinated by death. In eight successive miniatures he expresses his horror and fear. First we see a funeral procession, and monks praying around a coffin. Then gravediggers dig the grave in an old church, throwing up with each stroke of the pick the bones of the ancient dead. Terrible and mysterious scenes follow: The

dying man lies on his bed, his wife and son beside him, holding him by the hands in an effort to keep him back. But the moribund, rigid with horror, stares before him at something which he alone can see—a tall black mummy which is just entering with a coffin on its shoulder. Further on, a coffin lies on a trestle in the center of a cloister. Of its own accord it comes open and the livid face of a dead man peers out. Next, the dead man, naked and stiff, is stretched out on the ground, among bones and skulls, on the black burial cloth with the red cross. In the sky God the Father, sword in hand, shows His terror-inspiring visage. The hour of judgment has come. Praying is no longer of any use. However, while the angel and the demon dispute his soul, the wretched man still dares to hope, and a supplication inscribed on a banderole issues from his mouth (Pl. 32). Nothing in the art of preceding centuries had foreshadowed these frightening images.

Thus in the early years of the fifteenth century Death seems to have become the great inspiring force. In 1425 the Dance of Death is painted in Paris at the Cemetery of the Innocents, and all through the century similar works appear throughout Europe. The old legend of the Three Dead and the Three Living enters into art and becomes one of the favorite subjects of mural painting and miniature. In the fifteenth century the image of death is everywhere.

*THE DANCE OF DEATH* One of the most memorable sites in a city heavy with memories is the old sixteenth-century cemetery in Rouen, the Aître Saint-Maclou. The hallowed earth in which so many generations slept that at one time the slightest rain uncovered thousands of little white pebbles—which were teeth—is now the playground of an elementary school.

The living colors of the greenery, the groups of little girls playing at recess, make so strong a contrast with the surroundings that we feel more profoundly moved than when in the presence of a sublime work of art. Life and death have never been set face to face more naïvely. All around the cemetery there runs a cloister surmounted by a charnel house, which once upon a time held the bones of the dead who were dispossessed of their graves by new corpses. A carved wooden frieze decorates each story of the cloister. Tibiae, vertebrae, pelvic bones, coffins, the gravedigger's shovel, the priest's aspergillum, the acolyte's bell, are woven into a funeral garland. Each column of the cloister is ornamented with a group in relief, in which we recognize or rather divine the couples of a Dance of Death. A cadaver issuing from the tomb snatches by the hand the pope, the emperor, the king, the bishop, the monk, the countryman, and drags them briskly off. The shortness of life, uncertainty of the morrow, the vanity of power and glory—such are the verities proclaimed by the Dance of Death. Evoked in the proximity of the charnel house, these ideas sank deep into the general mind.

Even more impressive must have been the Dance of Death at the Cemetery of the Innocents in Paris. In the fifteenth century this burial place, old, and where so many dead had rested, was venerated as something sacred. A bishop of Paris who could not be buried there requested in his will that a bit of earth from the Cemetery of the Innocents be placed in his grave. As it was, the dead could not repose there for long. They had to make way for new-comers, for twenty parishes had right of burial in the narrow enclosure. Moreover, at that time there was perfect equality among the dead; the rich were not, as now, privileged even after death. When the time came their tombstones were sold and their bones were thrown into

the charnel house on top of the cloister. Countless name-less skulls showed through the openings, and the *maître des requêtes,* as Villon says, was no longer distinguishable from the *porte-panier.* . . . Over against the Church of the Holy Innocents was the cell of the recluse, walled in her prison like the dead in their tombs. In a hollow pillar was the lamp lit up at night to keep away ghosts and "the thing that walks in shadows." The legend of the Three Dead and the Three Living was sculptured on the church door. Most impressive of all, however, was the Dance of Death on the cloister walls.

The Dance of Death, here encountered for the first time, has its origin in the remote past; we find intimations of it in the twelfth-century verses of Hélinand. The figure of Death, which goes to Rome to seek out the cardinals, to Rheims for the archbishop, to Beauvais for the bishop, who lays hold of the poor man, the usurer, the youth, the child,

*la main qui tout agrape,*

the hand that seizes all,

as the poet calls it, already seems to lead the Dance of Death. And in the fourteenth century, the concept of a procession in which the human conditions march toward death emerges clearly. . . .

The Dance of Death in the Cemetery of the Innocents was the earliest known painting of this kind. The *Journal d'un bourgeois de Paris* records its date exactly: "In the year 1424 the Dance of Death was done at the Innocents, begun about the month of August and finished the follow-ing Lent." Unfortunately, this oldest example has been destroyed. In the seventeenth century, when one of the neighboring streets was broadened, the charnel house

next to the cemetery was torn down and the fresco disappeared without any artist having so much as taken the trouble to make a copy.

We can, however, arrive at a rather exact conception of what the work was like. Two manuscripts from Saint-Victor now in the Bibliothèque Nationale record a long dialogue in verse between the living and the dead. In the front matter of both volumes, in both tables of contents, we find the following rubric, corresponding to the folio of the page on which the dialogue begins: "The verses of the Dance of Death as they are at the Cemetery of the Innocents." Beyond any doubt, we have here an authentic copy of the verses which were inscribed beneath the figures of the fresco. The two manuscripts from Saint-Victor appear to date from the first half of the fifteenth century and indeed from a time very little later than that of the picture. The verses were transcribed in all their newness by some monk of the Abbey of Saint-Victor.

Thanks to the manuscripts from Saint-Victor (which agree exactly) we know the names of the figures painted by the artist, their number and their sequence. However, there is more we can learn about them.

Guyot Marchant, the Parisian printer, published in 1485 the first edition of his *Dance of Death,* in which wood engravings of the finest quality serve to illustrate a dialogue between the living and the dead (Pls. 33, 34). The verses accompanying the engravings are identical with those of the two manuscripts from Saint-Victor. Guyot Marchant has simply copied the inscriptions of the Cemetery of the Innocents.

If he copied the verses, is it not probable that he copied the figures too? And might his famous engravings not be, purely and simply, a reproduction of the Dance of Death begun in 1424 and finished in 1425?

145

In my opinion the *Dance of Death* of Guyot Marchant is modeled on the Dance of Death which once existed at the Cemetery of the Innocents; but I do not believe that it is a slavish copy. In the first place, the clothing has been brought up to date, several figures being dressed according to the fashions of the reign of Charles VIII. The square-toed shoes, for example, are of the latter epoch rather than of 1424. During the early part of the century and as late as 1480 boots with very pointed toes, called *à la poulaine*, "ship's head shoes," were the rule. Further, I noticed that one of the engravings does not exactly fit the accompanying text. In Marchant's book the sergeant-at-arms is dragged along by a single cadaver, whereas in the Cemetery of the Innocents he must have been held between two corpses.

*Je suis pris de ça et de la,*

I am caught from this side and that,

as the text says.

On the other hand, it is evident that several traits are faithfully reproduced from the original. The emperor, for example, carries in his hand the round globe of the world. The text has him say,

*Laisser faut la pomme d'or ronde.*

I must leave the round gold globe.

The archbishop, brusquely accosted by Death, throws his head backward. Which is precisely the attitude indicated by the verses,

*Que vous tirez la tête arrière,*
*Archevêque!*

How you pull your head back, Archbishop!

146

the dead man mocks him. And we could point out other corresponding cases.

Let us, then, accept the engravings of Guyot Marchant as a fairly free imitation of the fresco in the Cemetery of the Innocents and, lacking the original, study the copy. There are thirty couples, each living man led by a corpse. Who is the strange companion? Is it Death personified thirty times over? That is the common opinion, which, however, errs. The two manuscripts from Saint-Victor do not call this figure "Death" but "the dead man," and so does Guyot Marchant. The couple is composed, as the text for the *Dance of Death* declares explicitly, "of one dead man and one living." The dead man is the double of the living: He is the image of what the living will soon become. . . .

In the fifteenth century the dead of the Dance of Death are not skeletons but desiccated corpses. Certain soils having the property of preserving the dead, we can still see in the gloom of the crypts of Saint-Michel in Bordeaux and Saint-Bonnet-le-Château, hideous mummies turned into parchment by long sojourn in clay. Such monstrous sights were exhibited in several places toward the end of the Middle Ages, and served the artists as models. A mummified corpse is more horrifying than a skeleton, as it seems to be animated by a gruesome life of its own. These larvae dancing and hopping on one foot are extremely lifelike. They might be skinny students without paunch or calf. The mummies of the Dance of Death are scarcely leaner than Pigalle's Voltaire, and have the same grin. They are coquettish, drape their shrouds as if they were shawls, modestly hide genitals which they no longer possess. Often they are insinuating, persuasive, pass an arm familiarly through the arm of their victim, and hop as though keeping step to the shrill music of a fife.

147

The irony of the cadaver, the huge laughter of jaws without teeth, the whole atrocious gaiety which the painters caught so aptly, is also expressed by the poet, with even greater trenchancy. The verses of the *Dance of Death* stun with their harshness and cruelty. The sermon of former times has turned into a satire. To the pastor "who devoured the living and the dead" the poet declares with a ferocious joy that he will henceforth be devoured by worms. The abbot is grossly insulted: "Recommend the abbey to God," his companion tells him. "It made you big and fat. The better to rot." The bailiff is addressed in a menacing tone. "That you may make accounting for your deeds, I leave you to the great judge." But often the dead man prefers raillery to tragedy. He pokes fun at the bourgeois who will have to give up his revenues, at the physician who cannot heal himself, at the astrologer who searched for his destiny in the stars, at the solemn Carthusian who is likewise going to join the dance.

> *Chartreux . . .*
> *Faites-vous valoir à la dance!*

> Carthusian . . .
> Show thy prowess, join the dance!

Only for the poor countryman does the specter show a trace of compassion:

> *Laboureur qui en soing et peine*
> *Avez vécu tout votre temps,*
> *De mort devez être content,*
> *Car de grand soucy vous délivre.*

> Glebesman, thou thy life hast spent
> Always in toil and poverty.
> Death to thee should welcome be,
> From thy woes to set thee free.

Through all this speaks a society in which abuses have

become serious, in which the privileged are coming to be severely judged. Death, fortunately, is the same for all; through death, order is re-established. And yet the old society is still quite solid, apparently unshakable. The living advance according to the laws of a preordained hierarchy. The pope walks ahead, then come the emperor, the cardinal, the king, the patriarch, the high constable, the archbishop, the knight, the bishop, the squire, the abbot, the bailiff, etc. An order of such perfection must have seemed as immutable as the thought of God. It is noteworthy that a layman always alternated with a cleric, according to the harmony prevailing in a well-ordered society where men of action and men of thought balanced one another.

The living whom the dancing cadavers lead on do not dance, but walk at a pace already slowed by death. They lament, they pull back, and none wish to die. The archbishop considers that he will no longer sleep "in his fine painted chamber," the knight that he will no more awaken the ladies with an aubade at the hour of dawn, the curé that he will no longer receive the offering. The sergeant upbraids the dead man for his audacity in laying a hand on him, "an officer of the king!" He clutches at titles, functions, all the human realities which seemed so solid and which now break like bits of straw. Even the farm laborer is in no hurry to follow his companions, and says:

> *La mort aît souhaité souvent,*
> *Mais volontiers je la fuisse,*
> *J'aimasse mieux, fut pluie ou vent,*
> *Etre en vignes où je fouisse.*

> Often have I death besought;
> Now he comes, I want him not.
> Let it rain or let it blow,
> Rather I'll the vineyard hoe.

149

And the little newborn child, not yet able to articulate, is as unwilling to die as the aged pope and the aged emperor.

The desire to live and the impossibility of escape from death, this terrible contradiction innate in human nature, has never, I believe, been more forcefully presented. The Dance of Death may shock our sense of delicacy, we may not like it and find its brew too bitter, but there is no denying that it is among those great categories of artistic expression which have rendered visible to all eyes fundamental realities of the soul.

**THE ART OF DYING**  The *Ars Moriendi* is undoubtedly one of the most curious monuments of art and thought in the fifteenth century. We find the most interesting commentary in the edition published by Vérard, *L'Art de bien vivre et de bien mourir*. For there the Latin text, often obscure because of its brevity, is translated, explained, and developed by an authentic writer commanding a grave, already classical French.

As for the engravings, the finest are those of the xylographic editions, and in particular those of the edition which Dutuit calls, after the name of a collector, the Weigel edition. Vérard's drawings were modeled upon these originals, but the Parisian draughtsman weakened his models somewhat (Pl. 35). The originals have something rude and bold about them; the savage drawing is in perfect accord with the horror of the subject. The monsters with calves' heads and cocks' beaks and boars' tusks were born of fear; the peasant who had met the devil at the crossroads, the monk who had seen him slip under his bed, here found the reflection of their dread vision.

A work that has edified all Europe merits a brief study. Vérard's edition opens with a preamble expressing the

nameless anguish of the dying man who feels that every-
thing is abandoning him. His senses, by which every joy
came to him, "are already closed and locked by the strong
and horrible lock of death." A sort of vertigo takes pos-
session of the soul; and this is the tormented hour which
the demon has been waiting for. The dogs of hell which
prowl around the dying man's bed attack the Christian
more furiously than he has ever been attacked before. If
at the ultimate moment he doubts, or despairs, or blas-
phemes, his soul goes to the enemy. "O Virgin, protect
him!" prays Saint Bernard. "A single soul is more pre-
cious than the whole universe. May the Christian learn,
while there is still time, to die well and to save his soul."

The dying man is exposed to five principal tempta-
tions. God, however, will not abandon the Christian, and
five times He will send His angel to comfort him.

First, his faith is tempted. The old engraving shows the
dying man in his bed, his naked arms lean like those of
the sinister companion who leads the Dance of Death.
Christ and the Virgin watch over him, but he does not see
them, because a demon raises a cover behind his head and
hides the heavens; so little is needed to make a man forget
God. The dying man's eyes are fixed on a vision sent by
the demon. He sees pagans on their knees before idols,
and a venomous voice whispers in his ear: "At least these
people can see the gods they worship! You believe in
something you have never seen and never will see. Have
you ever heard of a dead man who came back to bear
witness, to confirm your faith?"

The poor fellow finds nothing to say. But—on the next
page of the book—an angel alights near his bed. "Do not
listen to the words of Satan," says the angel. "He has been
lying ever since the world began. If all is not clear to your
faith, this is God's will, that you may have the merit of

believing; that you may be free to believe. Be firm, then, in your faith, think of the constancy of the patriarchs, of the apostles and martyrs." Then we see at the bedside the saints of the Old and the New Law, and behind the first ranks appear other nimbuses. With a few strokes, the artist gives the illusion of a serried array.

The faith of the dying man remaining unshaken, the demon is obliged to change his tactics. Now he no longer denies God, but he represents Him as inexorable and assails the virtue of hope. Hideous monsters again prowl about the bed. One flourishes before the dying man's eyes a parchment listing all the sins that the poor creature committed in the world. By a malefic incantation, all his sins take on bodies and appear to him. He sees the woman with whom he sinned and the man whom he deceived; he sees the poor naked wretch from whom he turned away, and the beggar who went hungry from his door. He even contemplates with horror the still-bleeding body of the man he killed. "You have committed fornication," howls the chorus of demons. "You have shown no pity to the poor. You have killed." And Satan adds, "You were the son of God, but you have become the son of the devil. You belong to me" (Pl. 35).

But once more the angel descends from heaven. Four saints are with him: Saint Peter, who three times denied his Master; Mary Magdalen; Saint Paul, whom God stunned with lightning in order to convert him; the good thief, who repented only upon the cross. Here are the great witnesses to the divine mercy. The angel points to the four and addresses the dying man in words of divine forbearance. "Do not despair. Though you have committed as many sins as there are drops of water in the sea, a single motion of contrition is enough. The sinner needs only to grieve for his sins and he will be saved, for the

mercy of God is greater than the greatest of crimes. There is only one grievous sin: that of despair. Judas was more to blame for his despair than the Jews for crucifying Christ." Hearing these words, the demons disappear, shrieking, "We are conquered!" (Pl. 35).

If God pardons all to one who is truly repentant, Satan must then try to divert man's thoughts from his salvation and prevent him from repenting. So he conjures up images which stir the dying man to the depths of his being. He sees his wife, his little child. Without him, what will become of his house? A demon stretches out his arm and the house appears, cellar door open and a faithless servant already beginning to broach the wine cask. A thief enters the courtyard and unceremoniously removes the horse from the stable. How shall these possessions, "better loved than God Himself," be saved?

The angel returns and causes images of another kind to appear at the bedside of the dying man. He shows him Jesus Christ naked upon the cross. Following His example, we too must die despoiled of everything. May we have the strength, like our Master, to renounce all things of the earth. May we be resigned concerning the fate of our loved ones. God will provide for them. And the angel shelters the wife and the son under a veil.

Still the demon does not give up. Since the sick man has been put at peace with regard to others, he must be brought to think about his own sufferings, to blaspheme and accuse God. "You are suffering too much," whispers Satan. "God is unjust. Look at these people who crowd around, pretending to feel sorry for your ills. In their hearts they are only thinking of your money." At these words the man begins to toss about on his bed. He feels filled with hatred for God and man. He throws back the covers, overturns the table loaded with glasses and po-

tions, takes a good kick at the inheritor standing at his bedside. The servant, a plate in hand, stands petrified.

Again the angel appears, and with him martyrs in glory bearing triumphantly the instruments of their torture—Saint Lawrence, Saint Stephen, Saint Barbara, Saint Catherine, Christ Himself as He appeared to Saint Gregory. The angel speaks with his usual mildness. "Do not complain," he says. "The kingdom of God is not for those who pity themselves. What are your sufferings in comparison with your sins? These sufferings, moreover, will be counted to your credit. Know that evils are useful, for they oblige men to turn to God. Consider Jesus and His holy martyrs; they endured without murmuring and remained patient even unto death."

Four times rebuffed, Satan makes his last assault. With his profound knowledge of sin, he is aware that the last sentiment to perish in man is that of pride. So he appeals to the pride of the man who has so little time and breath left. Demons with bestial heads approach and lay down crowns upon his bed. "You have had faith, hope, and charity," they say. "Oh, you are not like the men who repent on their deathbeds after a life of crime. You are a saint in truth, and deserve a crown."

The dying man is on the point of succumbing, his heart full of pride, when a troop of angels flies to his rescue. One of them shows him the maw of Leviathan down which pride precipitated the demons. Another angel points to Saint Anthony, who, in his humility, triumphed over all temptations. Still another says, "To enter heaven one must be humble as a little child. Remember the Virgin, chosen by God for her humility." Straightway the heavens open, and the Virgin is revealed in the presence of the Trinity.

154

Convulsed in agony but victorious, the dying man emerges from the last battle. The artist has conveyed the violence of the struggle by which a soul is born to eternal life; and the last page of the book brings a sense of deliverance, of release. The Christian has just died, and the priest who has heard his last words puts in his hands a waxen candle. A soul is saved. The infernal pack howls, menacing claws are bared, maws are opened wide, the demons' hair stands on end, but to no purpose. Carried by an angel, the soul mounts peacefully toward heaven.

We can easily understand the popularity of the *Ars Moriendi*. With its dramatic text and dreadful engravings, it had a profound effect upon men and women who were continually possessed by thoughts of death. In an earlier age the work might have found its natural form in stone; but in the fifteenth century the rising printing trade took possession of it and, multiplied by thousands, the *Ars Moriendi* no doubt found its way to as many eyes and imaginations as if it had been carved in stone on the façade of the churches. . . .

Thus, at the end of the Middle Ages, the image of Death was omnipresent. One met with it not only in the frescoes of the charnel houses, but wherever one went: in the churches; turning the pages of a Book of Hours; at home, where a skull was carved on the chimney piece and a page of the *Ars Moriendi* was nailed to the wall. And at night the oblivion of sleep was rudely interrupted by the chant of the watchman, rising out of the dark:

> *Réveillez-vous, gens qui dormez,*
> *Priez Dieu pour les trépassés.*
>
> Ye who take your ease in bed,
> Wake and pray for all the dead!

155

*THE TOMB* We can hardly imagine today the immense number of tombs that once filled the churches. We are late-comers. But if we had set out on Saint Barnabas' Day in the spring of 1708, with Dom Martène and Dom Durand, the authors of the *Literary Journey of two Benedictine Monks,* and had gone with them from abbey to abbey and from cathedral to cathedral, we should have found old France in her magnificence. In spite of the damage done by the wars of religion, the churches were still paved with tombstones and the cloisters filled with commemorative statues painted in vivid colors not yet faded. In monasteries the very names of which are now forgotten marvelous monuments of enameled copper gleamed like azure and gold. Nothing has ever equaled in splendor these masterpieces of the artists of Limoges. There was not a church which did not relate, through its tombstones, the history of a province.

Dom Martène and Dom Durand, alas, were neither artists nor appreciative of art; all they did was to transcribe epitaphs, and they passed unmoved before works of art forever to be regretted.

Fortunately, there lived in the seventeenth century a singular man who loved what others scorned. Roger de Gaignières had a passion for the past, or we might better say, for death. The greater part of his life was devoted to the recording of funeral monuments and tombstones. Accompanied by a draftsman of great good will but little genius, he journeyed throughout France in the pursuit of his object. The result of his labors is an amazing series of volumes, now divided between France and England. It is with a sinking heart that we admire, in the thirty volumes of his record, so many beautiful monuments of which not a trace is left today. What exactly was Gaig-

nières's aim? Why so much ardor in bringing together records and drawings of monuments which at the time were of interest only to a few Benedictines? No doubt Gaignières could not have said himself. This eccentric was not an ambitious author. A mysterious instinct drove him to the quest. And he hurried, with good reason, for without conscious knowledge he was working for posterity, and saved for us a portion of old France.

It is through Gaignières that we know the place the dead took among the living. In Notre-Dame of Paris people stepped, not upon paving-stones, but on the flat stones of tombs or on sheets of brass decorated with funeral effigies. The largest cathedrals were too small, and cloisters and chapter-rooms had to be opened to the tombs. The Cathedral of Langres with its annexes housed nearly two thousand tombs.

Yet it was not the cathedrals that were the most beautiful necropolises. The great feudal families preferred the solitude and silence of the abbeys, where no crowds came to blunt the visage of the dead with their footsteps, and an eternal silence was interrupted only by prayer. Maubuisson, Royaumont, Saint-Yved-de-Braine, the Abbaye du Lys, a score of others which are only names to us now, were once, as we can see from Gaignières's records, full of the splendidly commemorated dead (Pl. 36).

Maubuisson housed the monuments of great ladies: Queen Blanche in a nun's habit, Countess Mahaut d'Artois, lover of artists, Catherine de Courtenay, the daughter of the Emperor of Constantinople, sculptured in black marble, Bonne de Luxembourg, the mother of Charles V, who was found sitting on a throne, her hair plaited with gold braid, when the vault was opened in 1635. Charles V had wished to lie close to his beloved mother, but his tomb

was already prepared at Saint-Denis. He commanded that his entrails at least should be interred near his mother, and an effigy of himself laid out not far from her tomb.

Royaumont was the burial place of the children of Saint Louis, among them his eldest son, the bitterly regretted young Louis of France. A bas-relief on his sarcophagus recalled that the King of England had desired to carry the young prince's coffin upon his shoulders. In the church, to which he had to return so often, Saint Louis knew the depths of grief, and suffered his own Passion.

Saint-Yved-de-Braine was the necropolis of the Counts of Dreux, a valiant family of royal lineage. First came the heroic knights of the thirteenth century: Robert II, who fought at Bouvines, Jean de Dreux, whose body reposed at Nicosia and whose heart only was taken to Saint-Yved, Pierre Mauclerc, who distinguished himself at Mansura and at Ptolemais. The only one missing was Philippe de Dreux, Bishop of Beauvais, hero of Tiberias and Saint-Jean d'Acre, who fought with a club because the Pope had forbidden him to strike with the sword. Next to their effigies, made splendid by the fine armor of the thirteenth century, lay the combatants of the Hundred Years' War. Cramped in their tight-fitting armor, they looked grim and melancholy, with none of the glamour about them of Syrian cities or the colors of the Orient. They had not degenerated, but they were beaten men: Jean VI de Roucy had been killed at the Battle of Agincourt. . . .

The abundance of tombs which once filled the French abbeys is further explained by the fact that members of great families frequently had several monuments. Their wills often stipulated that their remains should be divided in three parts, their bodies to go to one church, their hearts to another, their entrails to a third. Thus the

body of Charles V lay at Saint-Denis, his entrails at Maubuisson, and his heart at the Cathedral of Rouen in the Norman country which he had governed as a youth. So it is that the statues on the tombs often have, with a strange funeral realism, a heart in their hands, or a sculptured leathern pouch of the kind used to contain the intestines. . . .

It was during the Revolution that almost all the monuments were destroyed, with a savage sweep that makes one hesitate between admiration and horror. In 1792, when France was invaded, the municipalities received the order to break open the family burial vaults and remove the leaden coffins to turn them into bullets. The tombs were probably also searched for saltpeter. In this process the majority of tombstones and monuments was destroyed. Then it was decided that all copper sheeting and bronze statues should be melted down. The statue of Blanche of Castille became a cannon. Thus the chain of French history, which the Revolution had set out to break, found its continuation: The dead rose from their tombs to fight side by side with the living. . . .

*THE WINDOWS OF VINCENNES AND DÜRER'S APOCALYPSE* Beyond the end of individual men lay the end of man, the terrors of the last days as announced in the Revelations. In 1498 Dürer published illustrations of the events of the Revelations which came to be considered as authoritative as the words of Saint John. Later artists could only imitate them. As we shall see, all Apocalypses of the sixteenth century derived, directly or indirectly, from Dürer's Apocalypse. For Dürer had made the Apocalypse as much his own as Dante had the Inferno.

159

In the windows of Vincennes the inspiration of Dürer is unmistakable and yet, as we look at them, Dürer does not come to mind. There are various reasons for this paradox:

First of all, the most striking scenes of Dürer's are not included: At Vincennes we have neither Saint John prostrate before the Son of Man, nor the four horsemen, nor the great whore seated upon the beast. Perhaps these scenes were destroyed, or the artist of Vincennes may have rejected them as incompatible with his conception of aesthetics. For his idea of beauty differed greatly from that of the young Dürer. Dürer's art is an explosion of the creative imagination, recognizing no laws but its own. For the glassworker of Vincennes, on the other hand, it was an article of faith that imagination could bring forth only chaos unless subordinated to superior laws of symmetry, rhythm, and number—to that "divine proportion" in which Italian artists had instructed the world. Incandescent passion, in order to become beauty, must be subjected to law. Here again we find the eternal opposites: Latin discipline and Northern lyricism. From 1300 on, Italy demonstrated, by the great example of Dante, that perfect beauty is a blending of strength and order; her painters, sculptors, and architects taught the same lesson. The master of Vincennes is imbued with these great truths; tumult, passion, violence are resolved in the beauty of symmetry. The angels who distribute the robes to the martyrs are weightless as the draperies they hold; with harmonious grace they wing their way on either side of the altar. Below, four naked martyrs in juxtaposition symbolize the multitude. Around the bottomless pit, the smitten people lie in symmetrical groups, and the angel, with outspread wings, hovers in the center of heaven. Pure Ionic architecture frames the most tragic visions and

imparts to them some of its harmony and serenity. These scenes, at once so violent and so controlled, are reminiscent of the art of Virgil, which clothes with divine beauty massacre, horror, and death.

The master of Vincennes, even in borrowing Dürer's themes, could not resemble him. He translated the Teutonic into the splendid Italian of the Renaissance; quite naturally it becomes the language of Michelangelo. Everything bony, hard, angular in the original takes on a heroic amplitude of proportion. These athletically built elders receiving the white robes, these magnificent angels carried on a mighty gale, are of the same race as the formidable heroes of the Sistine Chapel.

The instinctive awe in which these windows of Vincennes were always held can be attributed to this: A greatness was felt in them—partly the inspiration of Dürer, and partly the genius of Michelangelo.

*THE LAST JUDGMENT AND THE INFLUENCE OF THE RELIGIOUS THEATER*
The extensive study devoted previously to Last Judgments in cathedral art permits us to touch upon the subject here more briefly. The theological concepts which had dictated the grouping of the dramatis personae on the tympanums of the thirteenth century were still active. We continue to see Christ pointing to His wounds, the angels carrying the instruments of the Passion, the apostles seated in judgment, and the Virgin and Saint John kneeling in intercession. On the surface nothing seems to have changed. Minor variations, however, reveal that art has not been at a standstill. The innovations appear in the fifteenth century and can, I believe, be attributed to the influence of the *tableaux vivants* and the mystery plays. No longer

are the Virgin and Saint John shown invariably kneeling on either side of the Judge. Frequently they now appear in a splendid chair of carved wood, like a seignorial chair. In the preamble to the only mystery of the Last Judgment extant in France, we read that "there should be upon the scene a chair finely adorned to seat Our Lady upon the right of her Son." Evidently the amateur actors who played the part of the Virgin or of Saint John could not remain kneeling during the three or four hours of the play's duration. The painters reproduced what they saw, regardless of the fact that they took from the Virgin and Saint John their function and value as intercessors, which was to hope against hope, and to believe, in spite of the terrible setting, that love might overcome the law.

Other examples show the influence of the theater even more clearly. In the thirteenth century the dead raise the covers of their tombs and stand upright in their sarcophagi. Not so in the fifteenth: Here the dead do not rise from the stone receptacle, but always from a grave dug in the ground. The miniatures of fifteenth-century Books of Hours, the wood engravings of the incunabula, show this version of the resurrection hundreds of times. The reason for the deviation from tradition is obvious. In the theater, the dead responded to the sound of the trumpet by rising halfway out of rectangular holes made in the stage floor. An engraving preserved in the Cabinet des Estampes shows quite clearly that the "graves" are simple trap doors opening upon the scene, through which the dead concealed in the basement made their appearance at the proper moment.

The same engraving shows us how the stage setters ordinarily presented Paradise. In the thirteenth century a simple arcade was supposed to be the door to heaven—a pure symbol, almost a hieroglyphic. In the fifteenth cen-

tury, requirements of stage setting led to the construction upon the stage of a wooden house with a stairway leading up to it. Our engraving shows this naïve monument, obviously copied from an existing model. By adding a few steps to the stairs, and giving the building a little more grandeur, we have the gate of heaven as Memling represents it in his Last Judgment.

The concluding chapter shows that the Reformation, in obliging the Catholic Church to supervise strictly all aspects of its thought, put an end to medieval art which had given such wide scope to legend, poetry, and dream. But religious art did not die with the Middle Ages. The Church of the Counter Reformation gave rise to new art forms, with their own rules and laws.

# RELIGIOUS ART
# AFTER THE COUNCIL OF TRENT

# THE RELIGIOUS CONTROVERSIES AND ART

We must endeavor to conceive what took place in the minds and hearts of a Spanish nun or an Italian mendicant friar when they were told by travelers from the North that Protestants were demolishing statues of the Virgin, burning crucifixes, transpiercing with their swords the images of saints. In a picture of the Crucifixion Christ had been torn to shreds, while with diabolical irony the figure of the bad thief had been left intact. In a reredos devoted to Saint Michael, the archangel had been destroyed while the demon at his feet was spared. In Germany and Switzerland Holy Mass was derided, the Real Presence denied, the Virgin defamed. Brentius said: "She was not without sin"; "Nor was she a virgin," declared Lucas Sternberg. Another repeated a sarcastic remark of Constantine Copronymus: "When she bore Christ within her womb, she was like a purse filled with gold. But after giving birth she was no more than an empty purse." "Those who recite the Ave Maria in her honor," said Weygandus, "commit the crime of idolatry, for they make a goddess of a woman." And Luther: "If you believe in Christ, you are as holy as she." . . .

Ignatius Loyola, unable to convince one of his traveling companions of Mary's virginity, was tempted to make use of his dagger. A few days later he hung the weapon in the Church of Montserrat and dedicated it to the Virgin.

The same dismay which gripped the hearts of a soldier on the roads of Spain and of a nun in her cell took pos-

session of the entire Catholic Church. From the height of the Castel Sant'Angelo Clement VII, most unfortunate of popes, saw Rome ravaged and plundered by roving bands of Lutherans. Denmark, Norway, Sweden, England all broke away from the Church. The Turks invaded the Christian kingdom of Hungary and Solyman appeared before the walls of Vienna. A medal which Clement ordered struck at the time shows Christ bound to the column, and underneath the somber device: *Post multa, plurima restant.* The profound sadness of the time was echoed by Michelangelo in the tombs of the Medici; all hope seems lost for these figures as they contemplate life with scorn or turn from it to sleep. Clement believed that the dreadful prophecies of the Apocalypse were about to come true, that the end of the world was at hand. Accordingly, shortly before his death, he asked Michelangelo to paint the Last Judgment in the Sistine Chapel. The great work was conceived in these tragic years.

It is not our place here to tell how the Church found within herself the saving faith and love; how she affirmed her dogmas at the Council of Trent; how she reformed herself and undertook, with the aid of the religious orders, the Jesuits in particular, to reconquer Europe. We can only say that for a century and a half the struggle against Protestantism was her constant preoccupation. In the sixteenth and seventeenth centuries not only theology but, as we shall see, art itself was affected by the controversy and sometimes even became one of the forms assumed by the controversy. Thus the art of the Counter Reformation defends all the dogmas attacked by the Protestants.

*ART EXALTS THE VIRGIN* In the chapel of Saint Januarius in Naples there is a fresco by Il Domenichino showing the triumph of the Virgin over the Reformation. The theme is obvious: A young hero treads underfoot Luther and Calvin, who are identified by name in inscriptions. He carries a white banner on which we read three answers to the Protestant attacks: *Semper Virgo—Dei Genitrix—Immaculata.* Against the innovators, the young champion of the Virgin affirms that she was virgin before and after the birth of Jesus, that she is the Mother of God and not merely the Mother of Christ, and finally that she is free from original sin. Near him a young woman, Prayer, carries the rosary which the Lutherans denounced as an invention of Satan. The Ave Maria mounts up to the Virgin, who is on her knees before her Son. She offers to Him the prayers of mankind which have moved her heart to pity, and two angels put back into the scabbard the sword of divine wrath. Painting here becomes apologetics; line and color could not speak more clearly in answer to objections.

We observe that the Immaculate Conception of the Virgin is affirmed in the fresco at Naples; Immaculata, signifying her who was conceived by God before all centuries and freed from the law of sin. The Immaculate Conception had not yet been declared a dogma, but it was already the profound thought of the Church. . . .

Murillo's paintings show us not the Church Fathers but ordinary laymen, students of the masters of Salamanca no doubt, licentiates in theology, in contemplation before the Purissima, who appears to them in a radiance of light. They see her as they dreamed her, perfect beauty allied with spotless purity.

But these theologians and worshipers were not neces-

169

sary to the affirmation of a belief; the Virgin seems even more celestial when she appears "before the abysses," accompanied only by angels, as the Spaniards most often represented her. They took from the Italians the conception of the Virgin with hands clasped in prayer, standing upon clouds or upon the crescent moon. But the Spaniards put into such images a profundity of passion not to be found elsewhere. The Immaculate Conception by Montañes at the Cathedral of Seville (Pl. 37) is in its purity and solemnity one of the noblest statues ever inspired by the Virgin.

Murillo glorified the Purissima in several major works, the most magnificent of which he painted for the Franciscans of Seville (Pl. 38). It is a cry of ecstasy of ancient Spain. Suspended in space above the earth, the Virgin meditates upon a mystery, hands clasped in prayer, with downcast eyes. The wind of the infinite blows out her hair and raises her cloak. Radiant with purity, more ancient than the world, and blessed with eternal youth, she is beautiful as a thought of God.

Murillo's splendid vision of the Virgin lifts her above all controversy. The Purissima has entered a realm beyond the reach of the attacks of innovators. She is endowed with the sublimity of an eternal idea.

*THE THRONE OF SAINT PETER*

Another theme of the Counter Reformation, that of the supremacy of the papacy, found its natural place of development in Saint Peter's at Rome.

In the apse, a work of Bernini's, which today is regarded only as a decorative piece of debatable artistic value, is in reality the formulation of a doctrine (Pl. 39). Tradition having maintained that Saint Peter had taught from the ancient chair, it was drawn from its obscure place

in a side chapel by Alexander VII and put up in splendor as a symbol. The shrine containing it is supported by two Fathers of the Greek Church, Saint Athanasius and Saint John Chrysostomus. The figures of the two towering old men in wind-blown garments signify that the finest intelligences of the East and West submitted to the teachings of the Roman See. Tiara and keys crown the throne and reveal its meaning. Above, in the center of long golden rays where angels float like moats in the light, the dove of the Holy Ghost, dazzling like the sun, hovers over the chair and seems to shed light on it. Here, art is making visible an idea often expressed by Catholic controversialists of the time. "Opposite the throne of pestilence," writes Father Coton, "stands the throne of verity," which is the throne of Saint Peter. To this throne only, he adds, inheres the right of teaching; it symbolizes the perpetual enduring of the doctrine and the promise of infallibility made to it. In the course of centuries this throne has triumphed over all heresies.

Without the Reformation we should probably not have had the monumental throne of Saint Peter, since what had been contested by no one would not have called for affirmation.

*ART DEFENDS THE SACRAMENTS*   Foremost among the sacraments defended by religious art was the sacrament of penance. Saint Peter weeping over his denial and the Magdalen weeping over her sins are symbols of penance.

For this reason the image of Mary Magdalen recurs frequently in the seventeenth century. Often she is shown as the solitary penitent of Sainte-Baume, according to the Provençal legend widely accepted in the early seventeenth century. Beauty consuming itself like incense

171

burned before God in solitude far from the eyes of men became the most stirring image of penance conceivable. Painters treated it a hundred times; and often their pictures were destined not for churches but for the palaces of cardinals or the houses of private citizens. The generosity of expiation, the gift of tears, were to the Christian a perpetual subject of meditation. No painter of this subject equaled Ribera. His "Kneeling Magdalen" at the Prado (Pl. 40), with her pure face, her long hair, her beautiful shoulders, retains her radiant beauty, but the dolorous mouth, the eyes raised to heaven, her luminous aura separate her from the world, confer upon her a nobility that transcends beauty.

The sacrament of the Eucharist was also championed by art as a consequence of the great religious controversies. It is a remarkable phenomenon that the Middle Ages, which had created the feast of Corpus Domini, chanted the hymn to the Holy Sacrament, and raised its towering cathedrals to heaven to make them a more worthy abode for the Real Presence—the mystical Middle Ages whose focal point was Holy Communion—at the height of its development almost never visually represented this sacrament. Only once, in France, at Rheims Cathedral, does Melchizedek offer bread in sacramental form to Abraham, represented as a knight. In Assisi, Mary Magdalen receives Communion from the hands of Saint Maximin and, in the Campo Santo in Pisa, Maria Egyptiaca receives the Host from Zosimus. This supreme act of the Christian is exceedingly rare in the artistic representation of the Middle Ages. In the seventeenth century, on the contrary, it becomes exceedingly frequent. Continually, on canvases and in frescoes, the saints receive the Eucharist; often they are shown at the hour of their death, being united with God for the last time, before entering

the Uncreated Light. The Last Communion of the saints becomes one of the greatest themes of religious art.

An apocryphal book attributed to Eusebius of Cremona tells how Saint Jerome at the age of ninety desired to receive Communion for the last time in the presence of his disciples. Supported by them, he receives the sacrament with moving fervor and pronounces an eloquent prayer. Though Erasmus and even Baronius did not consider the book authentic, the Carthusians of Bologna commissioned Agostino Caracci to paint for them "The Last Communion of Jerome," which he executed in masterly fashion. Saint Jerome, naked like an athlete preparing for his last contest, summons up his remaining strength to receive his God.

*CATHOLIC CHARITY* Similarly, art took up the defense of works and of charity attacked by the Protestants. One of the great heroes of charity, Saint Charles Borromeo, became a favorite subject. This nobleman, gently bred in a palace and surrounded in his youth by luxury and art, chose to live like the poor of Milan. A fine painting by Daniel Crespi shows him seated at table, with only a glass of water before him, eating a morsel of bread and reading a book. For the poor he deprived himself of everything, sold his furniture, had his curtains taken down. In one day he gave away all that the sale of his principality of Oria had brought in. His ecclesiastic benefices went into charitable works: to the relief of orphans, the poor ashamed to beg, repentant girls, hospitals. He kept nothing for himself, so that Panigarola could truthfully say in his funeral eulogy: "Of his riches Charles enjoyed only as much as the dog shares of his master's wealth—a little water, bread, and straw." But it was in 1576, during the siege of Milan, that his virtue

173

became manifest to all. He took the place of the city's governor, who had fled, and communicated his courage to all about him. The crowd pressed close in order to touch the hem of his robe. He moved among the plague-stricken, dispensing spiritual consolation, giving of all that he possessed, taking into his home the children whose mothers had died. "Now," said one of those who saw him, "he lacks the wherewithal to live, but his mere presence is enough to raise the dead." It is at this supreme moment of his life that art most often represents him.

Saint John of God was the saint of the abandoned sick, of the hopelessly ill. Charity in him had reached a heroic degree surpassing human limitations. John's biographer tells how one day he entered a church at Granada and knelt down before the figure of the crucified Christ to ask God for guidance as to his vocation. After he had finished his prayer he saw the Virgin and Saint John detach themselves from either side of the cross, step down to him, and set a crown of thorns upon his brow. He took this as a token that his was the way of sacrifice, and he entered upon it with heroic courage. The crown of thorns became his customary attribute, expressing the mysterious virtue of suffering. His entry into heaven was painted by Corrado Giaquinto on the ceiling of the Church of San Giovanni Calabyta, on the island in the Tiber in Rome. Saint John presents his crown of thorns to the Virgin, and she holds it above his head. Thus Saint John wears the symbol of suffering even in eternity. At Saint Peter's in Rome, he is again represented among the founders of religious orders, with his crown of thorns; the admirable statue by Filippo Valle shows a depth of feeling quite unusual in an artist of the eighteenth century. With sorrowful visage, wearing his crown of thorns, the saint stands erect, supporting a poor, almost naked man, who leans

heavily against him. The saint's eyes seem to look into the distance with an anguished glance, as though he were wondering if his heart were vast enough to take unto itself all the suffering he sees in the world. The art of Italy here equals that of Spain in intensity of feeling.

## MARTYRDOM

For the Catholic Church the age of the Counter Reformation was the age of martyrdom. There were martyrs in England, Germany, Asia, Africa, and America. The Jesuits decorated the recreation room of their novices at Sant'Andrea al Quirinale with scenes of martyrdom. The paintings no longer exist, but we have Father Richeome's descriptions of them.

The subjects were the murder of the missionaries to Brazil by the Calvinists, and the massacre of Father Aquaviva and his companions at Salsette. Above the frescoes ran a broad space, "a celestial zone," in which were painted the martyrs of the Order, "each with his angel bearing a palm and a crown, in honor of his victory."

There were Father Criminal, superior of the residence at Cape Comorin, "whose head was borne in triumph"; Father Correa, a Portuguese nobleman, "killed with arrows in Brazil," Richeome says, while teaching the word of God; Fathers James Kisaï, Paul Miki, and John Gata, Japanese "with olive skins and small eyes, crucified with twenty-three other Christians, their left ears cut off and their bodies pierced through with several lance thrusts, according to the custom of the country." In his enumeration of heroes, Richeome attains an epic grandeur. He tells of Abraham George, martyred in Ethiopia. The executioner who beheaded him broke his sword twice, and,

in the space of forty days, there were seen at the spot where he was buried three unknown white birds of exceptional size and beauty, and several lamps shining at the hour of vespers. The English martyrs, "Odoart Olcornus and Father Garnet," were "strangled for the faith in London and gutted according to the custom, in the year 1606." The three companion pictures, he continues, "show three English fathers: Edmund Campion, a great doctor and a greater saint, who in the same year, 1581, and after several hellish torments and laborings of body and spirit valiantly borne, was put to death by the Calvinist faction in London, city of his birth, where he became the first martyr of the Company. . . . After him, Father Alexander Bryant and Father Thomas Cottman of the same nation, strangled for the same reason and in the same way." Like the painter, the writer wishes death to appear as a triumph. Addressing the novices for whom he is writing, Richeome finishes with this admonition: "These, my well-beloved, are the pictures of your brothers, slain between the years 1549 and 1606; aligned in this room, not only to honor their memories but to serve you as examples."

This nobly worded document gives an excellent idea of the exaltation of spirit which animated the Company of Jesus at the end of the sixteenth century, fifty years after the death of Ignatius Loyola. Art was intended to assist the instructors in the tempering of souls, and the images of torture scenes were used as a preparation for martyrdom.

It was at this epoch too that the catacombs were discovered. Another great age of persecutions was revealed in its most striking aspect. Meanwhile, at the very time that Bosio was exploring the subterranean world of the catacombs, an extraordinary event aroused excitement al-

most as intense as when the Cemetery of Priscilla was discovered. In 1599 the coffin of precious wood in which Pope Paschal I had, in 821, enclosed the remains of Saint Cecilia, was opened. The relics of the saint were to be transported from the Cemetery of Callixtus to her basilica in the Trastevere. The body was discovered perfectly intact, as though the saint had fallen asleep. Baronius and Bosio were summoned at once, and both have described the soul-stirring appearance of the young patrician gently stretched out beneath her veil. She lay on her right side, knees slightly bent. A green silk cloth striped with dark red revealed the outline of her body. Under the veil a golden garment stained with blood gleamed faintly. All who saw her were seized with awe. No one dared to lift the veil, "for it seemed," says Baronius, "as though the Bridegroom kept watch over His slumbering bride." When Clement VIII came from Frascati "to contemplate this marvel" in his turn, he ordered that she remain untouched and that the ancient coffin of cypress wood should be enclosed in a silver sheathing sown with stars. Artists had time to sketch the fugitive vision, and the sculptor Stefano Maderna was commissioned to perpetuate it. We are indebted to him for a graceful masterpiece, the recumbent Saint Cecilia in the Trastevere, unforgettable to all who have seen it (Pl. 41). The saint is lying on her side with knees slightly bent, just as Baronius describes her. But the original could not have had this suppleness of line, the gentle abandon, the alluringly veiled visage, the disarmed innocence which has vanquished the world and even touched the heart of the executioners.

## VISION AND ECSTASY

On visiting Roman churches for the first time one is overwhelmed by the abundance of miraculous visions and images of ecstasy. The pale faces of saints seemingly suspended between life and death emerge from the shadows in the half-darkness; one perceives a young saint on whose head Jesus places a crown of thorns. There are churches where we find these pictures of ecstasy almost at every altar—works fraught with mystery, enveloped in somber clouds torn through with shafts of light. To understand them requires intimate knowledge of the saints of the sixteenth and seventeenth centuries, but even as enigmas they have a strange and powerful effect. We seem to be at the edge of another world, in a different atmosphere charged with a burning fluid.

All these pictures belong to the seventeenth century or to the latter years of the sixteenth. We have come a long way from the works of Raphael or his first followers, their Holy Families that seem so deeply human and illuminated by the clear light of Greece. There, all was peaceful love, serenity, harmonious union of body and soul; and here, all is transport, aspiration, painful effort to escape from human nature and to become absorbed in God. This is an incorporeal art. The perilous tottering of the Christian edifice, the rendings of schism, the struggle for the faith, the preparation for martyrdom, an atmosphere heavy with storms, all contributed to exalt the Catholic sensibility of the sixteenth century.

So we witness the appearance of new saints, saints after the image of their own time, very different from those of former days. We remember the saints of the Middle Ages,

the saints of the cathedrals, the venerable bishops who healed the sick, who sold their golden chalices to nourish the poor in time of famine and waited patiently for the hour of their deliverance while performing works of mercy. The saints of the Middle Ages wrought miracles. But the saints of the Counter Reformation *were* miracles. They all possessed the gift of vision, the aureole of ecstasy which astonished their contemporaries and inspired the wonder of succeeding ages. Their biographies are filled with these marvels. They are like explorers returning from a journey into another world. They have seen God face to face.

*THE ECSTASY OF SAINT THERESA TRANSVERBERATED BY THE ANGEL* — The transverberation or the piercing of Saint Theresa's heart by the arrow was depicted on the banner suspended from the vaulting of Saint Peter's on the day of the saint's canonization. The episode had acquired canonical authenticity, and we need not be surprised at encountering it frequently in art.

Bernini, for one, commemorated the event in a magical work in which marble seems to be perfectly malleable, supple as wax (Pl. 42). Fainting beneath her veils, almost prone upon the clouds which separate her from the earth, letting one hand drop lifelessly and exposing in her agony the bare foot of the Carmelite nun, Saint Theresa is faced by a peaceful winged child who aims the arrow at her heart. Since the time of the all-too-witty President de Brosse, it has been the fashion to speak of this group in Santa Maria della Vittoria with a smile. Such sly animadversions would have been highly astonishing to Bernini's contemporaries and above all to Bernini himself. The artist certainly intended to glorify her who was purity in-

179

carnate, who never knew the stirrings of the senses. The error arises in part from the fact that Bernini's work, despite all the efforts which have been made to present it advantageously, is even now difficult to see. Set high and at a distance from the spectator, the group is too far off to show the expressions of the faces except by way of photographs. Contrary to common report, the angel's smile is not mischievous but reflects an ingenuous kindness touched with a slight melancholy; for he knows that along with heavenly joy he brings suffering. As for the saint, there is a deathlike gravity in her sorrowful features, her nearly closed eyes and partly open lips. Her expression is the same as that of another of Bernini's saints, the blessed Albertona, whom he showed dying in a transport of celestial love. Faithful interpreter of Saint Theresa, Bernini has here shown the weakness of nature succumbing under the impact of the divine.

*HOW FRANCE, ITALY AND SPAIN REPRESENTED ECSTASY*

Ecstasy was the characteristic note in the art of the time, corresponding to the "mystical invasion" in religious literature. A feverish animation distinguishes seventeenth-century art from the art of the fifteenth and early sixteenth centuries. Passion, fervor, desperate desire for God tending always toward annihilation in God—this is what came to replace the serenity and silent love of Fra Angelico. We may prefer Fra Angelico, yet it cannot be denied that this pulsating art brings forth something new, expressive of what had not been expressed—God's pursuit and capture of a soul for Himself.

Each great Christian people interpreted ecstasy according to its own genius. The French, when they are not imitating the Italians, do not concern themselves with

mystical annihilation, but rather with union with God through prayer. Jouvenet, in contrast to Mola, shows Saint Bruno, not thrown to earth by the vision flashing in the heavens, but kneeling in his cell, his head resting against the foot of the cross. Saint John of the Cross is not elevated in ecstasy, but kneels in contemplation before a picture of the Passion. The attitude, the golden light, the silence of a convent library, everything suggests ardent prayer rather than spiritual ravishment. We see a grave Benedictine of Saint-Maur rather than a spiritual son of Saint Theresa.

Philippe de Champagne created the masterpiece which expresses the religious spirit of the seventeenth century in France (Pl. 43). Sister Catherine of Sainte-Suzanne and Mother Agnes are praying in a cell which is poor and bare, yet filled with a mysterious presence. The two nuns are awaiting a miracle. Nothing could be more simple, more modest and mild than the young nun, recumbent with clasped hands, her gaze upon a God Whom she seems to see and Who is not even astonishing to her, so accustomed is she to living in His presence.

Italy by contrast is far more passionate and ardent. She has created beautiful ecstatic visages, extenuated, pale as death, and deeply moving. But the body is always emphasized as much as the soul; it is shown bending, yielding under the touch of God. Yet the graceful Italian genius has known how to make of weakness beauty.

Spain, however, reaches the highest peak. The Spain of the great mystics, which has delved so deeply into the mysteries of love and death, represented ecstasy with an incomparable simplicity and grandeur. In Spanish art the body is as though frozen in immobility, as though forgotten, while the soul lives only in the saint's eyes and brow. The Saint Francis of Assisi of Pedro de Meña in

Toledo has his replica in the Saint Francis of Zurbarán in the museum in Lyons; both have their hands hidden in their sleeves, both are motionless, detached from all things earthly, all life concentrated in their eyes, which contemplate the ineffable.

# DEATH

Under the influence of Jesuit writings, death takes on a new aspect and is given an important place in art.

The tomb retains the form of a little temple façade framing a bust of the departed, but now a death's-head appears beneath the epitaph. The head is of a frightful realism: it has the color of old ivory which bones acquire with time, and the toothless jaws open in a terrifying grin. One has the feeling of being confronted by a real skull. Sometimes the death's-head is accompanied by two wings suggesting death's swiftness; sometimes it wears a laurel crown to symbolize its triumph. A little later Death himself, in the form of a skeleton, appears on the tombs, and for two centuries these funereal emblems make a melancholy sight of the sepulchers and epitaphs in Italian churches. We are far indeed from the tombs of the Renaissance, embellished by all the artistic graces, where the departed is like a hero fallen asleep. The tombs of the fifteenth century were consoling; those of the seventeenth are appalling. We feel a will to stir us deeply, an effort to affront our hidden paganism. These ironical skulls mock our faith in life. . . .

At San Lorenzo in Damaso, Rome, near one of the entrance doors, a winged skeleton holds up a medallion with the likeness of Alessandro Valtrini, prelate of Urban VIII. Bernini sculptured this funeral monument in 1639, and

may well have been the first to make use of this bold image. He was a man of sincere piety, a friend of the Jesuits, and in many respects their interpreter. Baldinucci tells us, for instance, that Bernini participated in the exercises conducted at the Gesù for a "goodly death." It would have seemed natural to him to suggest thoughts of death to church visitors. . . .

It is strange indeed to find, after the emulation of ancient models and the examples of Raphael and his school, a throwback to the Dance of Death. With new characteristics, however: The skeleton does not have the awful beauty of the mummified corpse, as conceived by the French artists of the fifteenth century. The dead in the fresco of La Chaise-Dieu seem alive, with gestures of a terrifying realism. But neither beauty nor life can reside in a skeleton. Taken singly, each bone in the human structure has character and individuality. Benvenuto Cellini, in his *Discourse on the Principles of the Art of Drawing*, admonishes his students to draw the sacrum bone with particular care, for, he says, "it is very beautiful." But the skeleton as a whole does not lend itself to art; the empty cage of the thorax, the dry linear structure, the angular attitudes convey no idea of life; a mummy shriveled to parchment can be animated, but not a skeleton.

## THE NEW ICONOGRAPHY

With the new spirit, the scenes of the Gospels assumed new aspects, and we witness the birth of a new iconography, that of the Counter Reformation, having essentially the same conventions among all Catholic peoples.

183

*THE ANNUNCIATION* In the art of the waning Middle Ages the Annunciation had become a scene of moving intimacy. In Flanders, the Virgin prays in an immaculate little room where the copperware glistens bright as gold and a lily blooms in a lovely vase. The angel has entered by a half-open door, without being seen, and knelt down. In this silence, between the sideboard and the andirons, the destiny of the world is to be decided. The Italians adorn the room with an antique garland, and sometimes open it upon a vista of the laurels of the garden or the Umbrian horizon, yet always preserving the intimate character of the scene.

The Annunciation of the seventeenth century contrasts sharply with that of preceding centuries. Heaven suddenly invades the cell where the Virgin is praying. The angel, a lily in his hand, kneels upon a cloud. Mists, sometimes luminous and sometimes somber, obscure the bed, the hearth, the walls, blotting out objects which recall the realities of life. We seem to be within the heavens rather than upon earth. Almost always other angels escort the heavenly messenger. Art strove to effect the union of heaven and earth. The Virgin of earlier days, isolated in her cell, was not deemed sufficiently majestic or mysterious. The idea to be conveyed was that the angels and God Himself waited upon a maiden's answer.

*THE NATIVITY* As conceived during the later centuries of the Middle Ages, the Nativity was a scene full of humility, silence, and fervor. The Newborn lay naked upon the ground, more destitute than the poorest among the children of men, while the kneeling Virgin, her hands clasped, worshiped Him, and Saint Joseph looked at Him with awe. The ox and ass served to recall the fact that the Son of God was born in

184

a stable. This poor, abandoned family, ignored by the rest of the world, deeply moved the heart. The presence of God was revealed only by the profound faith of the mother and the foster father.

In contrast, the seventeenth century shows the Child no longer naked upon the ground, but wrapped in swaddling clothes and laid in an ample basket full of hay. His mother kneels before Him, as in the earlier scene, but she does not join her hands in prayer. Rather, she draws apart the swaddling clothes to reveal the newborn Babe, showing Him to the shepherds who gaze and wonder at the Saviour announced by the angel. Saint Joseph stands in the shadows, but the animals are not always in evidence.

This Nativity scene is of an entirely novel character, not essentially different from the Adoration of the Shepherds. The artists are no longer concerned with the sad abandonment of the Holy Family, but rather with the moment when the Son of God is first recognized by men. For this reason the mother draws aside the swaddling clothes to show the Child, and the Child, become radiant, lights up the shadows and the faces of the onlookers. Once there were only three figures; now there are shepherds and shepherdesses, wonder-stricken children, the shepherd dog and, carried on the shoulders of a young man, a lamb with his feet tied, an offering from the poor to one still poorer. Sometimes angels hover in heaven, which seems to have invaded the poor hut. Sometimes the angels descend to earth and kneel before the Holy Child.

Animated, full of figures, rich in contrasts of light and shadow—such are the Nativity scenes of the seventeenth and eighteenth centuries. It is strangely surprising to find this scene continually recurring, always the same, in times when we might have expected artists to be less submissive. For more than two hundred years we find the

185

Child lying in His basket while His mother raises the cloths to show Him to the admiring shepherds.

*THE FLAGELLATION* In comparing the scenes of the Passion, it is surprising to find the Flagellation more powerful and heart-rending in the seventeenth than in the fifteenth century. Formerly Christ had been shown bound to a high column, which supported Him and held Him standing erect beneath the blows. Now He is bound by His hands to an iron ring in a low column, so that He has no support and succumbs under the whips and rods.

The column in question is the one still preserved today in Rome in the Church of Santa Prassede. In 1223 Cardinal Colonna brought it back from Jerusalem, where it was believed to have been the actual column of the Flagellation. In Rome it was placed in a resplendent setting, the beautiful chapel of San Zeno, which Paschal I had decorated with mosaics in the ninth century. For several centuries it was an object of veneration, yet nobody thought of incorporating it into iconography. Then, suddenly, toward the end of the sixteenth century, we find it taking its place in religious art. . . .

We can readily understand how this kind of boundary post, to which Christ was attached, and which gave Him no support, must have made His torture even more painful. Carlo Maratta shows Him thrown backward under the weight of the blows; Lazzaro Baldi shows Him on His knees, collapsed under the brutality of His torturers; Lucio Bonomi represents Him lying on the ground, held to the column by His bound hands, crushed like the earthworm of which the prophet spoke.

Though the tall column of former times did not entirely disappear, the low pillar of Santa Prassede became

widely accepted in France and Flanders. We find it in pictures by Stella, Le Sueur, François Perrier, as well as in those by Rubens, Gerard Zeegers, and Diepenbeke. Cornelis Schut showed Christ attached to the column in seven different pictures, each with new variations in the attitudes of the Victim.

Spanish artists, who were also familiar with the low pillar of the Flagellation, as the fine Christ by Hernández in the Carmelite Convent of Avila proves, set their peculiar seal upon this scene of suffering. A picture by Murillo shows Christ, freed at last from the pillar, and forsaken by His torturers, crawling toward His clothes while two angels, filled with pity, watch Him (Pl. 44).

# NEW DEVOTIONS

Christian thought, always active, gave birth at this time to new devotions, notably those to the Holy Family, the Child Jesus, Saint Joseph, and the guardian angel.

*THE GUARDIAN ANGEL* The last-named devotion became general in the sixteenth century during the religious wars, Catholics growing more and more attached to it as Luther and Calvin condemned it more severely. By the seventeenth century it had become so widespread that Clement X imposed it upon the Church Universal. In Rome and in many other places, churches, chapels, and altars were raised in honor of the guardian angel, and confraternities were founded under his patronage. An angel, the numerous books devoted to the subject tell us, receives each of us into his charge when we are born and lovingly watches over us from our earliest childhood. He walks beside us, and a

187

hundred times without our suspecting it saves us from death. When we are children he reassures our mothers, who, without him, would live in perpetual anxiety. It is our guardian angel who offers our prayers to God, our poor prayers, which, as Bossuet said, "would fall of their own weight" if left to themselves. He defends us against temptations and never permits himself to be discouraged by our failings. From him come "the sudden flashes of enlightenment, the prompt resolutions, the unhoped-for consolations" which are surprising even to ourselves. The decisive encounters in our lives, the meetings with a particular man, or book, or important thought come from the God-sent angels. Nor does the guardian angel abandon the Christian after his death. He stays with him in purgatory to console him, awaiting the hour when he will be able to carry the purified soul up to heaven. He also watches over the ashes of the body and gathers them together piously for the day of resurrection.

At first the guardian angel was represented in the guise of the archangel Raphael accompanying Tobit. But this image needed the biblical interpretation. Therefore, another image followed, which placed before the eyes of the faithful the guardian angel himself, a lovely angel leading a child by the hand (Pl. 45). Sometimes the child is very small, since it was taught that the guardian angel is sent to every human being at the moment of his birth; more often, however, the child is at the age when evil thoughts gain access to the soul; sometimes, also, the angel guides an anxious, melancholy-looking adolescent. Together they advance along the earthly passage, and the angel, with raised hand, points to heaven. . . .

Sometimes the scene takes on dramatic qualities, and we see the angel protecting the child from the stealthily approaching demon. . . . In Carlo Bonone's painting in

188

the Gallery of Ferrara, the demon has already laid his hand on the shoulder of the trembling child, but the angel, tranquil as befits a son of light, gently heartens his charge and points to heaven. Only in pressing danger does the angel's serenity become disturbed: Andrea Sacchi shows him snatching the child by the hair out of the clutches of Satan. Engravings and paintings reproduce such scenes many times over. Often the works were intended for the numerous confraternities of the guardian angel; but no doubt many were made for the private chapels of the gravely devout families of the seventeenth century, where, after morning prayers, the mother told her children about their angel.

## SURVIVALS OF THE PAST

Attentive study of seventeenth-century works of art reveals that the spirit of the past survived more tenaciously than current belief has it. The *Biblia pauperum* and the *Speculum humanae salvationis* continued to exert their influence upon artists.

The Jesuits continued to cherish these ancient compilations. It is a curious phenomenon that throughout Catholic Europe the painters depicted isolated scenes lifted from both books. We are surprised to find Rubens painting Job beaten by the demons, or Tomyris plunging the head of Cyrus in blood—both symbolical subjects from the *Speculum*, one, the prefiguration of the Flagellation, the other a symbol of the Virgin who gains her triumph over the demon by participation in the bloody Passion of her Son. The *Speculum* and the *Biblia pauperum* contributed several other subjects for Rubens' pictures. Like a medieval artist, he shows the angel bringing bread and

189

wine to Elias, Jonah cast to the sea monster, Abigail before David. It is unlikely that Rubens himself searched in these ancient tomes for symbolical subjects; rather, the pious donors who commissioned the paintings from Rubens were familiar with the books. Medieval symbolism, with its poetic associations, continued to exert its powerful charm over many souls.

In spite of the apocryphal character of the stories relating to the Virgin's parents, Saint Anne and Saint Joachim, and to the Virgin's childhood, these subjects are still represented in religious art. In the Church of Saint Isidor in Rome, built in 1622 for the Spanish Franciscans, we find, for instance, the chapel of Saint Anne decorated with frescoes illustrating the apocryphal gospels. An angel announces to the kneeling Saint Joachim that God will send him a daughter; whereupon the couple, long separated from each other, meet again. As in Giotto's fresco at the Arena Chapel in Padua, shepherds accompany Saint Joachim and slender-waisted ladies escort Saint Anne. We do not see the Golden Gate mentioned in the legend, but even that appears in the picture that Niccolo Berrettoni, a pupil of Maratta's, painted for another Roman church, Santa Maria di Monte Santo. Again, in the seventeenth-century pictures which decorate one of the chapels of Saint-Eustace in Paris, we find the angel appearing to Saint Joachim and the meeting at the Golden Gate. Even though the Church had taken a severe attitude toward the legend—in 1572 Pius V had suppressed the service of Saint Joachim from the breviary, and struck Joachim's name from the calendar—the legend persisted in these and many other paintings.

Another medieval work, the *Golden Legend*, exerted its influence over religious art in its own fashion: It owes its perennial sway to the attributes of the saints, of which

it is the sole interpreter. The saintly attributes were conventions consecrated by centuries of use. How else could the confraternities and the corporations recognize their protectors? True, it is startling to find Poussin painting Saint Margaret with a dragon, the monster she vanquished with the sign of the cross. Poussin, however, only followed the example of the Italian masters. In Santa Caterina dei Funari in Rome, Annibale Caracci painted Saint Margaret as she sets her foot on the gaping monster. The noble attitude of the saint who points to heaven, the inscription *Sursum corda* on the pedestal against which she leans, convey a moral grandeur which makes one forget the naïveté of the tradition.

For many centuries Saint Barbara was shown carrying a model of the tower in which her father had immured her, in order to identify her among other youthful saints. Saint Barbara was inconceivable without her tower. In the seventeenth and eighteenth centuries, painting and plastic art give her this immutable attribute. We see it in Saint-Roch in Paris, and in countless village churches. Italian painters followed the same tradition. Guercino is even more faithful to the *Golden Legend* than the French artists. Not only does he give Saint Barbara her tower: he also shows the angel with the chalice and the Host at her side, as a reminder that Saint Barbara is ever mindful of her faithful worshipers and does not let them die without the last sacrament.

How recognize Saint Catherine except by her broken wheel? The great Caravaggio paints her with this attribute, lifted from a page of the *Golden Legend*.

Saint Jerome could not be imagined without his lion, the faithful companion the Middle Ages had given him in his solitude. He was known by the lion lying at his feet. Even at the hour of his death, when he received the

supreme viaticum, his lion was at his side, and Domenichino, in his noble painting of the "Last Communion of Saint Jerome," does not neglect this telling detail (Pl. 46) . . . .

No doubt the old legends were somewhat less fecund than they had once been, and artists made use of them less frequently, since they were no longer accepted with the unanimous faith of earlier times. The serious-minded no longer gave them credence. The Church, however, with her habitual moderation, judged them less severely, and did not wish to deprive simple hearts of the spiritual sustenance they found in the ancient tales; she thought it wise to make allowance for the world of dreams. We see her indulgent for the apocryphal gospels and the *Golden Legend* as she was for the *Revelations* of Maria of Agreda, so harshly judged by Bossuet. Because of that wise tolerance artists could still find inspiration in the old tales and symbols, and the great current of poetic imagery which had come from so far, and run through the entire Middle Ages, could still vivify the art of the seventeenth century.

ALLEGORY

In the Italy of the seventeenth and eighteenth centuries, allegorical figures and personified abstractions became the fashion. While studying the works of Bernini at the Villa Borghese in Rome, I was astonished to find that his fine figure of Truth holds a sunlike disk darting forth rays of light, and rests her foot on a globe (Pl. 47) . How were these attributes to be interpreted? What meaning had Bernini hidden therein, who, as is known, conceived his statue in a mood of profound melancholy? And were these strange symbols his own invention? I came to doubt

it when I found, in Santo Spirito dei Napoletani in Rome, on the tomb of Cardinal Giovanni Battista de Luca, a similar statue of Truth holding also the sunlike disk and standing on a globe. Was it a rule to represent Truth in this manner, and from whence was this rule derived? It seemed to me that I perceived a kind of allegorical language with its own vocabulary and laws. In the library of the Collegio Romano I finally discovered the book which had inspired all Italian allegories, the *Iconologia* of Cesare Ripa, a book at one time celebrated, though today completely forgotten. It is an illustrated dictionary of allegories listing instructions for the personification of abstract ideas. I was looking through it absent-mindedly, not suspecting the interest of the work, when an image of Truth arrested my attention. Nude, and corresponding exactly to Bernini's statue, Truth had a sun in her hand and a globe beneath her feet. Ripa's commentary reads: "Truth has to be represented quite naked, because her nature is simplicity itself. . . . She holds up the sun to signify that she loves the light and is herself the light. . . . The globe is under her feet to show that she is more precious than all the riches of the world; that is why Menander said of her that she was a citizen of the heavens."

These lines were first printed in 1603, five years after Bernini was born. When the artist began his statue, in 1644, Ripa's work had already gone through seven editions. Beyond any doubt, we have here the source of Bernini's attributes for his Truth.

Ripa's allegories are met with in many Roman churches. In Saint Peter's, for example, we see in the nave and the transepts over each arcade large recumbent female figures, works of Bernini's pupils, dating from the middle of the seventeenth century. Little attention is paid to them, and even less to the accompanying curious attri-

193

butes touched up with gold. They aroused my curiosity, and I soon recognized some of the grave Ideas, nobly draped, which I had learned to know from Ripa. What, for instance, is the allegorical meaning of the seated woman holding a cross and a book, with a tiny figure at her feet? She is the true Christian religion, as described by Ripa: Holding a cross and carrying a book on which is written *Diliges Dominum tuum,* she sets her feet upon a small dead female figure to show that she triumphs over death. For true religion is defeat of death, and the figure seems to repeat the words of the poet: *Cur tibi mors premitur? mors quia mortis ego.* Further on we find a woman carrying a lamp. There is a crane near by and, peculiarly enough, the bird, standing on one leg, holds a pebble in the other claw. One of the engravings in Ripa's book shows Vigilance with these attributes, and his text unravels the puzzle. The lamp signifies that vigilance is best exercised at hours when people are normally asleep. The Roman sentinels divided the night into four watches. Even the animals set us an example of the vigilance that is the mother of security. When cranes are migrating one of the band watches over the others during the hours of repose. So that he will not succumb to sleep himself, the sentinel crane holds a pebble in his claw. If he senses some danger he drops the stone and awakens his fellows, who fly off. . . . This was a tale which Ripa considered perfectly worthy of belief, since he took it from Piero Valeriano, who had it from Horus Apollo. Incidentally, we observe that some of the natural history of the seventeenth century was not strikingly different from that of the Middle Ages.

## DECOR IN THE CHURCHES OF THE RELIGIOUS ORDERS

Each order had its special iconography; on entering a Roman church, it is obvious at once whether we are with Jesuits, Carmelites, Augustinians, Franciscans, or Carthusians. The Carmelites may serve as an example.

Of all orders, the Carmelite laid claim to the most ancient origin and vaunted itself on a lineage going back to the times of Solomon and Homer. The founder was none other than the prophet Elias. It would be difficult to conceive of a more imaginative story than the one put forward by the Carmelites in the early years of the seventeenth century.

By their account, the first exemplar of monastic life had been instituted upon Carmel, the mountain commanding the plain of Esdrelon and the sea. The name, resplendently enshrined in the *Canticle of Canticles,* was felt to be an ornament for the Order. Elias had imposed upon himself a severe rule accepted by Elisha and propagated by the ascetics of Carmel for several centuries. At the advent of the Christian era, these monks of the Old Testament still continued in existence: Saint John the Baptist was one of the Order. The words and the example of the Precursor revitalized the Order of Carmel. John lived surrounded by disciples, several of whom became illustrious. There were Saint Andrew, later the apostle, Silas, the companion of Saint Paul, Saint Martial, first Bishop of Limoges, Saint Saturnin, son of a king of Achaea and apostle of Toulouse, Saint Front, Bishop of Périgueux, who buried Saint Martha in Provence. After the death of John, the Carmelites of the apostolic age became

195

disciples of Jesus Christ, and, on the morrow of Pentecost, joined the apostles. The Virgin was bound by mysterious bonds to the Order of Carmel. . . .

So we are not surprised to find the life of Elias with that of Elisha his disciple so often related in Carmelite churches. San Martino ai Monti in Rome, the church that Lezana calls "the most precious pearl in the treasure of the entire Order," offers a fine rendering of this subject so full of mysterious allusions. There are eighteen frescoes, in which the landscapes, if not the human figures, are by Gaspard Dughet, the nephew of Poussin (Pl. 48). They were painted between 1639 and 1645, and some had particular significance for the Carmelites. One of them shows Elias, during a great drought, ordering his servant to go and observe the sea from the height of Mount Carmel. "Climb up," he says, "and look out toward the sea." The servant does so, and comes back with the answer, "There is nothing." Elias says, "Return seven times." The seventh time, the servant says, "I see a tiny cloud, as big as the palm of a man's hand, rising from the sea." Elias says, "Go up and say to Ahab, 'Harness thy horses and come down, so that the rain may not overtake thee.' " Then Elias, girding his loins, ran before Ahab as far as Jezriel.

How are we to interpret this cloud "which rises out of the bitterness of the sea without participating therein"? It is, the theologians tell us, a figure of the Immaculate Virgin. Humanity waits. upon her coming for centuries on centuries. At last, during the seventh age of the world, she appears and refreshes the aridity of the earth by bringing to it the Christ.

Still another episode had been one of the favorite Christian symbols ever since the Middle Ages. An angel brings to Elias, lying under a broom bush and resigned to dying,

a loaf and an amphora; this is a symbol of Holy Communion, which restores strength to the soul. Certain scenes from the life of Elias are not fully understandable except in the light of Carmelite interpretations. Elias covering Elisha with his mantle while the latter was plowing in the fields signifies the founder of monastic life receiving his disciple into his order. Elias mounting up to heaven in the fiery chariot and casting down his mantle to Elisha represents the superior passing on his power to his successor. The white mantle, it was said, had been folded, and the flame had touched only certain parts of it. When Elisha wore it, it showed brown stripes, and such became the mantle of the Carmelites during the early centuries. These are some of the salient episodes from the life of Elias and Elisha as it is told at San Martino ai Monti.

The scene of the Transfiguration recurs frequently in Carmelite churches, because Elias appeared at the side of Christ together with Moses, a signal honor of which the Order was proud. A legend became associated with this scene. It was said that Elias had obtained from Christ at that moment the promise to preserve his Order unto the end of the ages. This explains the group of the Transfiguration on the magnificent altarpiece of the Carmelite church at the Place Maubert in Paris, and the picture in Salamanca showing Elias of the Transfiguration dressed in the striped mantle of the Carmelites.

A considerable number of works of art of the seventeenth century were born, like these, of the convents, of passionate spirits who desired visions, ecstasies, legends, and cared little for the work of critical research and its sober verities. The Carmelites cleaved to Elias, deriving a great moral force from this union with a long history, this contemplation of a galaxy of souls arising from the

depths of the past. The other religious orders likewise held fast to the remote, the poetic, to the emotionally appealing. The Middle Ages were perpetuated through the orders, which imparted their traditions to the artists. In all these works we feel an immense aspiration. This monastic art proclaims boldly that the only verities are those of the soul. Saint Francis of Assisi, Saint Francis of Paola, Saint John of the Cross, and Saint Theresa taught the triumph over inimical nature. Those who were elevated above the earth as they prayed called upon humanity to mount up, to raise itself above the earth.

## CONCLUSION

An art conceived during the tragic years when the papacy saw large portions of Christendom break away could no longer, like medieval art, express repose in faith. Art was committed; was obliged to struggle, to affirm and to refute. It became the auxiliary of the Counter Reformation, one of the aspects of apologetics, defending what the Protestants attacked—the Virgin, the saints, the papacy, images, sacraments, works, and prayers for the dead. It developed themes which in the past had been only sketched; and it expressed sentiments and forms of devotion which were entirely new.

Later, when a Church purified of abuses and ready to give its blood was undertaking to reconquer the Old World and to carry the faith into the New, art participated in the enthusiasm. It glorified martyrdom, it set the Christian face to face with death so that he might learn not to fear it. At the same time, it opened up the heavens. The great saints of the sixteenth century,, perhaps the most impassioned of all saints, seem to have lived at the

198

furthermost limits of this world; and sometimes they went beyond to be united with God. Ecstasy appears not only as the recompense of their love but as the evidence of their mission. Heresy could not communicate with Christ, nor see His luminous face, nor hear His voice. Ecstasy became the culmination of Christian life and the supreme effort of art. To express ecstasy, art made use of all its incantations, all its magic of light and shadow. Religious art had never attempted anything of the kind before; it too reached the extreme limit of the possible. The art of the Counter Reformation added something new to the modes of expression of Christian art, and sounded chords of a resonance not heard before.

So it became the perfect interpreter of a historical period. Those who have read Bellarmine, Saint Ignatius of Loyola, Saint Theresa, will find an echo of their thought in the pictures and statuary of the churches. For, even unknowing, the artist participates in a spirit infinitely greater than his own.

# INDEX

200